THE BIG BOOK OF
BASKETBALL FASHION

Mitchell S. Jackson

 ARTISAN BOOKS
NEW YORK, NY

Library of Congress Cataloging-in-Publication Data is on file.
ISBN 978-1-64829-092-3

Design by Nina Simoneaux

Artisan books are available at special discounts when
purchased in bulk for premiums and sales promotions as
well as for fundraising or educational use. Special editions
or book excerpts can also be created to specification.
For details, please contact special.markets@hbgusa.com.

The publisher is not responsible for websites
(or their content) that are not owned by the publisher.

The Hachette Speakers Bureau provides a wide range
of authors for speaking events. To find out more,
go to hachettespeakersbureau.com or email
HachetteSpeakers@hbgusa.com.

Published by Artisan,
an imprint of Workman Publishing Co., Inc.,
a subsidiary of Hachette Book Group, Inc.
1290 Avenue of the Americas
New York, NY 10104
artisanbooks.com

Artisan is a registered trademark
of Workman Publishing Co., Inc.,
a subsidiary of Hachette Book Group, Inc.

Printed in China on responsibly sourced paper
First printing, July 2023

10 9 8 7 6 5 4 3 2 1

LeBron James for *GQ* in 2017. The "King" flexing his
royalty with a resplendent burgundy peacoat and a
ball that might've been touched by Midas himself.

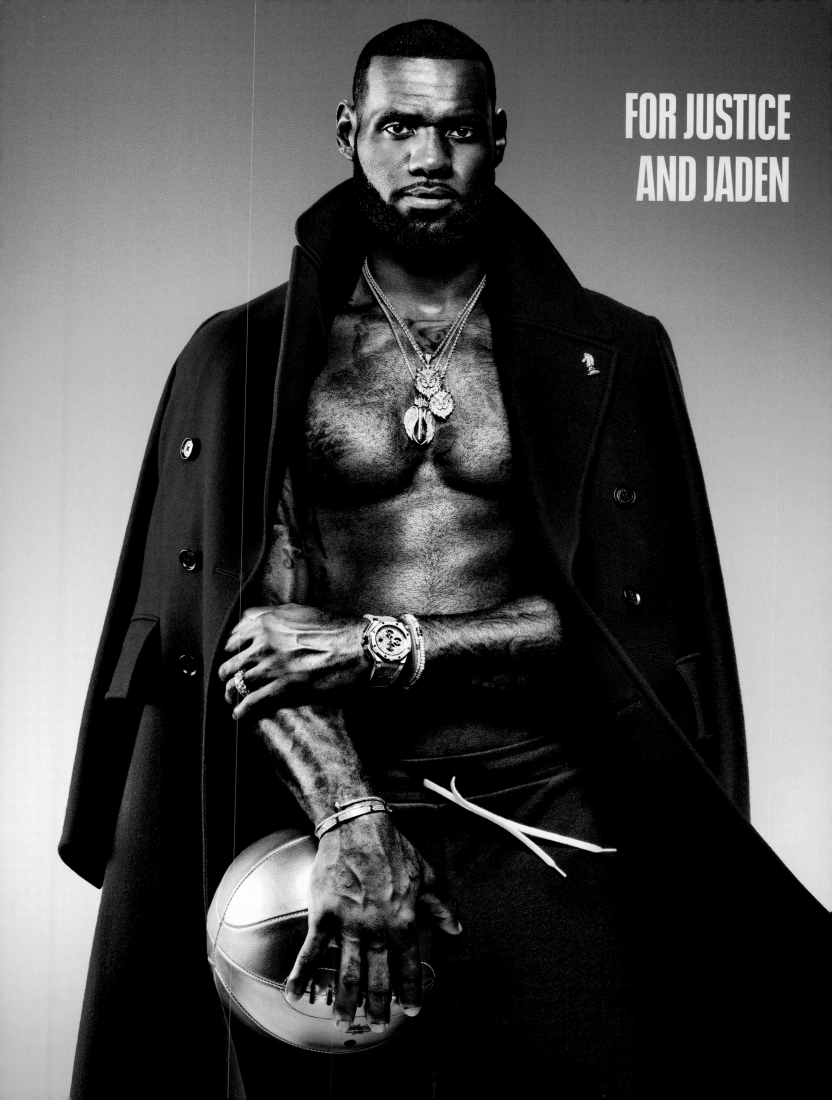

FOR JUSTICE
AND JADEN

CONTENTS

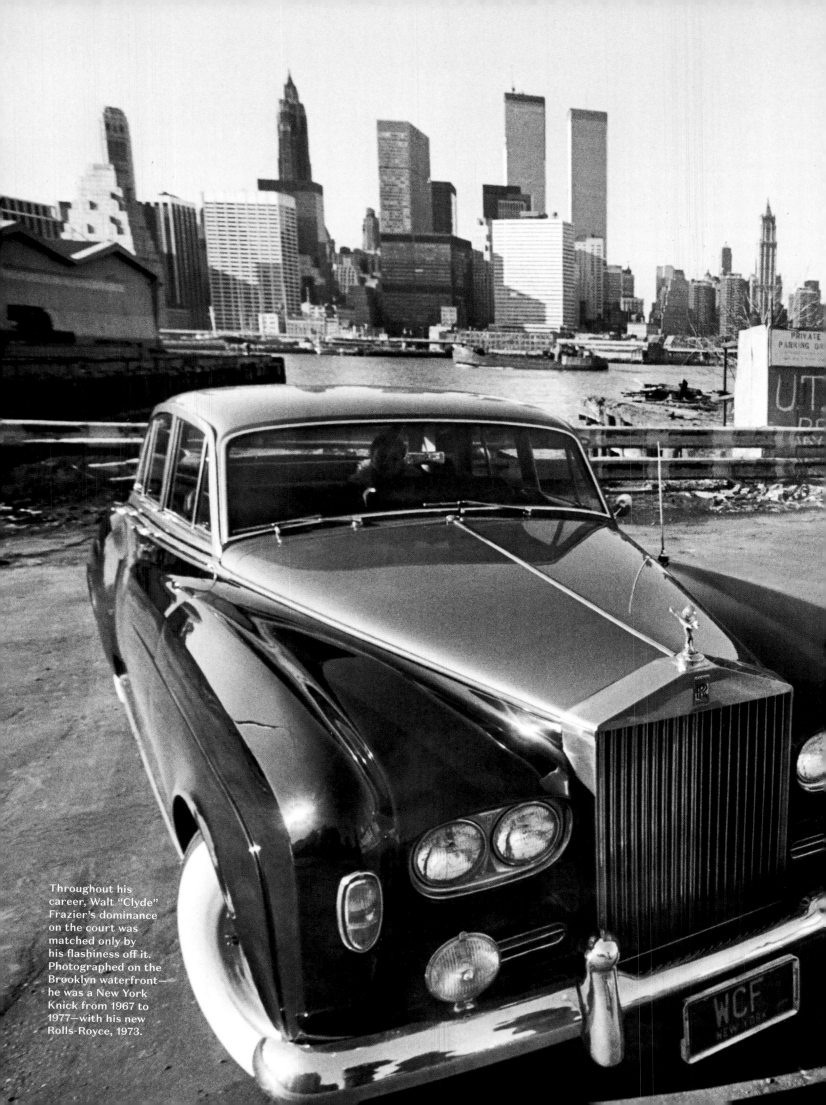

Throughout his career, Walt "Clyde" Frazier's dominance on the court was matched only by his flashiness off it. Photographed on the Brooklyn waterfront—he was a New York Knick from 1967 to 1977—with his new Rolls-Royce, 1973.

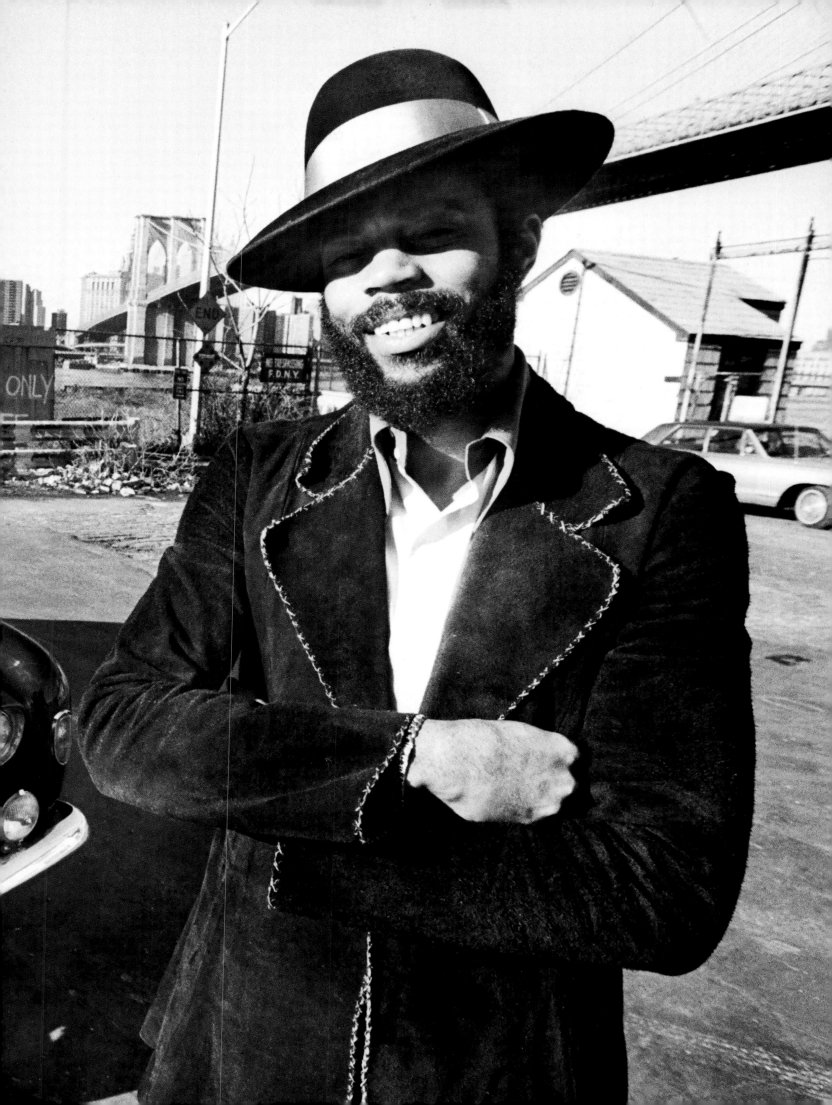

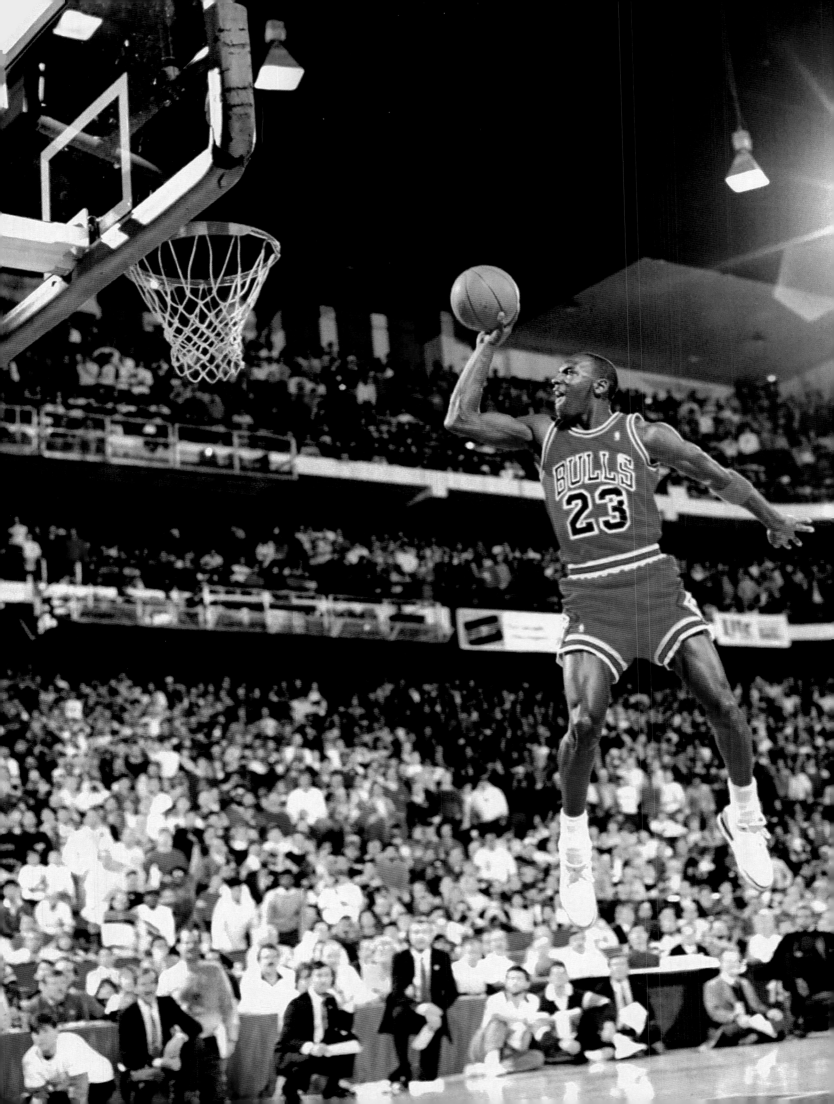

WHAT'S STYLE?

George "Mr. Basketball" Mikan barreling across the lane and banking his signature hook for two . . . Bill "Secretary of Defense" Russell leaping almost to the Garden's rafters to knock a high-arching shot damn near into the nosebleeds . . . Julius "Dr. J" Erving defying physics as he swoops behind the backboard, his planetary 'fro close to kissing the foam, and reverses a one-handed layup over outstretched Lakers . . . George "The Iceman" Gervin all but floating the length of the court and, over a packed key, finger-rolling a ball that falls from heaven straight through the net—*swish* . . . Larry "Legend" Bird shooting a silky baseline floater in the game he played with his off hand just because he could . . . Earvin "Magic" Johnson fast-breaking in the Forum with his signature high dribble and legerdemaining defenders with a wide-eyed lookaway that finds a divining Michael Cooper for the score . . . Michael "Air" Jordan soaring from the free throw line in that mythic dunk contest, the GOAT's sky-walking legs abaft, right arm double-clutching the ball above his head, left arm winged at his side . . . Allen "A.I." Iverson step-back crossing Tyronn Lue off his feet—ankles, ankles—then stepping over his fallen foe with the aplomb of a human who feels implacable . . . Steve "Captain Canada" Nash zigging and zagging and spinning and twirling through a whole team of confounded defenders before sinking a crunch-time mid-range fadeaway . . . LeBron "King" James bounding from a whole other dimension to smack Andre Iguodala's crunch-time, could've-been-a-game-sealing layup almost through the glass, an astonishment that

helps his Cavs win their very first championship . . . Stephen "Chef" Curry launching a f-i-f-t-e-e-n-t-h all-star three-pointer from a deep corner and turning to a section of gobsmacked courtside fans while the ball arches to affirm what he knows: *splash* . . . Temetrius "Ja" Morant turning the Nuggets into a facile skills challenge and soaring into a sublime 360 that ends with an immaculate off-hand finger roll.

The transcendent ones.

WHAT'S FASHION?

We watch sports for exemplars of excellence, for the chance to see a human flout physics, best odds, prove mettle, for the sagas born of the perennial pursuit of victory.

We remember feats like the ones above for how they testify to physical gifts and bear on the outcomes of games, but also for the flair in which they were achieved.

In other words: The greats, or soon-to-be greats, enthrall us not only by *what* they do but by *how* they do it.

By their style.

Style—a way of doing and seeing and being seen. A way of expressing taste, a sense of beauty. A reflection of whether one tends toward conforming or fancies oneself an iconoclast. Style—one of the most explicit ways to define individualism, personality, identity.

This is me. This is me. *Only me*, is its aspirational mantra.

But this book ain't about style in general nor style of play, but personal style/fashion. That is to say: what someone wears; how they wear it.

Personal style demands a stance on aesthetics. At its purest, it proclaims someone as a one of one, declares that they've discovered the most apt expression of the truth of themselves. At its best, personal style is intentional to the hilt but looks oh-so effortless.

While the choices that comprise it are individual, personal style never occurs in a vacuum. Rather, those decisions are ever and ever a reflection of politics and economics; cultural shifts and popular trends; of broader values, beliefs, mores. Style, you see, is always an amalgam.

PREVIOUS PAGE
At the 1988 NBA Slam Dunk Contest, Michael Jordan was still building his legacy as one of the most stylish players of all time.

RIGHT LeBron James of the Los Angeles Lakers arrives at the Crypto.com Arena dressed to the silky nines on February 7, 2023, the night he became the NBA's all-time leading scorer, breaking a long-standing record held by former Laker Kareem Abdul-Jabbar.

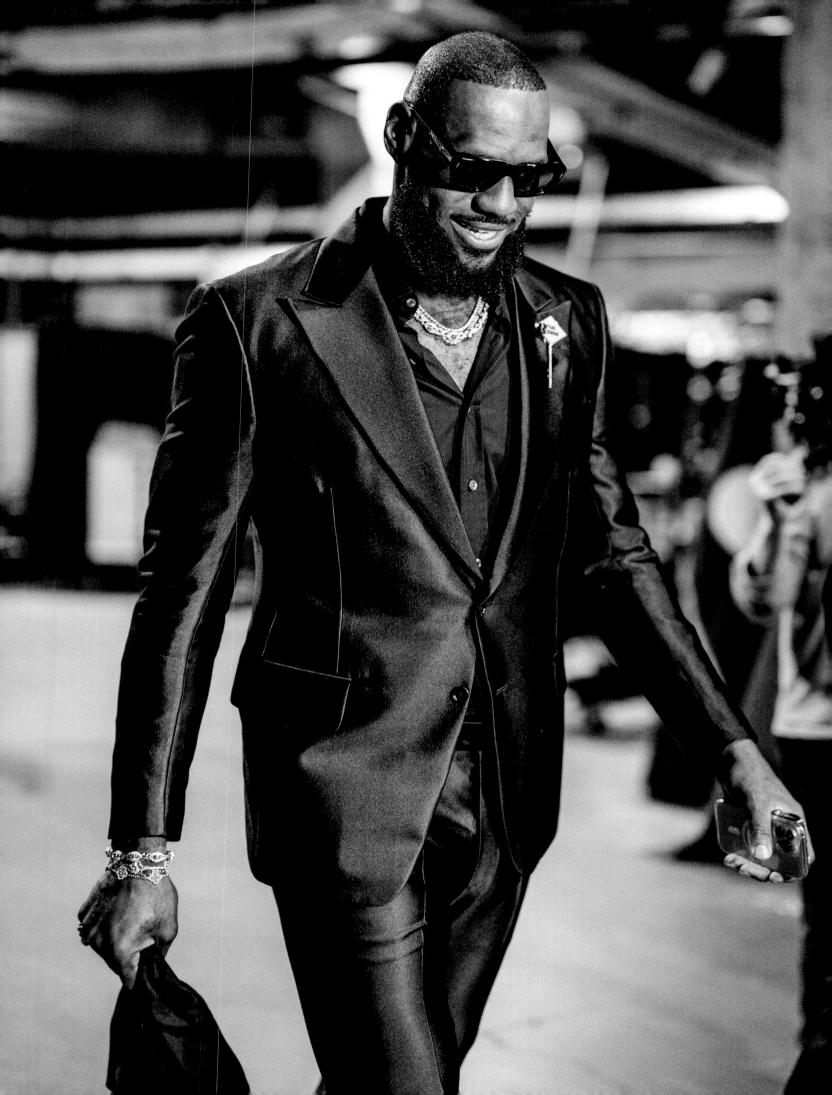

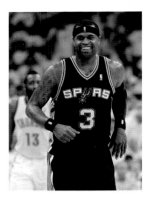

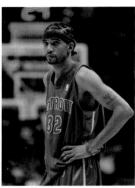

76ers star Allen Iverson pushed the limits of NBA conformity throughout his career—including with his trademark devil-may-care lollipops. He spurred a diaspora of style around the league, personified by the likes of (*above, from top*) Stephen Jackson, Richard "Rip" Hamilton, and Carmelo Anthony (*left, with LeBron James*).

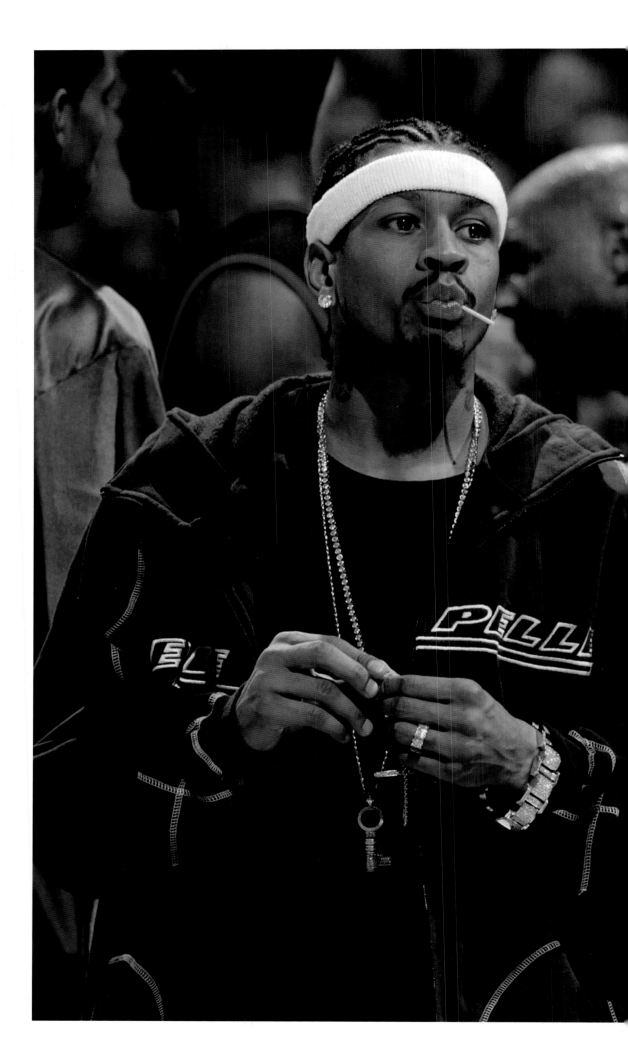

INFLUENCE

For most of its first seventy-five years, the NBA has been dominated by what some sports outlets have dubbed teams of the decades.

In the early years, it was Mikan and his Minneapolis Lakers, who won five championships from 1949 to 1954. Russell's Boston Celtics won eleven championships in thirteen seasons from 1957 to 1969. Johnson's Los Angeles Lakers and Bird's Celtics together won eight of the ten championships of the 1980s: rivaling bicoastal dynasties that propelled the league to tremendous growth.

Jordan's Chicago Bulls dominated the 1990s, doubling up on three-peat championship runs that helped cement Jordan as not only the most influential NBA player of all time, but at one point during his playing days, the most famous human being on Earth. Since then only the Kobe-and-Shaq Lakers have completed a three-peat, though the Steph-Klay-Draymond Golden State Warriors are at four total chips and counting.

While soccer is the most popular sport in the world, the top ten spots on *Forbes*' 2022 list of The World's Most Valuable Teams were owned by American sports teams. (The NBA was represented by the New York Knicks at number 6 with $5.8 billion; the Golden State Warriors at number 8 with $5.6 billion; and the Los Angeles Lakers at number 10 with $5.5 billion.) As well, the United States owns the largest share of the global sports market: 32.5 percent as of 2018.

Not only is the U.S. sports market the most lucrative in the world and its teams the most valuable, NBA players—many of whom display remarkable personal style—are the most well-known athletes. In 2019, ESPN published its most recent World Fame 100, a respected statistical ranking of athletes' global influence. There were three NBA players in the top twenty. LeBron James came in at number two overall and number one in endorsements ($52 million), followed by Steph Curry at number nine and Kevin Durant at number eleven. In fact, those three were the only *Americans* in the top fifteen. The highest-ranked American football player? Tom Brady at number thirty-one. And the lone baseball player on the list was Bryce Harper, who squeaked in at number ninety-nine.

STYLE MATTERS

While exceptional play is no doubt the nexus of why an NBA player matters to the masses, personal style has become an undeniable part of what commands our attention.

Prior to the release of Beats by Dre, the trendy headphones that hit the market in 2008, Jimmy Iovine—the legendary rock producer and partner of Dr. Dre in the creation of Beats—met with Maverick Carter, one of LeBron's confidants and business partners. Iovine ended up sending LeBron fifteen pairs of the headphones.

As a result, LeBron bopped off the plane—as did many of his teammates—for the Beijing Olympics wearing an Olympic T-shirt and a pair of the headphones, birthing a pivotal viral moment. The headphones had been marketed as equipment for musicians, and as a way for regular consumers to "hear what the artists hear." But LeBron and a planeload of NBA Olympians showed the world that Beats weren't just useful for audiophiles. Beats were *cool*.

Sales of the headphones boomed.

Prior to 2008, it seemed Madison Avenue believed athletes could do little more than shill apparel and equipment; sports drinks and cereals; the occasional car. But that year, LeBron's impact on Beats by Dre—magnified by the fresh age of viral marketing—signaled to ad execs that, perhaps like never before, star basketball players could exert massive influence beyond sports and its adjacent realms.

Soon the NBA players themselves—and not just the megastars—discovered what hip-hop had known going back at least as far as Run-DMC's 1980 collaboration with Adidas, a sentiment distilled in Jay-Z's famous line on Kanye West's "Diamonds from Sierra Leone": "I'm not a businessman / I'm a business, man."

Nowadays NBA players are brands unto themselves.

The story of NBA fashion over the past seventy-five years is also, in many ways, the story of America. Basketball and fashion have always been intertwined in a way that reflects our national ethos. See remnants of America's World War II rigidity in the crisp, minimal uniforms of the 1950s. The

Julius "Dr. J" Erving always understood the importance of individuality. Uniondale, New York, 1974.

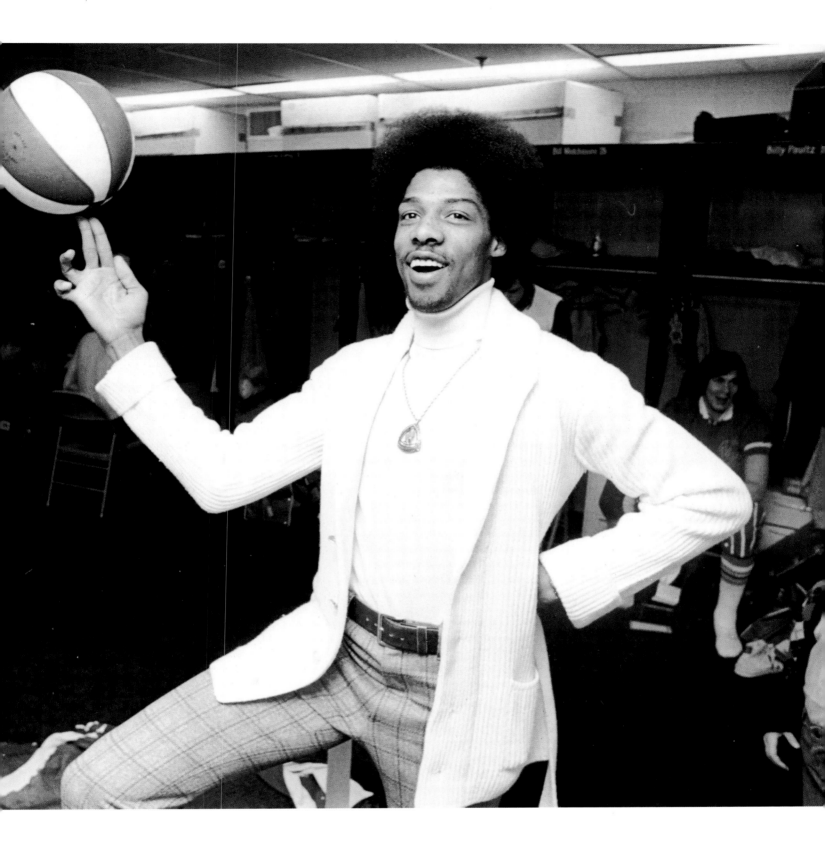

newfound freedom of Black men to express themselves in the fur coats and bare chests of the 1970s. The flouting of corporate respectability in Iverson's baggy denim and ample tattoos.

The confluence of professional basketball and fashion holds a mirror to American culture. But it also, as we shall see, helps define it.

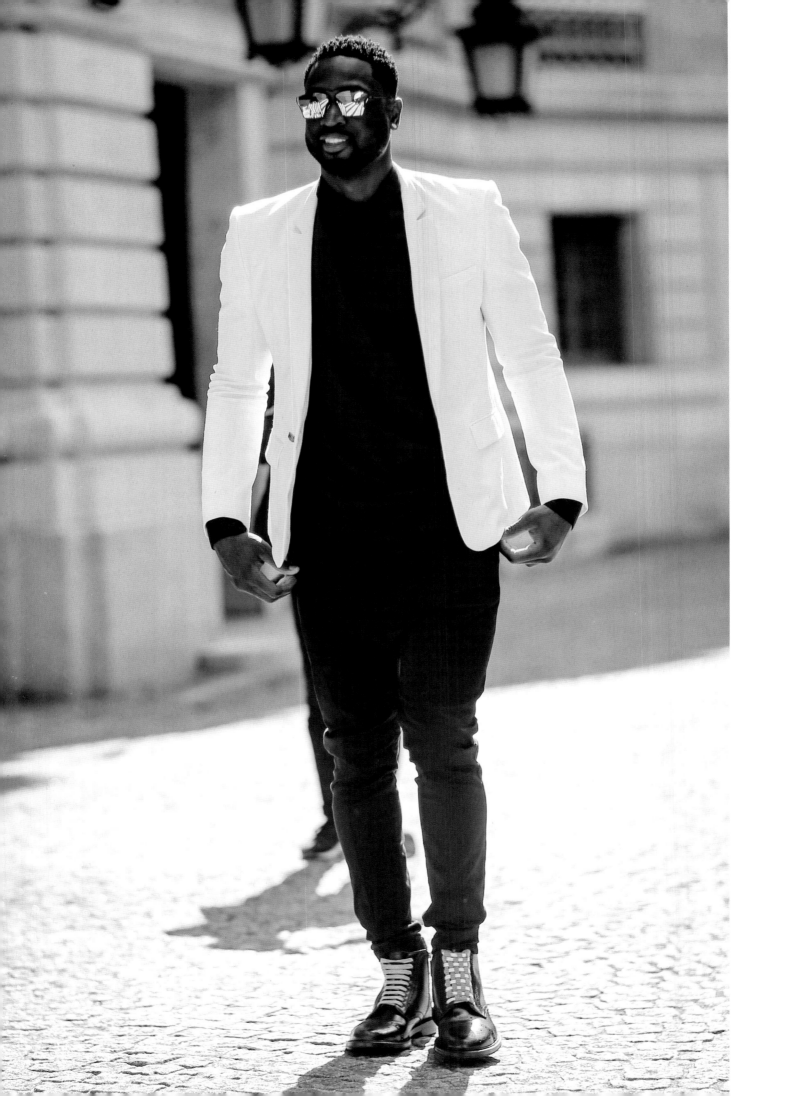

THE ERAS

This book is organized by eras rather than decades. Decades are arbitrary measures of time. But an era is different. An era is a report on the times, a span defined by the zeitgeist, by the political and cultural milieu, by the events that will go down in history—years that often forge distinct fashion.

The Conformists: 1946-1963
Flamboyance: 1964-1980
Jordan: 1981-1998
The Iverson Effect: 1999-2009
Dress Code: 2010-2015
The Insta-Tunnel Walk: 2016-beyond

The indelible ones across the eras:

Picture Wilt "The Big Dipper" Chamberlain in baggy pleated pants and long sport coat, his fifties-style fit paired with a dark tie and pocket square.

Bill Russell and Lew Alcindor (a few years before he renamed himself Kareem Abdul-Jabbar) with their arms slung over the dwarfed-in-size-but-not-stature Muhammad Ali at the famous Cleveland Summit—the Secretary of Defense decked out in a three-piece suit and patterned tie, the Captain in a double-breasted suit with paisley neckwear.

Julius Erving swaggering outside the Nassau Coliseum in a cream-colored shirt and bell-bottom pants, the tint of Dr. J's oversize shades matching the burgundy of his leather lace-ups, plus golden: both his digital watch and his pinkie ring.

Walt Frazier strutting from his car into Madison Square Garden, "Clyde" in a fur-trimmed sport coat—part of a three-piece getup—his fedora cocked just so, a luxurious leather bag in hand.

Envision Earvin Johnson all smiles in a light-colored suit with wide-legged pants and gator-skinned boots, Magic shaking the hand of his coach Pat Riley as he cools on the hood of a Corvette, his Finals MVP trophy gleaming beside him.

Shaquille "The Diesel" O'Neal, towering on the sidelines during a night off from the Lakers, a seeming infinity of buttons on his knee-length Laker-purple suit jacket, a hefty gold medallion hanging to the middle of his broad chest.

Michael Jordan at the *Space Jam* premiere—Air Jordan's left ear adorned with a signature gold hoop, the jacket of his capacious gray suit, the one with the collarless black shirt beneath it, about as long as his wingspan.

Dennis Rodman a shock on the red carpet of the MTV Video Music Awards, the Worm in a sparkling crop-top camisole, baggy jeans, and scuffed combat boots, his mini Afro dyed pink.

Allen Iverson sideline posted on a night off, A.I. quintessentially, unabashedly hip-hop in an oversized Pelle Pelle sweat suit, giant diamond bracelets, pair of long diamond chains, diamond studs the size of a basketball, and his intricate braids wrapped in a thick white headband.

Dwyane Wade swanking to a Balmain show during Paris Fashion Week, D-Wade decked out in an off-white sport coat, tab-collar black shirt, and jeans, his combat boots strung with mismatched laces—polka-dot green in one, fluorescent orange in the other—his look finished with mirror-tint shades.

LeBron James swaggering through a tunnel during the NBA Finals, the King so fresh so clean in a Thom Browne signature suit, striped socks, and skinny tie, all gray, plus a green alligator version of the Mr. Thom bag and sunglasses dark as limo tint.

Russell Westbrook broadening the boundaries of NBA fashion during New York Fashion Week—the Brodie dressed in an ankle-length skirt, ivory cardigan, and wingtip combat boots—all Thom Browne—daring made more emphatic by his shirtlessness and his electric-blue hair.

See Jayson Tatum sauntering into Chase Center for Game 1 of an NBA Finals, the young star LeBron nicknamed "The Problem" super chic in Dolce & Gabbana's two-face sport coat (one side of the jacket featuring a navy-and-white pin-striped fabric with a paisley lapel and the other side a pink top half with a black pin-striped bottom), the sleeves rolled to flaunt its leopard-print lining—a sartorial boldness paired with colorful Nike Dunks.

Jalen Green—so new he hasn't been christened with a handle yet—ultralight beaming on draft night in a sparkly pin-striped bell-bottomed Balmain suit, a high-fashion look he complemented with a white lace shirt and a diamond-encrusted choker chain and number four pendant.

Picture them, envision them, see them, the next ones and the next . . .

Russell Westbrook epitomizes the redefinition of masculinity during New York Fashion Week 2022.

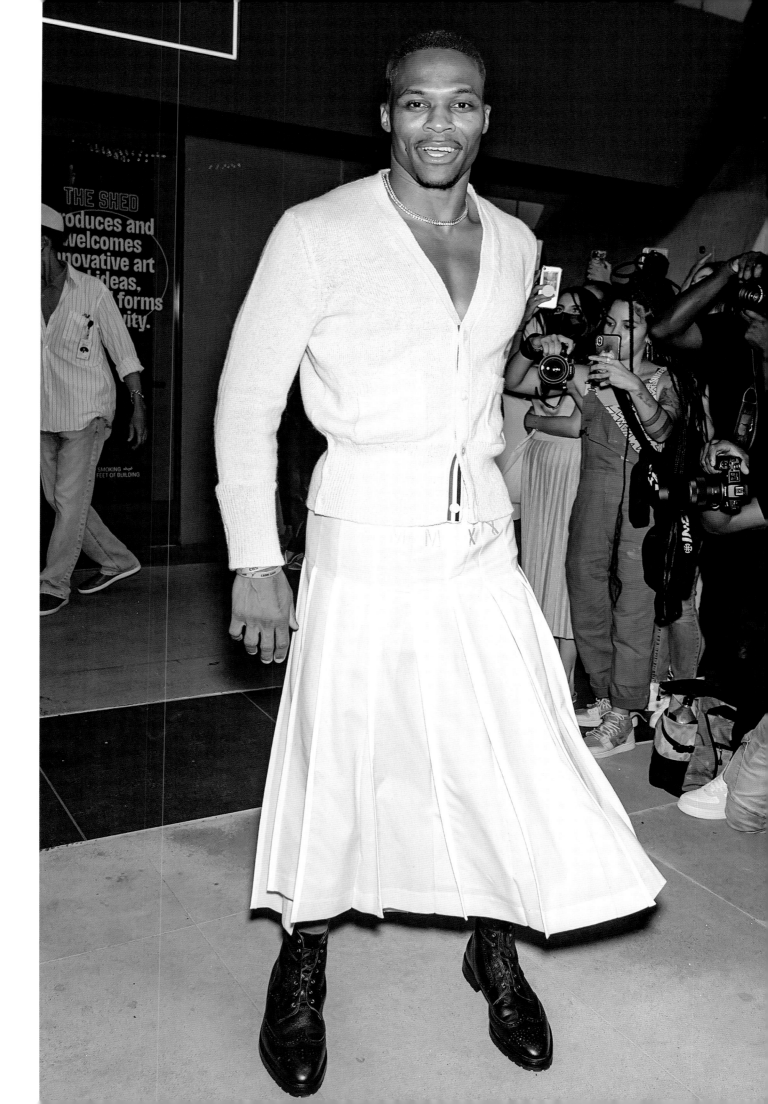

Style in sports often mirrors the culture at large. This photo shows three extraordinary athletes looking dapper—(*from left*) Bill Russell, already a Celtics legend; Muhammad Ali, former and future heavyweight boxing champion; and Lew Alcindor, a star at powerhouse UCLA who would become a Hall of Famer as Kareem Abdul-Jabbar—as they gathered to support the rejection of the draft at an event in Cleveland in 1967.

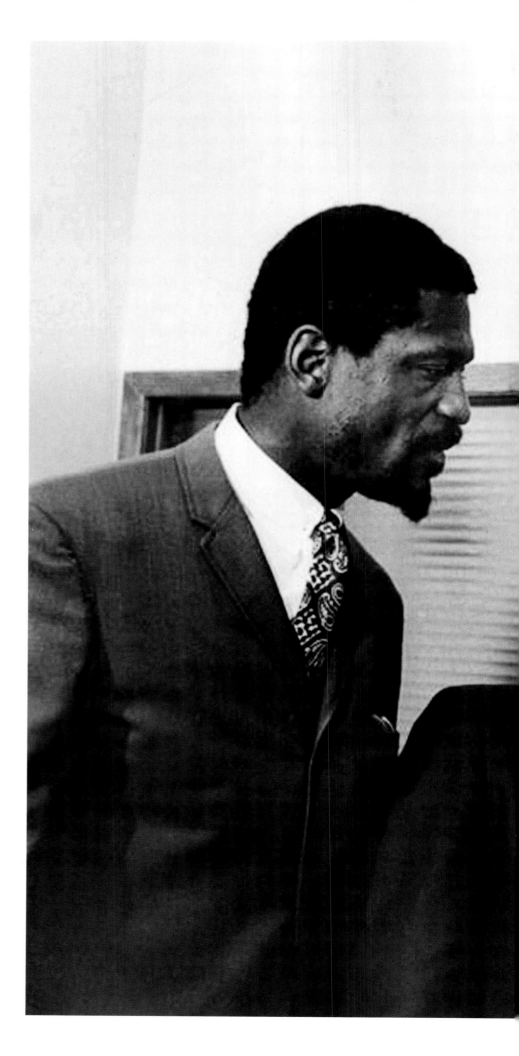

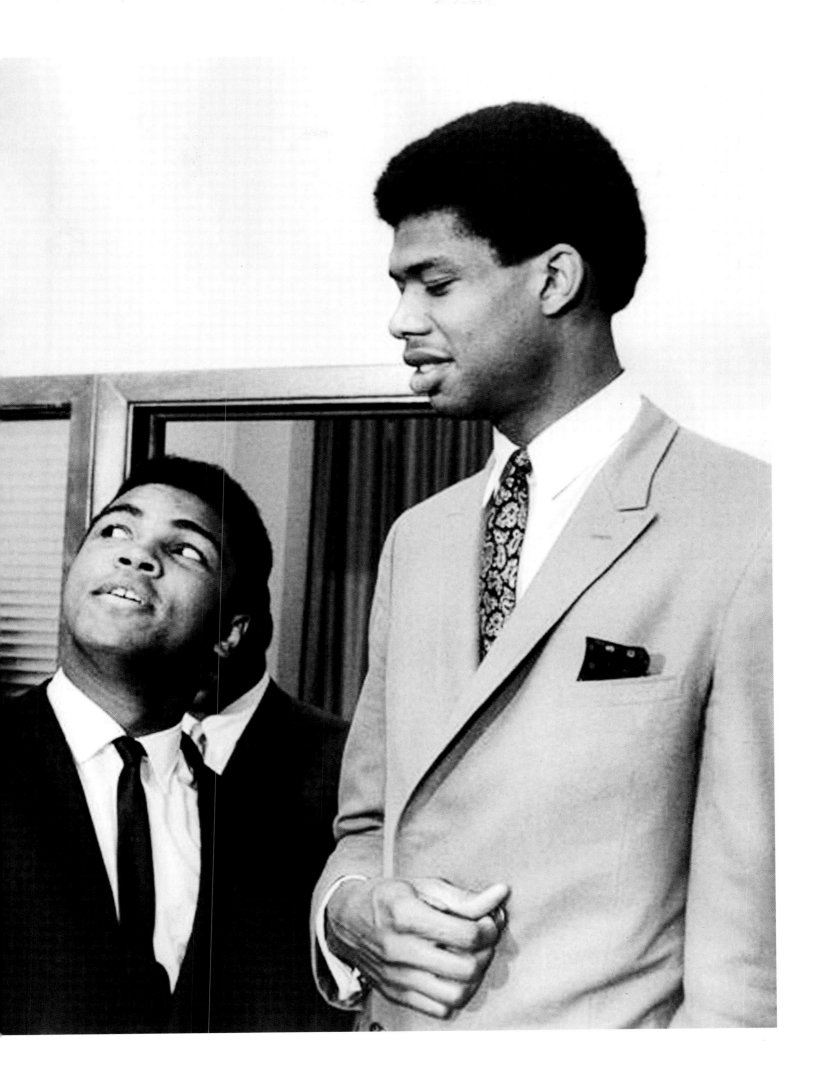

The
Confo

mists

In the NBA's first era, its players were at best dapper in the most quotidian sense.

Is there a year more significant to contemporary world history than 1945?

It began with the end of the Nazis' failed offensive in the Ardennes forest, forevermore known as the Battle of the Bulge. A few months later, Adolf Hitler committed suicide in his Berlin bunker, hastening the Nazi surrender. The United States dropped the atomic devastation of "Little Boy" on Hiroshima and "Fat Man" on Nagasaki that August.

The effects of World War II on American fashion are both fascinating and well chronicled. In step with the rationing of goods considered crucial to the war—tires, personal autos, sugar, coffee, meat—the rationing of clothes was deemed part of the sacrifice Americans must make to secure an Allied victory. Unlike the forced approach the government used to secure the rationing of war-related materials, it chose propaganda as the means to achieve clothing conservation, inventing slogans like "Sew for Victory."

Neiman Marcus executive H. Stanley Marcus was head of the clothing and textile program at the War Production Board (WPB). In 1942 the WPB hosted a meeting of eight hundred fashion-industry representatives, during which Marcus declared, "In the past, fashion has received its inspiration from the pages of history—the Renaissance, the Puritans, the French Empire. But today the inspiration must be the realistic modern one—war." Marcus implored designers and manufacturers to "stretch today's plenty into enough for tomorrow."

Beyond propaganda, the WPB issued General Limitation Order L-85 in 1942, which, among other rules, forbade the production of shirts with cuffs, wide lapels, double-breasted jackets, pockets, pants with cuffs and pleats, and suits sold with two pairs of pants, which had been a norm until then.

The NBA was born during that spirit of sartorial conservation. That ethos is evident in those early photos, in the slim tailoring of the suits the players and coaches wore, in the uniformity of the color palettes—the blacks and grays and blues—in their dark dress shoes (shoe rationing didn't end until a month after the armistice), and in the white shirts with the small club collars. Even in the cropped haircuts and preponderance of clean-shaven faces. It's apparent in the fact that you won't find photos of the league's pioneers wearing the flashy zoot suits popular in their day among fashion-forward iconoclasts.

In 1937 three corporations—General Electric, Firestone, and Goodyear—founded the National Basketball League (NBL). The league featured thirteen

27

teams, most of them from the Midwest. In June 1946 Walter Brown, the owner of the iconic Boston Garden arena, helped found the Basketball Association of America (BAA) in New York, with the intention of scheduling more events in his area. On November 1 of that same year, the league played its first official game, albeit in Toronto: The New York Knickerbockers eked out a win over the Toronto Huskies, 68–66.

After a three-year rivalry for players and fans, the NBL and BAA merged to form the National Basketball Association (NBA). Its official founding: August 3, 1949. George "Mr. Basketball" Mikan began his pro career with the Chicago American Gears of the NBL, moved to the Minneapolis Lakers the next season, and became the first star of the brand-new NBA. Other stars of the league's nascent years included Bob Pettit, Dolph Schayes, and Bob Cousy.

In 1950, the same year Cousy joined the NBA, so did a barrier-breaking triptych: The Boston Celtics drafted Chuck Cooper as the NBA's first Black player. Nat "Sweetwater" Clifton became the first Black player to sign a contract. And Earl Lloyd became the first Black player to suit up in an NBA game: October 31, 1950.

By the late 1950s, Black players began to dominate. Bill Russell—often touted as the greatest winner in the history of professional sports—joined in 1956 and, in his first season, helped lead his Celtics to their first title. Elgin Baylor joined the league in 1958 and won Rookie of the Year. Wilt Chamberlain came on in 1959, scoring a flabbergasting 43 points and grabbing an astounding 28 rebounds (the most points and rebounds in any NBA debut) in his first game with the Philadelphia Warriors.

While the fashion of the early white players had been shaped by the remnants of World War II conservation mandates, the NBA's early Black players were still subjected to the cruel injustices of the Jim Crow South (some were often unable to sleep or eat where their white teammates did) as well as the more tacit oppressions of the North. Still, those Black NBA players became men of prominence, beacons expected to help their people achieve long-denied civil rights.

That expectation governed not only how they comported themselves on and off the court but also what they wore. Peep the fashions of those pioneering Black players, men dressed like their white teammates—the opposite of pushing it. Those conventional dark suits, the dark dress shoes, the white shirts with the slim ties, the groomed mustaches and short-cropped hair.

In the early years of the NBA, actors and entertainers were almost the lone arbiters of what was considered cool or fashionable: James Dean, Sammy Davis Jr., Cary Grant, Harry Belafonte, Marlon Brando, Miles Davis, Frank Sinatra, and Sidney Poitier. These were men known for pushing against custom, men who dressed to express their individuality, who lived by the adage "It's not what you wear but how you wear it." But those sensibilities were the antithesis of early NBA fashion, an era ruled by convention, by conservatism, by dressing to command respect. In the NBA's first era its players, like most American men at the time, were at best dapper in the most quotidian sense.

Though his masterful play in the early days of the NBA set him apart, primal star George Mikan looked like most other players in the mid-1940s. Just taller.

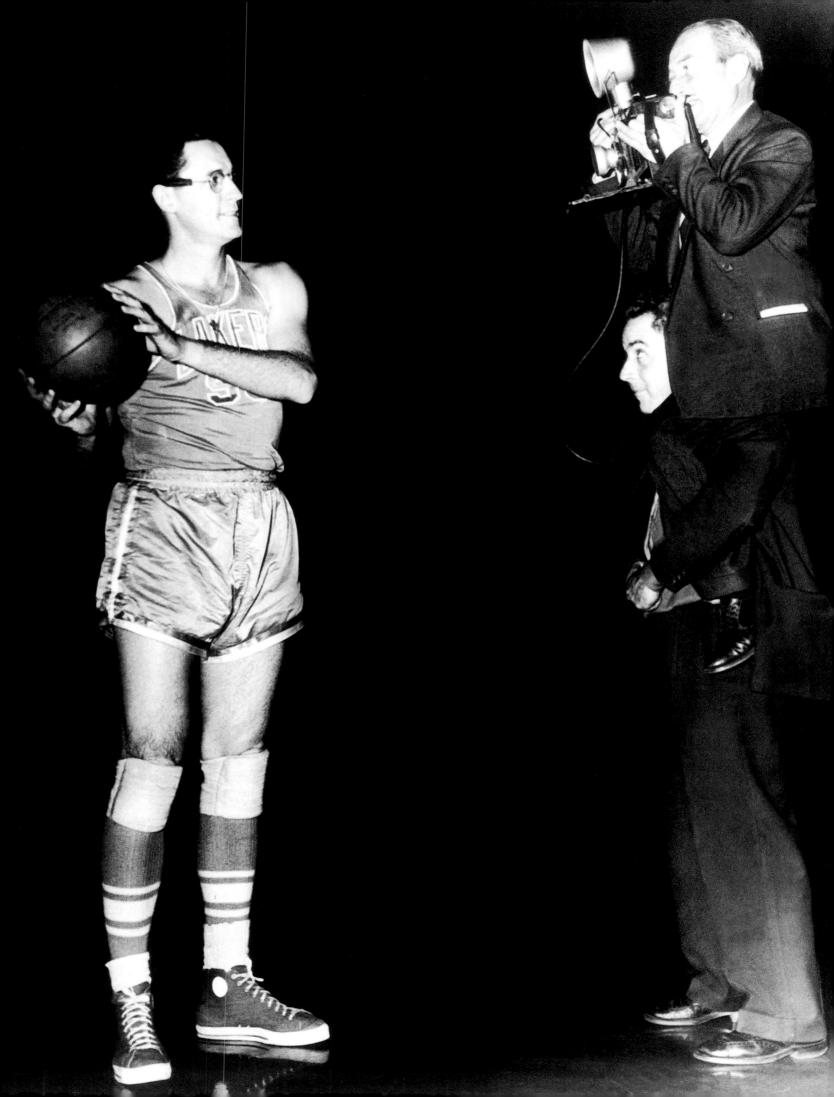

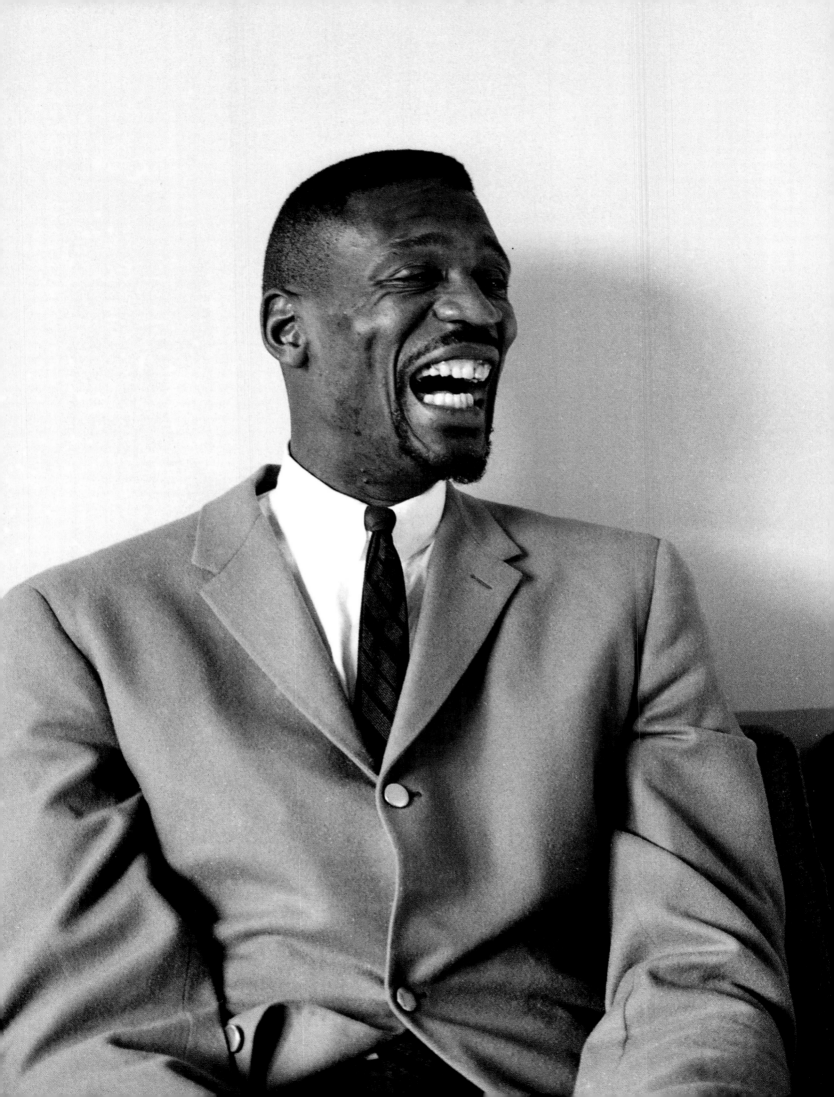

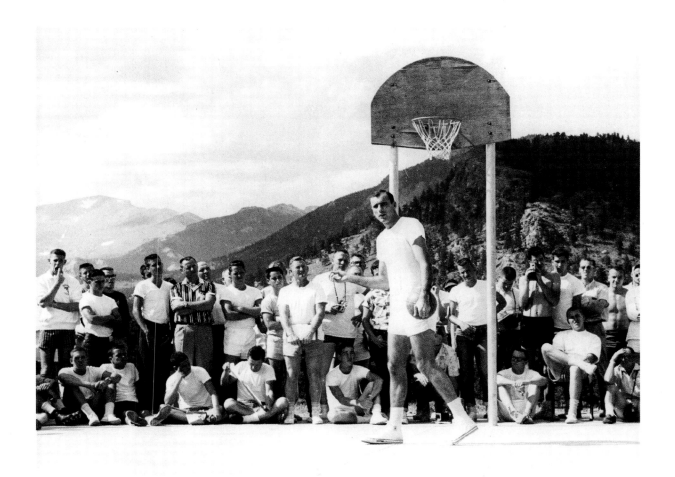

ABOVE Bob Pettit (with ball), of the St. Louis Hawks, teaches a group of athletes at a Fellowship of Christian Athletes camp in Colorado, 1959. Notice the high thigh cut of his shorts, the James Dean–style fit of his white tee.

OPPOSITE Sharp, tailored, conforming: Bill Russell played mostly in an era before Black players felt they had a license to stand out.

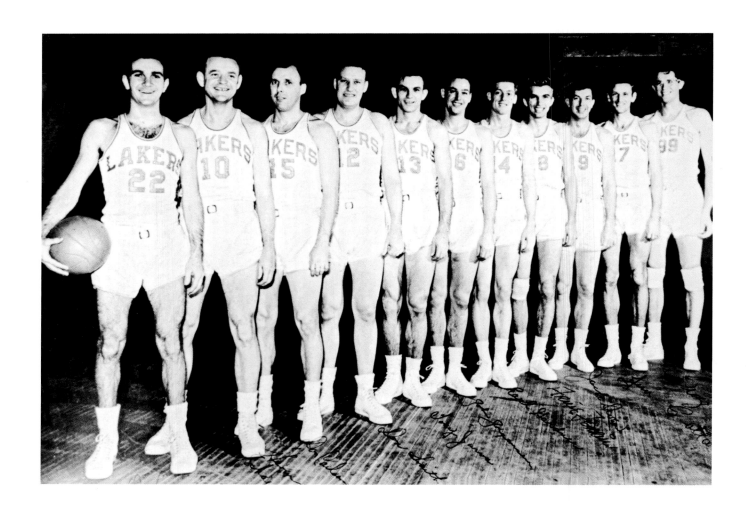

ABOVE Uniform in every way:
the 1949 world-champion
Minneapolis Lakers.

OPPOSITE Elgin Baylor during
a game at the Los Angeles
Memorial Sports Arena in
Exposition Park in 1965.
Neither his game nor that
side part were anything to
play with.

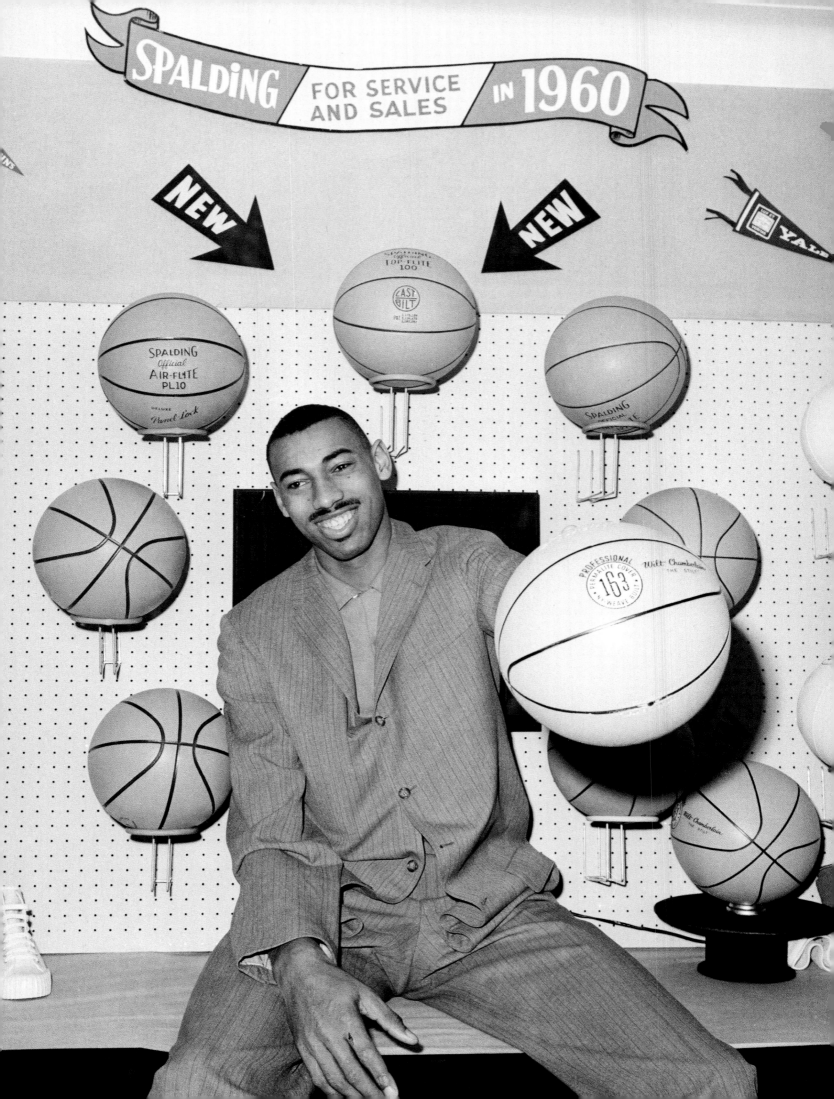

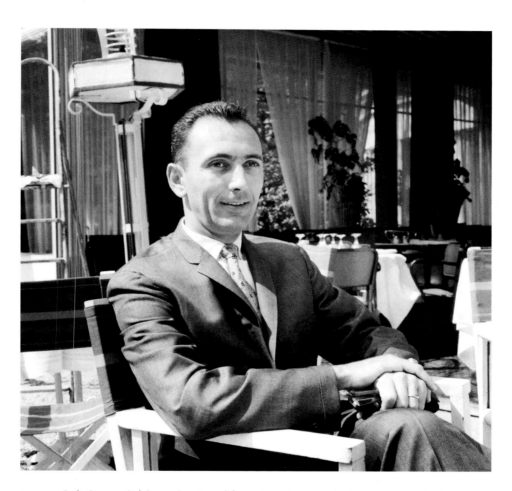

ABOVE Bob Cousy, Celtics point guard from 1950 to 1963, looking very much like a member of the Rat Pack.

OPPOSITE Long before every star player had his own sneaker, Wilt Chamberlain had his own autograph-stamped basketball, 1960.

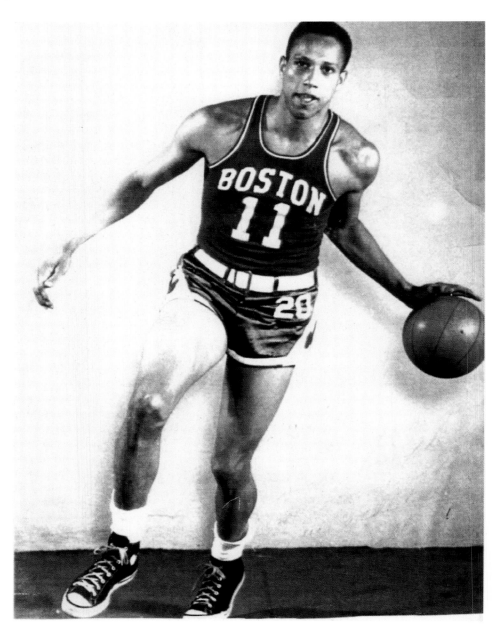

ABOVE Chuck Cooper, the Jackie Robinson of basketball.

OPPOSITE Nat "Sweetwater" Clifton was christened as such because of a boyhood love of soda pop and his easy disposition. Tidbit: His giant hands helped make him an exceptional ball handler.

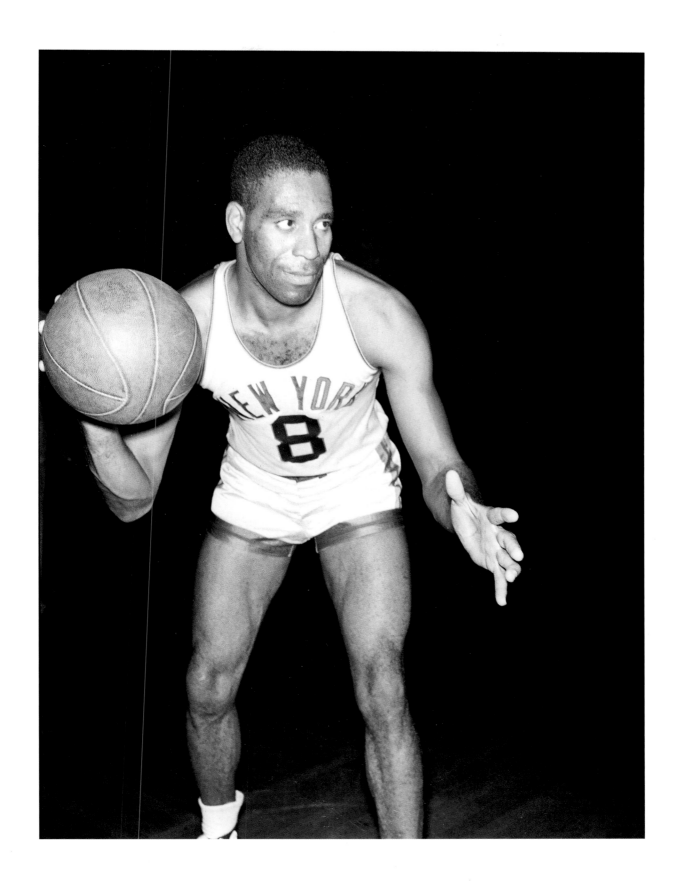

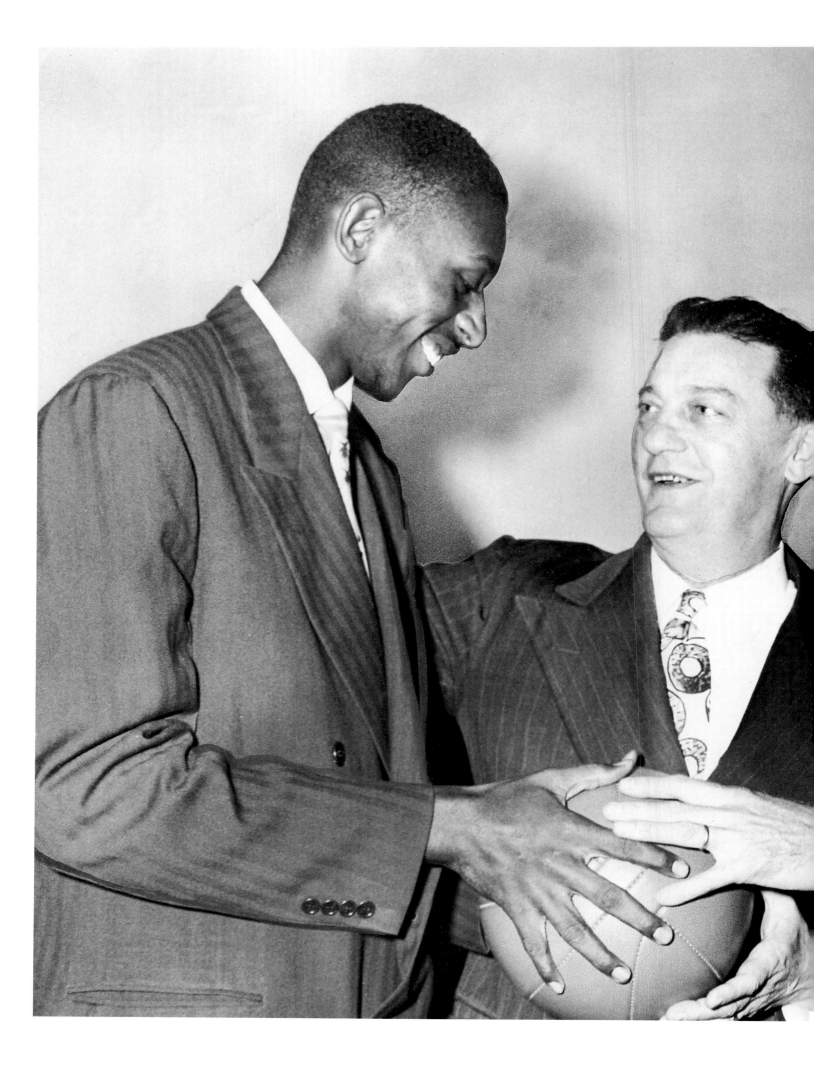

On October 31, 1950, Earl Lloyd became the first Black player to play in an NBA game, scoring six points for the Washington Capitols. Here he is welcomed to the team by player-coach Horace "Bones" McKinney and executive Jim Magner. Lloyd, known as a defensive stopper, broke another barrier as the NBA's first Black assistant coach; he also became the league's second Black head coach when he took over the Pistons in the 1971–72 season.

THE TOP 10 SNEAKERS OF ALL TIME

In the ancient epoch of the mid-twentieth century, just about every professional basketball player (and most of America, for that matter) wore Converse All Stars. They were an unadorned piece of equipment you didn't think twice about. But these days, hoop shoes are the opposite: emblazoned, high-tech, elaborately cushioned, style-heavy symbols of individuality. Shoot, they might even help players play better. As Spike Lee, in his role of Mars Blackmon, told his "main man," Michael Jordan, in the famous 1988 Air Jordan commercial: "Money, it's gotta be the shoes!"

CONVERSE ALL STAR
1960S

In 1921 Chuck Taylor, a Converse shoe salesman, suggested redesigning the All Star, a sneaker Converse had unveiled four years earlier. For the next fifty years, "Chucks" were everywhere— helping Converse claim an 80 percent market share in the 1960s.

PRO-KEDS 69ER
1969

The sneaker brand of choice for the NBA's first dominating big man, 6-foot-10 George Mikan, the PRO-Keds 69er became ubiquitous when stars including Nate "Tiny" Archibald and "Pistol" Pete Maravich laced up pairs for games. Soon it seemed almost every kid in New York sported them. Sneaker authority *Sneaker Freaker* sums up just how big they were: "Considered the very first must-have sneaker, demand for the 69er in Harlem and the Bronx was so overwhelming that they became known as 'Uptowns'—almost two decades before Nike's Air Force 1 would wrest that mantle."

PUMA CLYDE
1973

Only right, style hawk Walt "Clyde" Frazier was the first player to score a signature shoe. And suede, no less. The Knicks star had it in his contract that Puma would make him a different color combo for every game he played. The Clyde became a staple not only on the hoop court but in skateboarding, street fashion, hip-hop, and beyond.

NIKE AIR JORDAN
1985

Now known as the Air Jordan 1, back in 1985, before "drops," it was called merely Air Jordan. This shoe is steeped in lore: the NBA banning it for violating the shoe-color policy, the league fining Jordan $5,000 a game for wearing it, Jordan calling them "clown shoes" at first. Now, how much of that is truth? Who knows. Who knows.

CONVERSE WEAPON
1986

A snug, shiny high-top that extended Converse's dominance, the Weapon was a favorite of no few players but two most notably: Magic Johnson and Larry Bird, who wore dueling versions throughout the 1980s, when their fierce Lakers-Celtics rivalry got the league back popping again.

FILA GRANT HILL
1994

The former Duke Blue Devil was only the fourth NBA player to snag a sneaker deal for his first year in the league. And the marshmallow-looking shoe was an instant hit. Almost twenty-five years later, Fila brought back their classic and broadened it into a bestselling line.

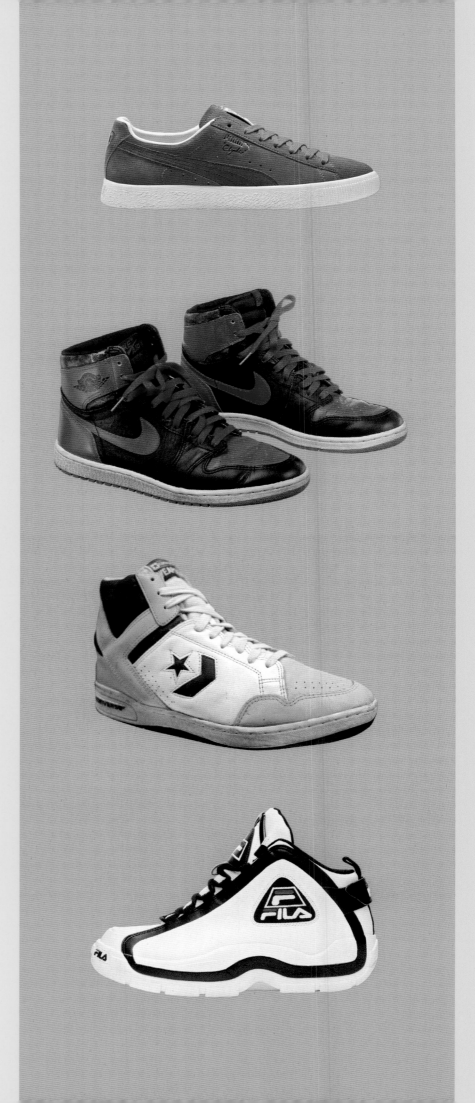

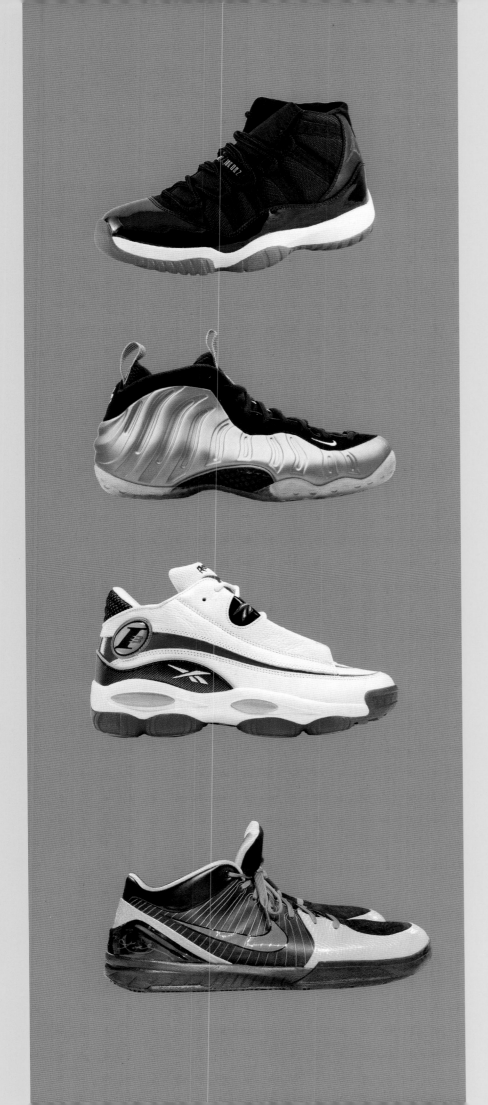

NIKE AIR JORDAN 11
1996

The evolution. Dropped multiple times starting in 1996, plus resuscitated in 2019. Spit-shined black, red, with a slip of white along the sole and the Jumpman logo. Not to mention, collectible boxes. This shoe was the fullest realization of an experiment born back when MJ was just a year out of UNC.

NIKE AIR FOAMPOSITE ONE
1997

Penny Hardaway made them famous—the kicks Nike designers imbued with Martian waves on the outer shell. Plus, the liquid-molded tech allowed for a sneaker that wrapped around the foot like a second skin, a fit that could even improve over time. All told, an innovative game-changing mainstay.

REEBOK ANSWER 1 DMX
1997

Hall of Famer A.I.'s signature shoe, one with air flows among translucent pods around the edge of the sole. Some called them a gimmick, but if they were, they were one that made the Answer a perennial winner in global sales and spurred major ground gained in the crucial what's-cool-to-youth sneaker wars.

NIKE ZOOM KOBE 4
2008

Here's winning math: minimalist design, maximum influence. Big-time sneaker site SoleCollector wrote of the 4's diminished profile: "The gamble to drop the top on the Kobe 4 paid off as it changed the industry when it was introduced in 2008 by dismissing the myth that wearing low-top hoop shoes would get you injured."

Flambo

oyance

Black players were free to be flamboyant, to break norms, to eschew the white man's uniform.

A in't no talking the second era of basketball fashion—circa the mid-1960s through the 1970s—without noting July 2, 1964. On that momentous day, President Lyndon B. Johnson sat at a desk in the East Room of the White House and signed into law the Civil Rights Act. Backdropped by dozens of dark-suited leaders—including Martin Luther King Jr., Ralph Abernathy, and John Lewis—President Johnson called on his citizens to "eliminate the last vestiges of injustice in America."

The ostensible new freedom thus bestowed on Black people everywhere trickled down in countless ways, big and small, including fashion; for it in time emboldened Black people to dress themselves in the more forward styles of the day, like shorter skirts and hot pants for women; like tighter shirts and denim for men. Meanwhile, Black NBAers started taking more risks in what they wore—almost. (More on that in a moment.)

A month after President Johnson signed the Civil Rights Act into law, North Vietnamese gunboats attacked U.S. Navy destroyers in the Gulf of Tonkin, spurring him to authorize air strikes on Vietnamese patrol bases and Congress to pass the Gulf of Tonkin Resolution, authorizing him to "take all necessary measures to repel any armed attack against the forces of the United States and to prevent further aggression" by North Vietnam, a declaration tantamount to war. Opposition to America's involvement in the war birthed a counterculture and its attendant hippie fashion, developments which weren't lost on the NBA.

Bill Walton, one of the best players of the era (when he was healthy), was an unabashed Deadhead and Southern California hippie. There are plenty of in-game pictures of Walton with his wild red hair semitamed by a headband, bushy muttonchop sideburns, and a scraggy mustache-less beard.

Phil Jackson, a role player on the Knicks championship teams, would go on to become one of the greatest coaches of all time, if not the greatest; however, in the late 1960s, he was a flower child contemporary of Walton, a player who wore his thick beard and brown curls wild and who could be seen biking around the Big Apple in overalls, a raglan tee, and Converse.

Meanwhile, the liberation that civil rights writ purported to afford Black people somewhat relieved professional athletes from the expectation of serving as respectable (i.e., conforming) representatives of blackness.

Black players were free to be flamboyant, to break norms, to eschew the white man's uniform.

In 1967 the American Basketball Association (ABA) was founded to fill the basketball void left by what was then a ten-team NBA. The league selected NBA pioneer George Mikan as its first commissioner and instituted popular innovations including the three-point shot. The ABA played a more exciting brand of basketball, and after its merger with the NBA in 1976, its players infused the NBA with that exuberant style.

Many of the ABA's players also dressed the part as entertaining sportsmen. The biggest star in the league was Julius "Dr. J" Erving, a man whose silky-smooth game seemed matched off the court by his perfect Afro and impeccable style.

While Dr. J may have been the biggest star on the court and a formidable fashion presence off it, the incontrovertible style champion of the 1970s was Walt "Clyde" Frazier, who helped the New York Knicks win their lone two NBA championships. Clyde was a paragon of the Black NBA player's newfound prerogative to dress as an individual: Clyde in a checkered double-breasted suit; Clyde in a fedora and fur coat; Clyde in a black cape, turtleneck, and fedora with a gold medallion hanging mid-chest; Clyde with his butterfly collar unbuttoned to his navel.

Though Clyde reigned as the style champ, Artis Gilmore, the number one pick of the ABA dispersal draft and a future Hall of Fame player, was a formidable challenger. Peep proof in his full-length double-breasted mink coat and leather gloves, in how he styled his rugged Afro with thick muttonchop sideburns.

The 1970s produced the NBA's greatest parity on the court—eight different teams won the championship but no team more than two—however, significant political and cultural shifts produced an era of players who weren't afraid to assert their individualism both on and off the court, players who heeded the clarion call of the sartorial.

New York Knicks stars Willis Reed (*middle*) and Dick Barnett (*right*) played most of their careers in an era when a flashy appearance was almost unheard of. By the end of their careers—this photo, taken at a sporting-goods store, is from 1971—fashion was loosening up.

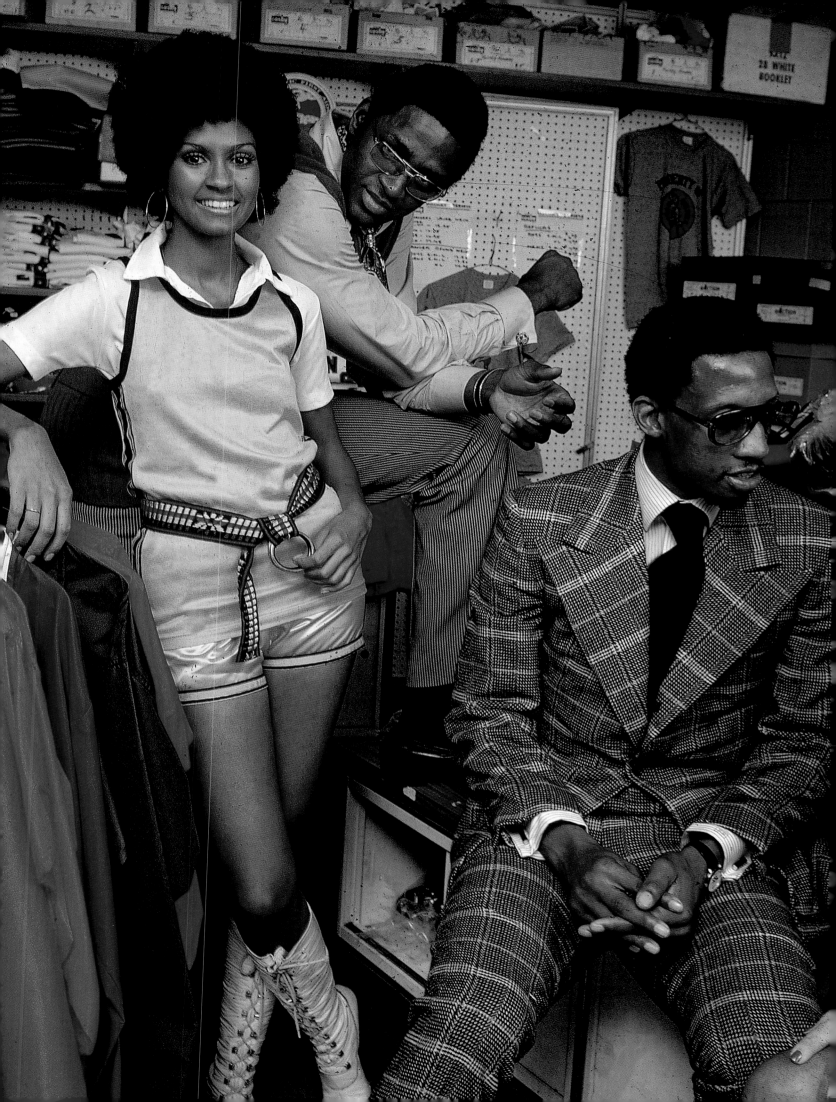

ABOVE Philadelphia 76er
Darryl Dawkins, circa 1978,
bling-blinging with a pendant
chain and earrings, style
reminiscent of a then nascent
culture called hip-hop.

OPPOSITE In the 1961–62
season with the Cincinnati
Royals, Oscar "The Big O"
Robertson became the first
player to average a triple
double. But here he is as
a veteran Milwaukee Buck
in 1970, with an Afro and
muttonchop sideburns,
grooming that bespeaks
the rest of that decade.

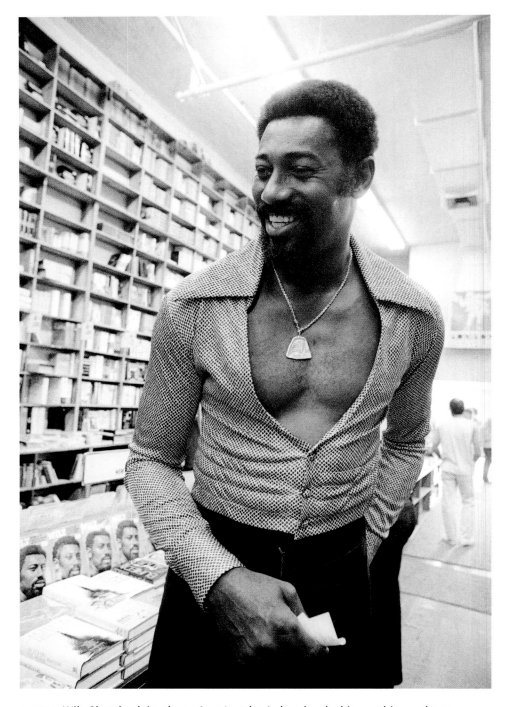

ABOVE Wilt Chamberlain, then a Los Angeles Laker, hawks his autobiography at a bookstore in 1973, living by the mantra "if you've got it, flaunt it."

OPPOSITE Walt "Clyde" Frazier, New York, 1970. The leather trim (on the hat and cape) and studs were touches sweet as his game.

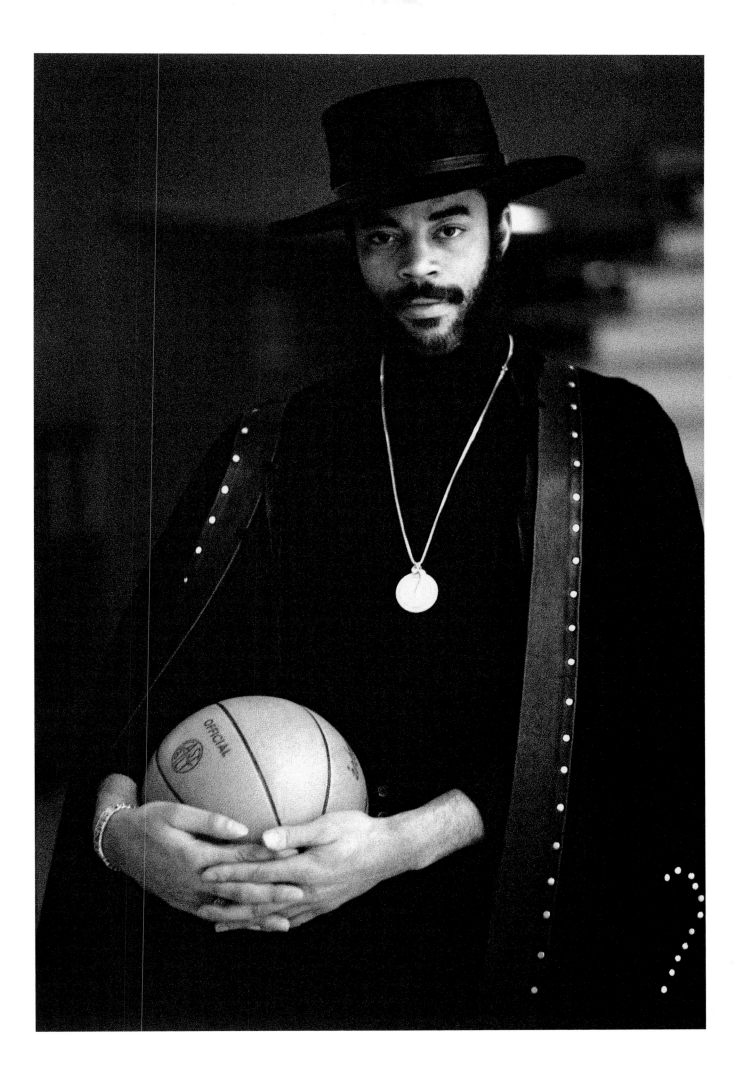

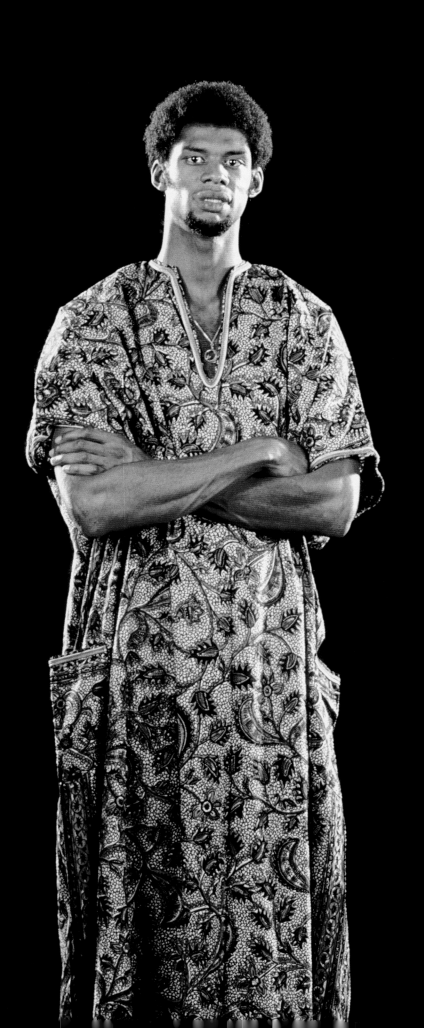

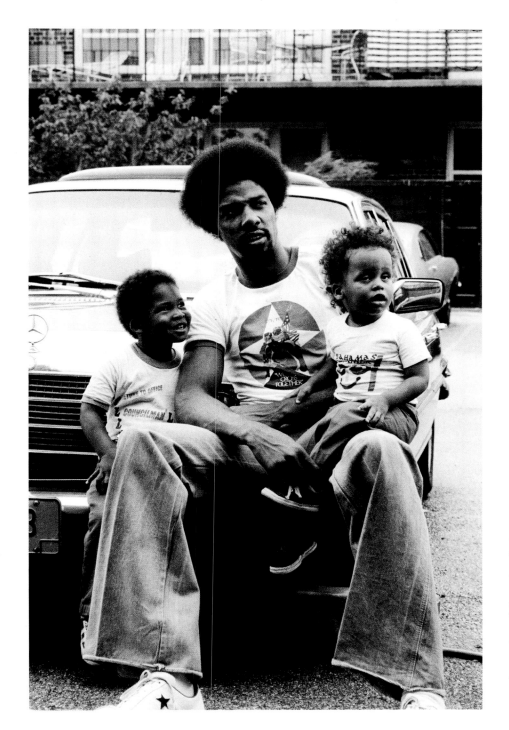

LEFT Julius "Dr. J" Erving with his children in 1976. His T-shirt commemorates the United States bicentennial and depicts George Washington crossing the Delaware River with Prince Whipple, an enslaved man from Africa who was later freed.

OPPOSITE By 1969, the Civil Rights Movement had made space for Black players to dress in ways that felt true to them. Lew Alcindor, in his rookie year in the NBA, wears an African dashiki.

OPPOSITE Then Portland Trail Blazers center Bill Walton embraced the hippie movement, the Grateful Dead, bandannas, and other non-jock cultural phenomena.

BELOW Wilt Chamberlain relaxes at home in Beverly Hills in crimson slacks, September 1974.

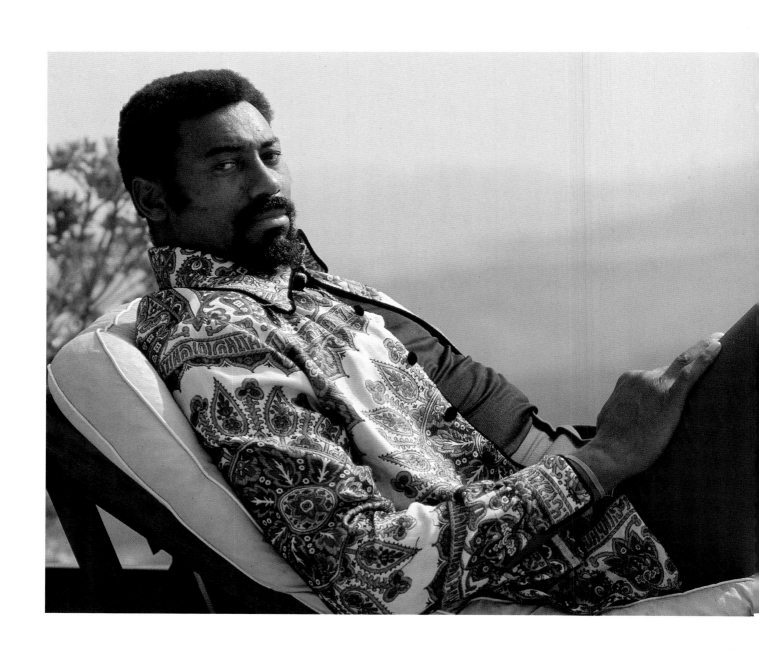

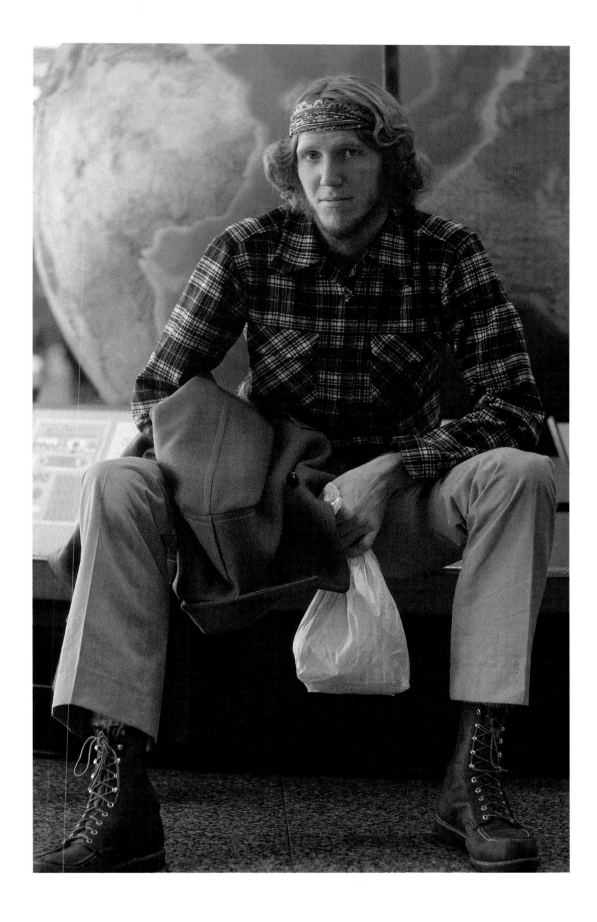

Julius Erving outside New York's Nassau Coliseum in 1976. Dr. J showcasing his high fashion IQ with lenses that match the shade of his shoes.

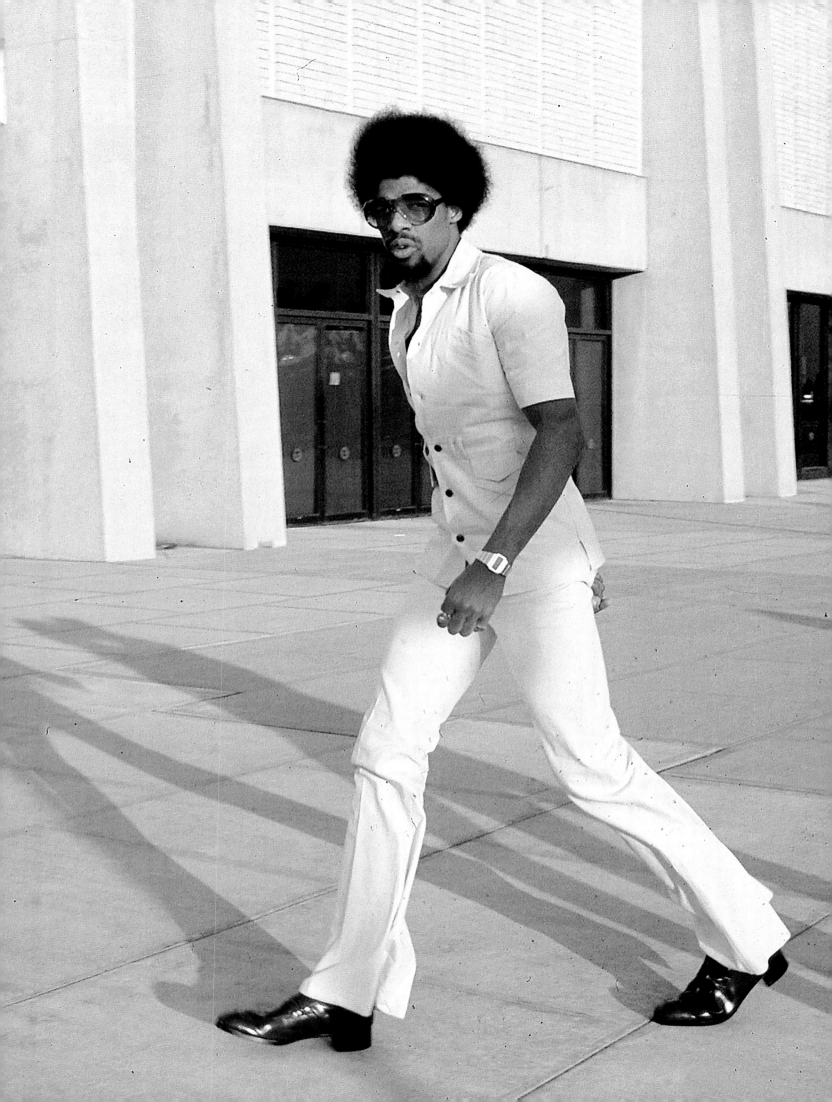

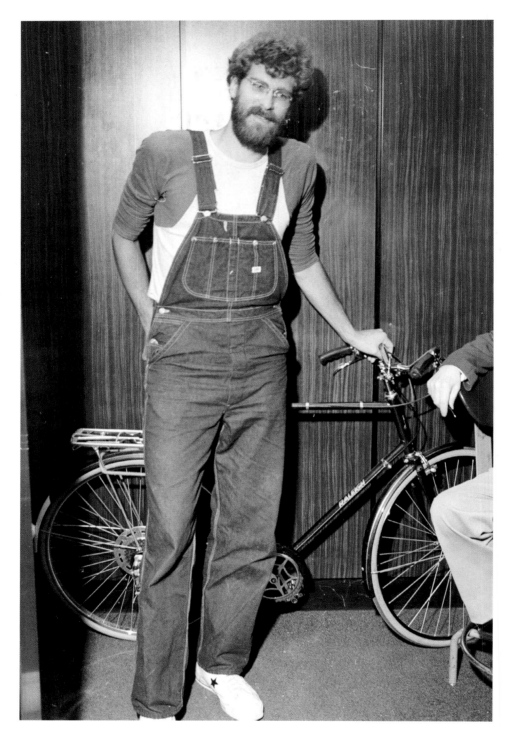

ABOVE Future Chicago Bulls coaching legend Phil Jackson sports overalls at the Knicks' offices at Madison Square Garden, 1974. The bicycle is also his.

OPPOSITE Artis Gilmore, then of the American Basketball Association's Kentucky Colonels, feeling his 1975 Afro and necklace. A year later, the stylish big man became the number one pick when the ABA dispersed its players into the NBA.

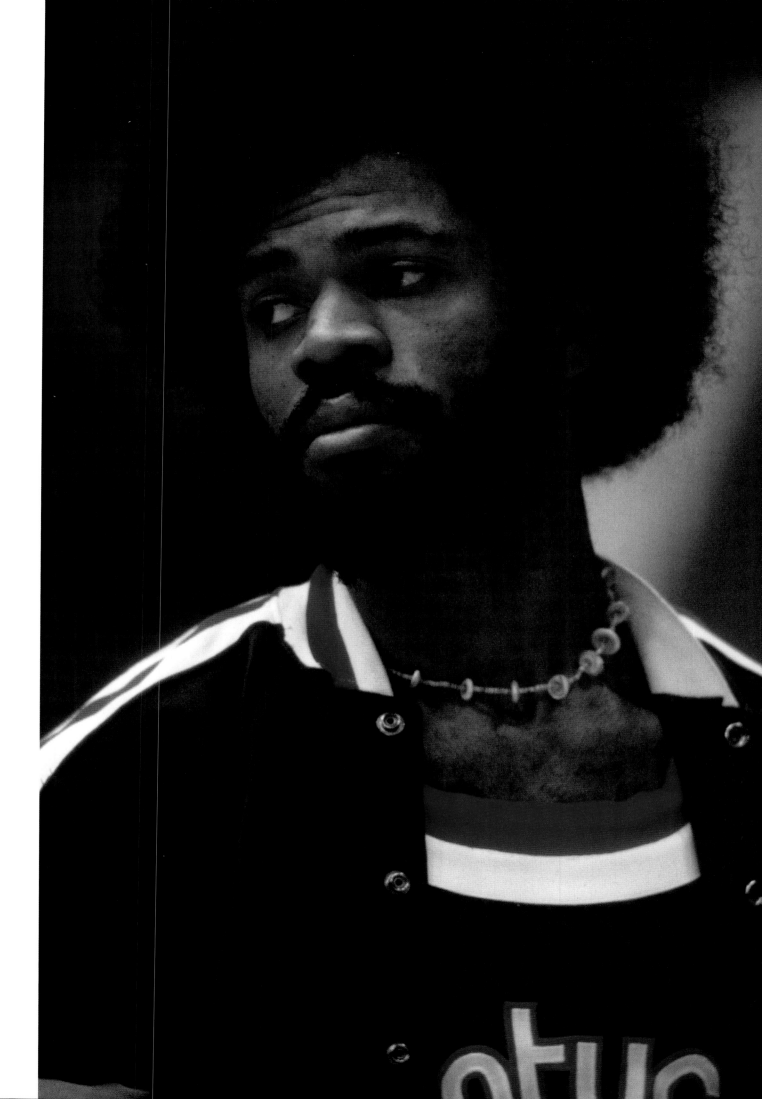

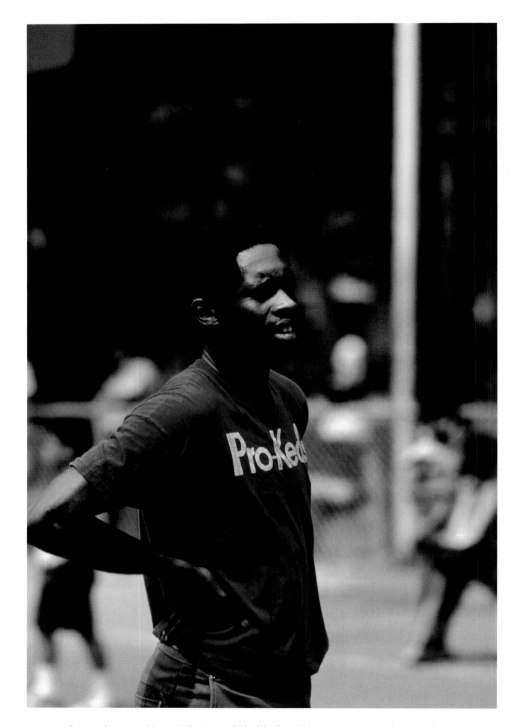

ABOVE Seventies star Nate "Tiny" Archibald played in Kansas City during the season but coached kids back in his native South Bronx in the off-season. Note the PRO-Keds T-shirt—he was an early adopter of the shoe.

OPPOSITE George "The Iceman" Gervin in one of the most iconic posters ever. It was shot for Nike in 1978, and if you're wondering, that's a real ice throne.

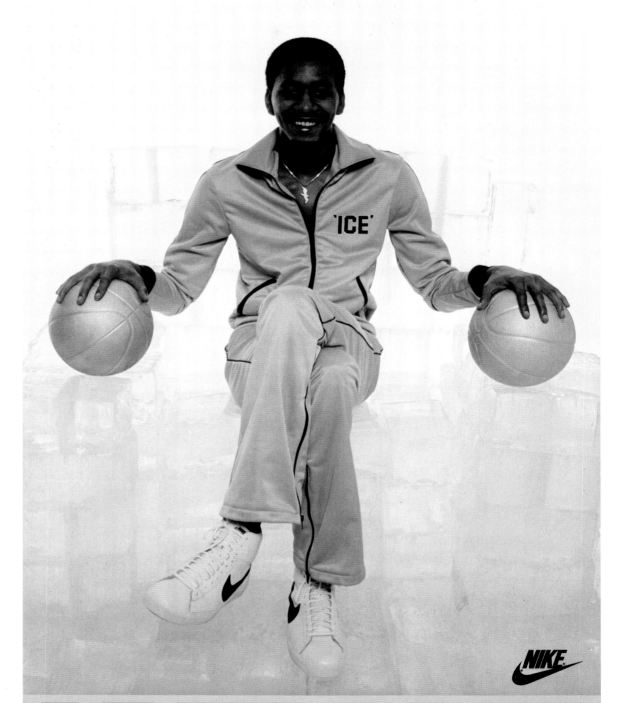

ICEMAN

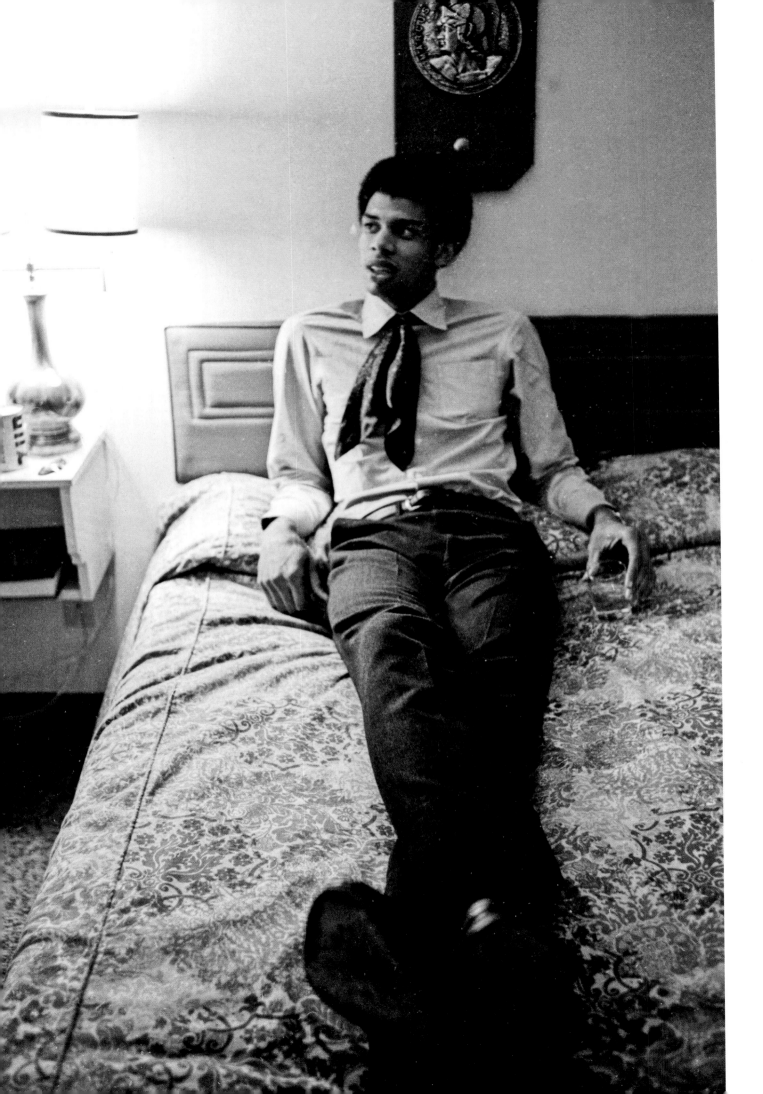

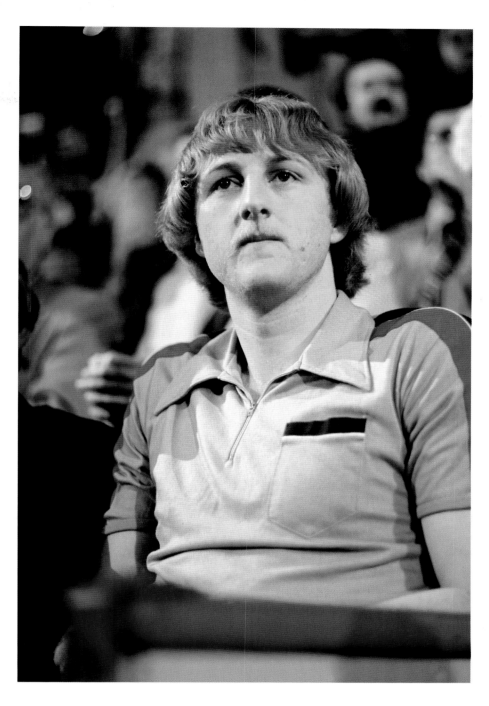

ABOVE Larry Bird in 1978, the year he signed with the Celtics. His signature off-court look—blond mop, bowling shirt—seemed to align with his focus on the purity of his game rather than the flashiness of his wardrobe.

OPPOSITE Even relaxing at a Holiday Inn the day after winning one of his three national college championships, Lew Alcindor—a future number one NBA draft pick—had MVP style.

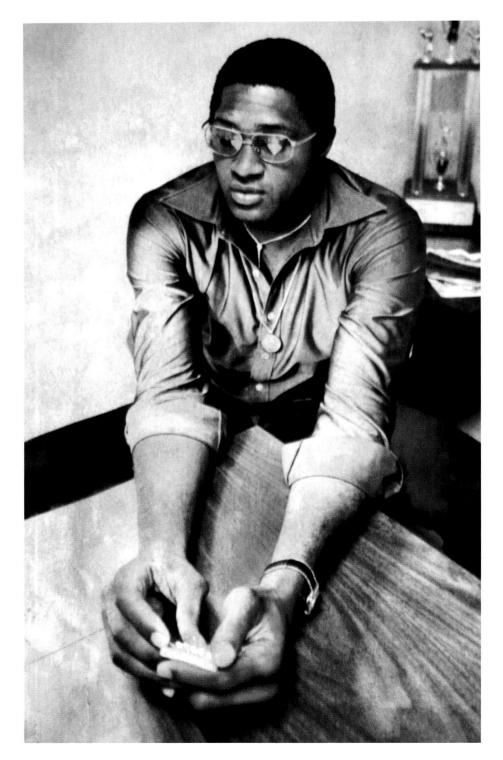

ABOVE Willis Reed. The man responsible for what might be the greatest moment in Knicks history (Google "Willis Reed limps onto court") looking NY cool in a butterfly collar and two chains in 1974.

OPPOSITE A native of sunny Florida, Bulls great Artis Gilmore looks quite comfortable in fur outside his home in freezing Chicago, 1981.

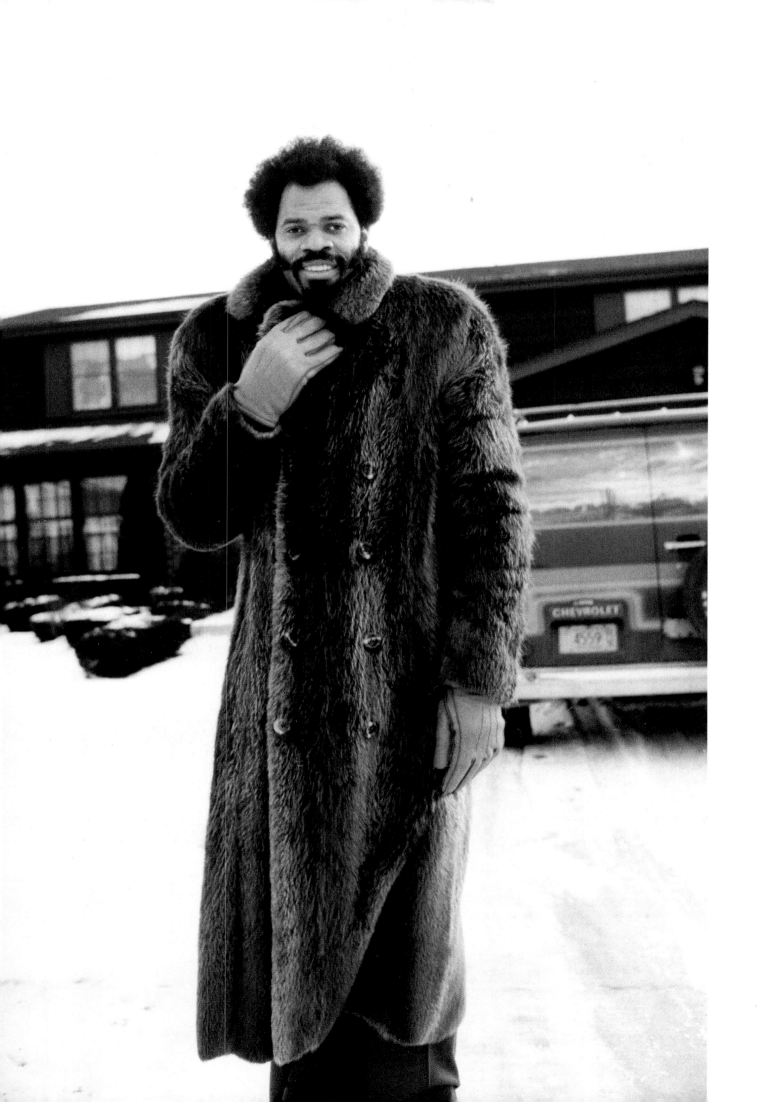

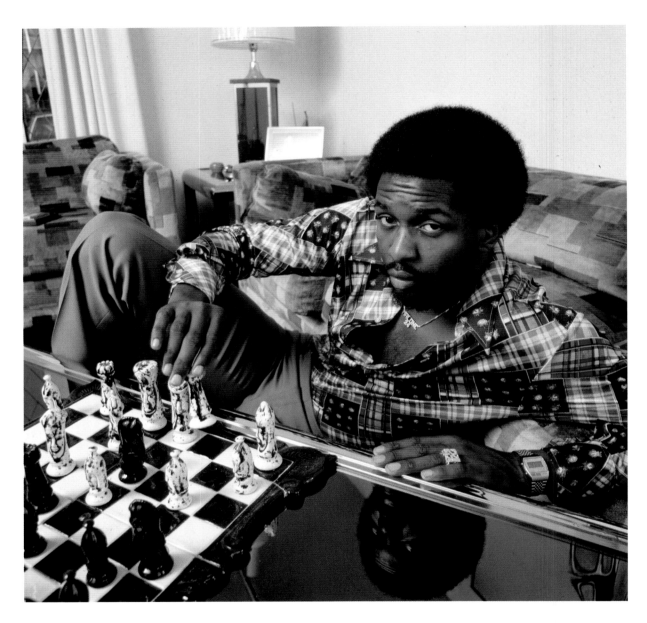

ABOVE They called Moses Malone the "Chairman of the Boards." But here he is at home in 1979 showing just how much a chessboard can inspire not only slick fashion but also home décor. The Hall of Famer wasn't no slouch in the accessories department either, with his gold digital watch, number-nameplate chain, and gold number 24 ring.

OPPOSITE New Orleans Jazz star Pete Maravich at a team press conference in 1977. The oversize frames, pinstripes, and gold medallion paralleled the ultra-flash of "Pistol" Pete's game.

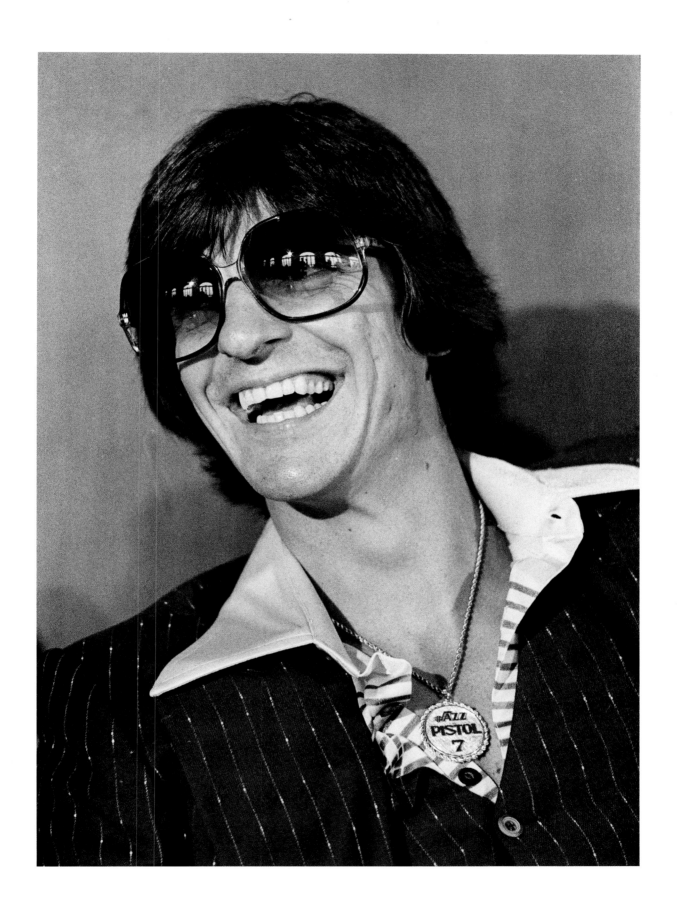

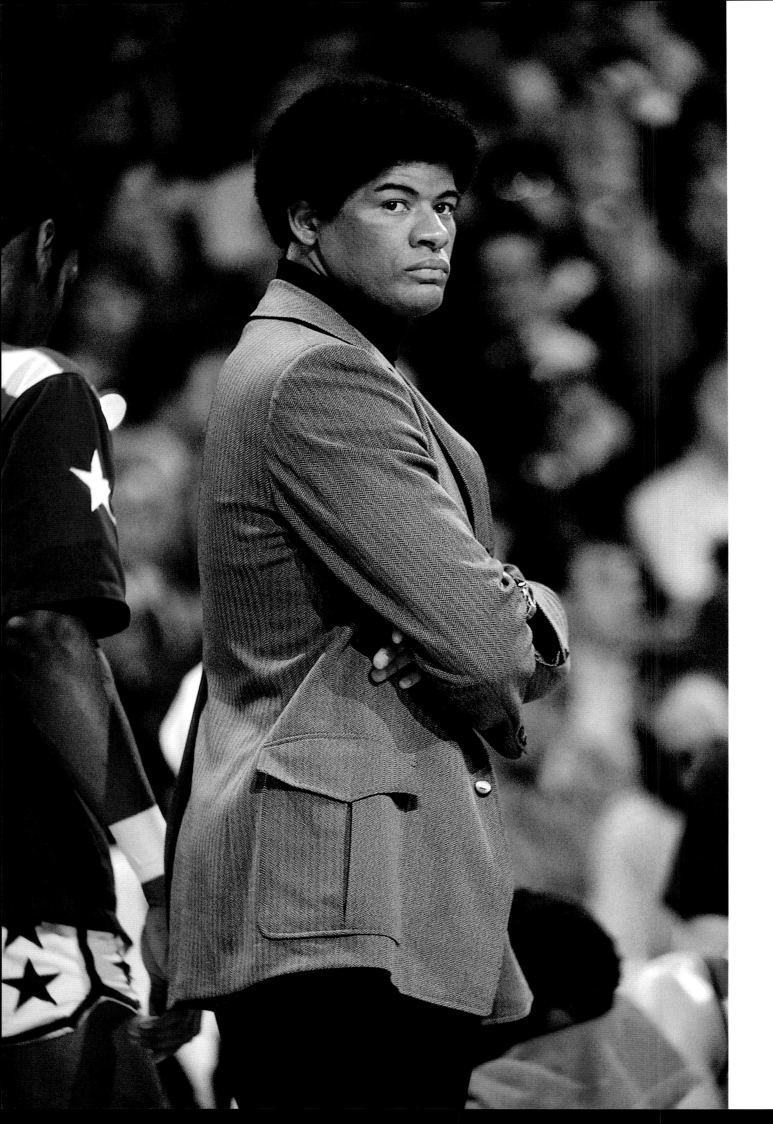

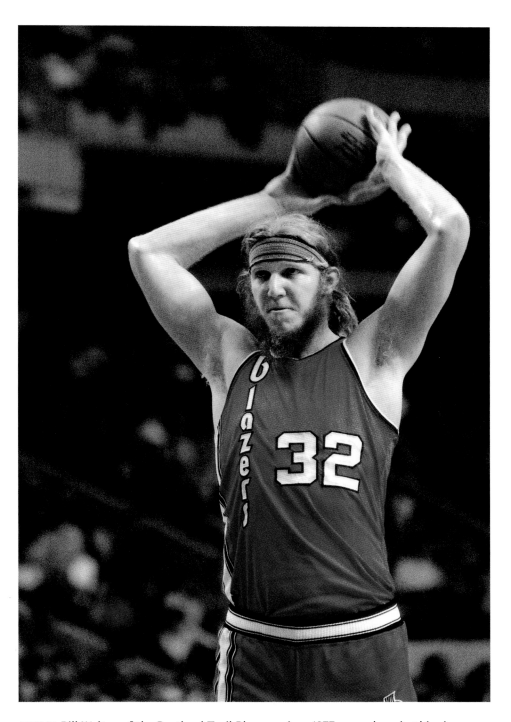

ABOVE Bill Walton of the Portland Trail Blazers, circa 1977, a pro-hooping hippie paragon.

OPPOSITE Wes Unseld of the Washington Bullets, circa 1976, looking cool as a Blaxploitation film hero in his turtleneck, sport coat, and oblongish Afro. The man needed a theme song.

THE TOP 10 HAIRDOS OF ALL TIME

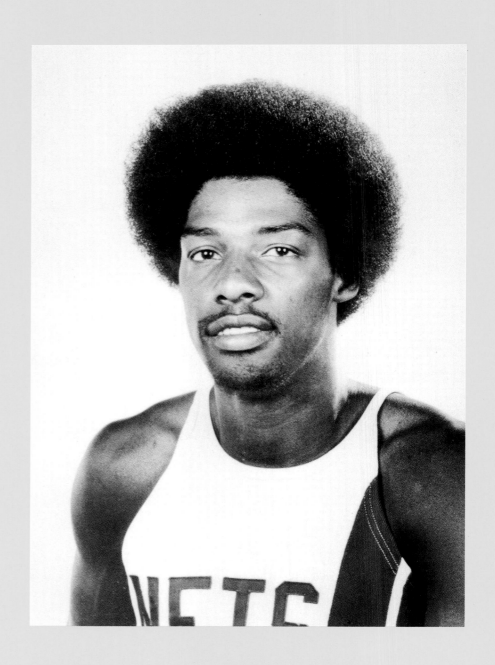

JULIUS ERVING'S AFRO
LATE 1970S

Dr. J, who measured 6-foot-7, was already an imposing figure when he moved from the ABA to the NBA in the 1976 merger. And his perfect planetary Afro added not only a few inches and intimidation but mystique to his legend: Witness his famous, soaring, free-throw-line dunk in '76, his hair the tail of a comet flying behind him.

Funny thing about NBA fashion: On the court, everybody wears a uniform. Nonetheless, the league has never imposed rules on hair length or style. Plenty of players have taken that ball and run with it, shooting for forget-me-never by way of beards, Afros, mohawks—and, sometimes, slick bald heads.

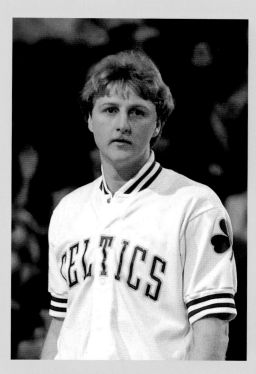

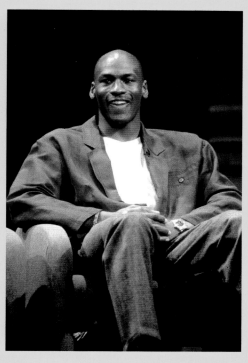

**LARRY BIRD'S MOP
1979-1982**

The Hick from French Lick looked the part when he entered the league with a curly, tangled mop of blond hair, and a mustache to boot. (The look being "guy taking tickets for the Tilt-A-Whirl.") But dude was a miraculous basketball savant, and his 1979–80 Rookie of the Year award was just the beginning of the lore.

**MICHAEL JORDAN'S SHAVED HEAD
1989**

His hairline receding, Jordan pioneered the cue ball look, and, quick as a bullet pass, a generation of men knew it was OK to shave their balding domes. It made Mike look clean and fierce on the court. To this day, the GOAT remains a shiny-headed paragon.

ANTHONY MASON'S DESIGNS
1990S

"I got my hair cut correct like Anthony Mason," the Beastie Boys rapped on "B-Boys Makin' with the Freak Freak" on their 1994 album *Ill Communication*. The lyric was a tribute to the beloved Knick, who went to a creative barber in Queens for his over-the-top etchings: the Statue of Liberty, "In God's Hands," "Knicks."

DENNIS RODMAN'S KALEIDOSCOPE
1996

Rodman won four championships and led the league in rebounds for seven straight seasons in the 1990s, but he also garnered much attention for his Technicolor hairscapes. Designs that featured everything from the AIDS ribbon to tie-dye, the latter a nod to Bulls coach Phil Jackson's hippie spiritualism.

JASON KIDD'S BLEACHED BLOND
2000

For a brief, glorious sliver of a season in Phoenix, point god Kidd—not known for flair—went platinum. Years later, as head coach of the Dallas Mavericks, he joked that he was late for a game and the barber simply didn't have time to finish washing his hair. (The Suns got bounced by the Lakers in the second round that year. Coincidence?)

CHRIS ANDERSEN'S MOHAWK
2014

Andersen's famous mohawk—along with the tattoos that cover most of his body—caught attention for years and earned him the nickname "Birdman," but when he shaved it in 2014, he downplayed its influence: "Oh my goodness, it's a haircut," he told a reporter who was trying to make news of it.

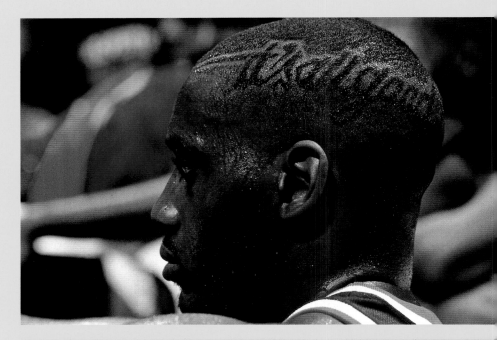

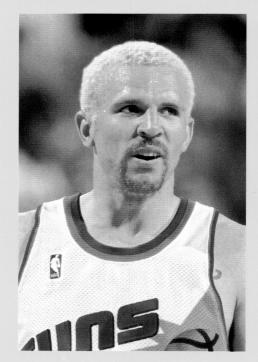

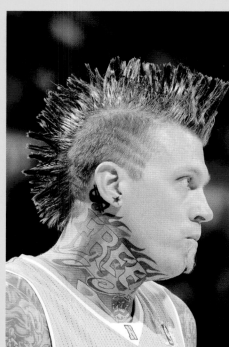

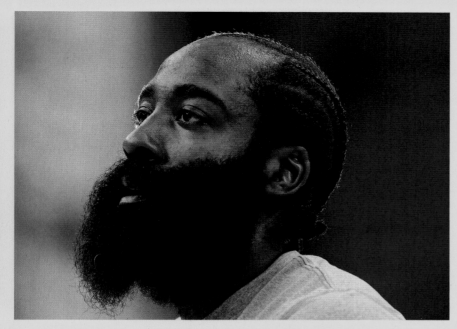

JAMES HARDEN'S BEARD
2009-PRESENT

It started as stubble the way beards do. It grew, and grew, and grew, along with his status as a bona fide star (2018 MVP, multiseason scoring champ, perennial all-star), until reaching its current impressive length. (Fun fact: Harden has said he would shave his beard for charity.)

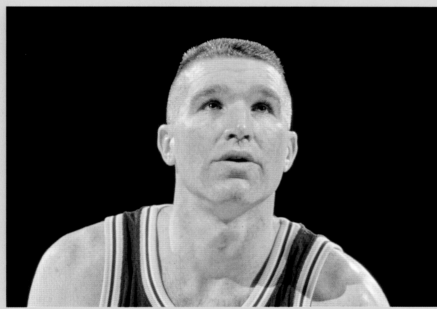

CHRIS MULLIN'S BUZZ CUT
1988

When New York legend Chris Mullin was drafted to the Golden State Warriors with the seventh pick of the 1985 draft, he sported a brown mop. Bummed about his NBA fortunes out west, Mullin not only got down but also began drinking. Enter coach Don Nelson, who demanded him into rehab. When Mullin returned, he shaved his mop into the flat-top buzz cut that became his signature, became a five-time all-star, and landed a spot on the greatest sports team ever assembled: the 1992 Olympic Dream Team.

JIMMY BUTLER'S PRANK
2022

The high-scoring Miami Heat all-star revealed a new look on Instagram: long, sparse braids with blond ends, which he insisted were "not extensions." Turns out Butler was toying with us—he cut them for the start of preseason—using social media as a kind of social experiment. "I'm just messing with stuff to make the internet mad," he said. "That was my goal this summer, and it worked."

Jor

The NBA's loooong third era . . . defined by superstar-led golden-era dynasties and the ascendance of the GOAT.

The NBA's looong third era: defined off the court by Reaganomics, hard drugs, and, later, by the end of the Cold War, and defined on the court by superstar-led golden-era dynasties and the ascendance of the GOAT.

About that first part: On January 20, 1981, old Ronnie Reagan, the pride of Tampico, Illinois, was sworn in as the fortieth president of these United States. The telegenic former governor had won the White House with a promise to "make America great again" by establishing diplomatic relations with the Soviet Union (the Cold War was in its fourth decade), modernizing our armed forces, and repairing the nation's suffering economy with broad cuts to government spending. On July 27 of that year—a scant six months after he began the job—Reagan touted the Economic Recovery Tax Act of 1981 in a national address from the Oval Office. The initiatives that would become known as Reaganomics were aimed at making good on his campaign promise of restoring "the great, confident roar of American progress and growth and optimism."

Reaganomics indeed helped the country recover from the economic straits of the 1970s. You could see it in popular TV shows of the time. Like *Dynasty* and *Falcon Crest*, which dramatized the lives of feuding rich families. Like *Lifestyles of the Rich and Famous*, on which bombastic host Robin Leach detailed the trappings of the ultrarich. On *Magnum, P.I.*, in which Tom Selleck heart-throbbed around Hawaii in a Ferrari to solve crimes; on *Miami Vice*, in which stylish undercover cops played by Don Johnson and Philip Michael Thomas battled bad guys in Magic City; and on *Knight Rider*, in which the leather-jacket-clad David Hasselhoff fought crime with the aid of a tricked-out, talking Trans Am named K.I.T.T.

The prosperity of the 1980s also forged no few fashion trends: the punk-rock appeal of ripped jeans, destroyed tees, slim leather pants, and biker jackets. The leather ensembles made cool by comedy icon Eddie Murphy. The mainstreaming of hip-hop via Run-DMC's curated athleisure: unlaced shell-toes, track jackets, leather pants, and Kangol bucket hats. The 1980s was also the era of the shoulder-padded power suit, a look popularized by Michael Douglas as Gordon Gekko in *Wall Street*.

The NBA reflected the ethos of the era. There was Patrick "The Hoya Destroya" Ewing, during his rookie season, sporting an olive double-breasted suit, red patterned tie, a Knicks duffel bag slung over his shoulder. There was Magic in a blue wool double-breasted jacket and light gray pants, his fantastic fit finished with a gleaming white granddad-collar shirt. There was Hakeem "The Dream" Olajuwon suited and booted in a black tux with a red bow tie on draft night '84. There was Jordan in the '85 Slam Dunk Contest decked in two gold chains and his infamous "banned" Jordan 1s. There was Chuck Person razzle-dazzling at the '86 draft in a white tux finished with a magenta cummerbund and bow tie. Perhaps, though, no outfit sums up the decade more than Magic swaggering the halls of the L.A. Forum in a hooded fur coat in '88.

The prosperity of the Reagan years produced decadence, which was evident in the league in two particular forms. One was the play, which by the late 1970s had transmuted from the team-first, fundamentals-win ideal of the Celtics dynasty into a flashy, ABA-esque street-playground play that fostered widespread league parity and—pretty darn swift—disenchanted die-hard fans.

Ubiquitous drug use by the players amounted to more proof of the league's decadence. Matter of fact, drugs were such a significant problem that in 1983 commissioner Larry O'Brien announced what, at the time, was the strongest stance on drugs of any professional sport: rules that banned any player who was convicted of or pleaded guilty to using or selling heroin or cocaine. "The message we are sending out today is clear," said O'Brien. "Drugs and the NBA do not mix."

The Drug Act improved the league's drug problem over time; however, the issue of waning interest in the actual game persisted.

Recall the 1979 draft, which added the two players most credited with ushering the league into this golden era: number one pick Magic Johnson and Larry Bird, who signed a record contract for a rookie in any sport a few weeks before the draft. Talk about ruling a decade: Magic's Lakers and Bird's Celtics won eight of the ten championships of the 1980s, and either the Celtics or the Lakers appeared in every single Finals series that decade. Talk about individual dominance: During that same ten years, Bird won three league MVPs and two Finals MVPs, and Magic won two league MVPs and three Finals MVPs.

In many ways, the rivalry that resuscitated the league was the struggle between the old basketball values represented by Bird's Celtics and the substantive flash represented by Magic's Lakers (they didn't call them the Showtime Lakers for nothing).

And while Magic and Larry (soon to be known as Larry Legend) were ruling the basketball world, another guy you might've heard of named Michael Jeffrey Jordan was drafted by the Chicago Bulls in 1984. If you're even a minor hoop head, you know Jordan was a phenomenal scorer and highest-magnitude star from the get-go—and that, even so, his Bulls took playoff L's aplenty in the Eastern Conference. You're also aware that the former Rookie of the Year didn't break through the bullytastic "Bad Boy" Detroit Pistons in the Eastern Conference Finals until 1991, the same year his Bulls beat the Magic and the Lakers for his first championship.

FOLLOWING PAGE
These many reflections of Chicago Bulls legend Michael Jordan, shot for *Sports Illustrated* in 1991, was no doubt how his defenders saw him: fierce, relentless, and every which way they turned.

But boy oh boy did Jordan break through in the most major way, completing *two* three-peat championship runs with his Bulls (with time off to try his hand at baseball) and establishing himself as the GOAT.

Jordan also helped to define the NBA fashion of the 1990s—for better and worse. On the one hand were his Peter Moore–designed Air Jordans, which debuted his rookie year and are now the most popular sneaker in the world. (Consider this: Before Jordans, there was no such thing as a sneakerhead.) There were his baggy basketball shorts (the roomier to wear his North Carolina Tar Heel shorts under his Bulls uniform), which moved the league away from the high-thighed team shorts of yore. There was his iconic hoop earring, which inspired mass copycat looks. There was his clean-shaven head, which gave many a balding gentleman the courage to go razor-slick.

On the other hand, there was Jordan's nineties penchant for capacious bespoke suits, a look that became not only a league trend but a mainstream one. Recall Jordan arriving at the United Center arena in Chicago in a suit made from enough fabric for several championship banners, five-button jacket hanging almost to his knees, his pants at least as baggy as the game shorts he popularized.

While MJ was hands down the most influential player of the era, his rival-turned-teammate Dennis "The Worm" Rodman delivered its most memorable fashions. Start with the outrageous hair colors—he began with bleached blond—and designs cut in his Afro. The painted fingernails decades before the current trend. The multiple face piercings: ears, nose, lip. The manifold tattoos.

The future Hall of Famer at the '95 MTV Video Music Awards in a sequin high-cut tank top accented with a red AIDS awareness ribbon, a chain around his midriff, jeans so low-rise they showed his pubics, and his short-cropped Afro dyed magenta.

Rodman horse-and-carriaging up to his '96 book release in a white wedding dress replete with veil, blond wig, and full face of makeup.

Rodman on David Letterman with a neon-green-and-yellow Afro, knit top and pants, silver choker, and a version of his go-to shades: the Oakley wraparounds.

If the eighties were an age of decadence, the nineties—with their rapid technological advancement, U.S. political dominance, and the ascendance of Air Jordan as the pinnacle of the zeitgeist—begot that kind of excess on steroids.

Jordan's dominance ended in 1998, the year his Bulls completed their second three-peat. Just as he'd wrested the title of the league's most dominant and winningest champion away from his predecessors, there were new (although arguably none greater) players vying for not just basketball but cultural and fashion relevance. One of whom, Allen Iverson—the 1996–97 Rookie of the Year—would remake NBA fashion in his image.

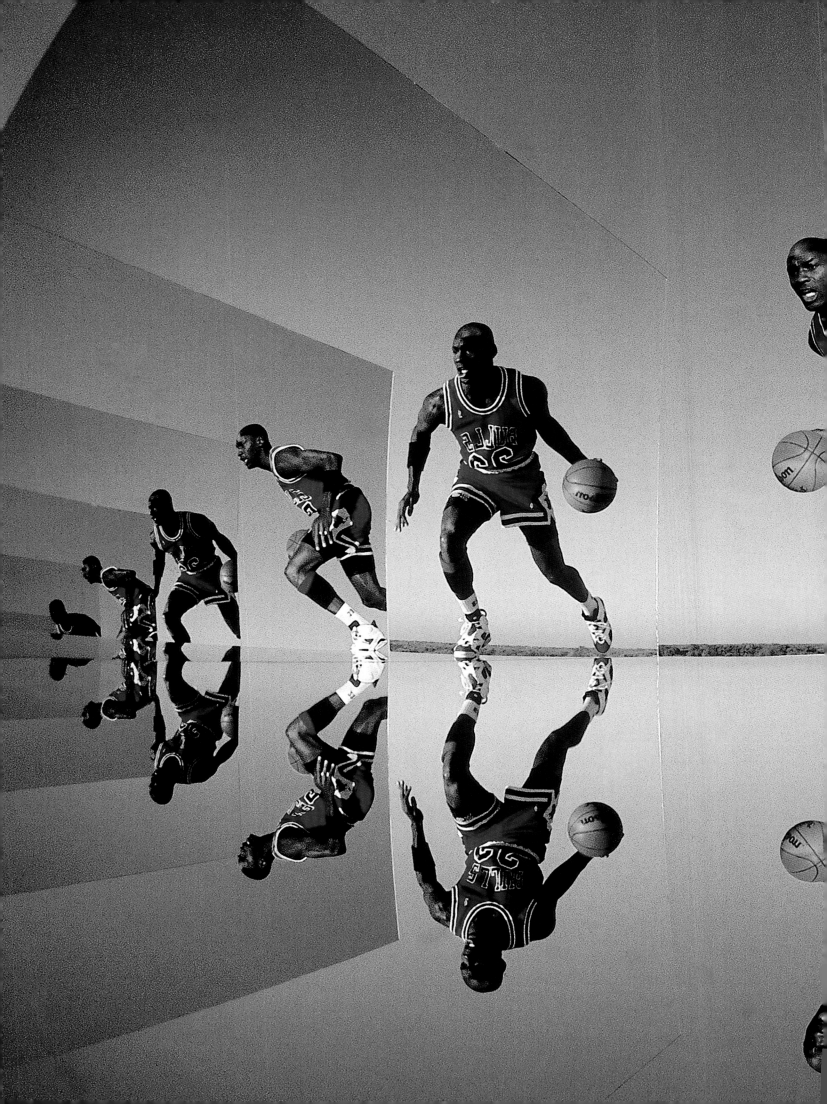

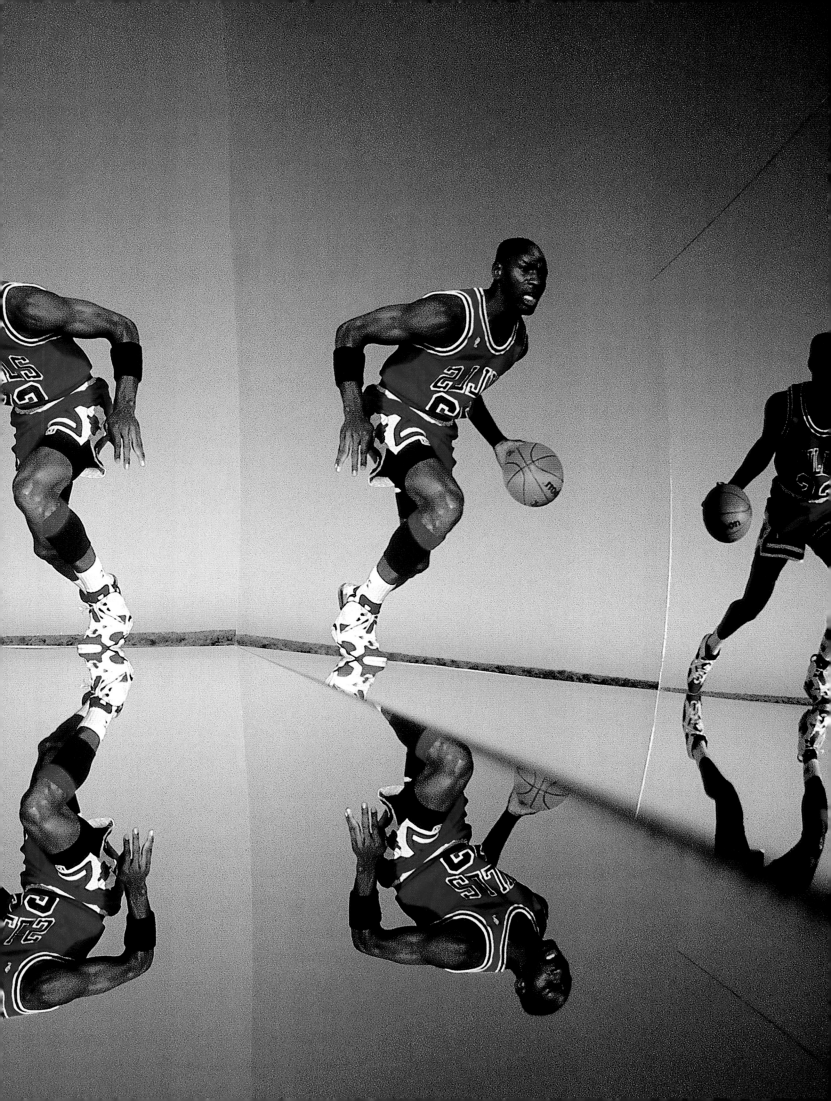

ABOVE Style and substance:
Magic Johnson and his Lakers
coach Pat Riley, 1989.

OPPOSITE Six-foot-eight-inch
Dominique Wilkins wears a six-
foot-eight tuxedo to the premiere
of the Eddie Murphy movie
Boomerang in Hollywood, 1992.

ABOVE Hakeem "The Dream" Olajuwon, of the Houston Rockets, poses during his rookie season (1984) in a neon yellow graphic shirt that screams of 1980s excess.

OPPOSITE Patrick Ewing, double-breasted at the 1985 NBA draft, smiling like the number one overall pick that he was.

DRAFT SUITS

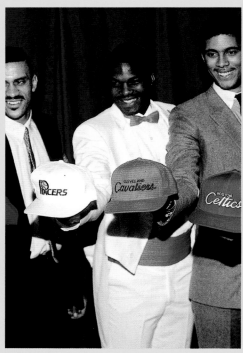

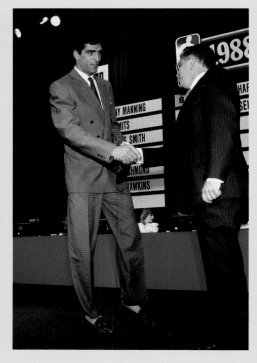

HAKEEM OLAJUWON
1984

Hakeem "The Dream" Olajuwon was drafted number one by the Houston Rockets in maybe the greatest NBA draft *ever* (who could argue against a draft that included Jordan at number three and Barkley at five, not to mention Stockton at sixteen). And showed how ready he was for the honor by donning a black suit and skinny red bow tie.

CHUCK PERSON
1986

The number four overall pick of the 1986 draft, Chuck Person made a bold fashion statement on his big day: a stark white tux with a fuchsia bow tie and matching cummerbund.

RONY SEIKALY
1988

Rony Seikaly was the first-ever pick of the Miami Heat—and number nine overall—in 1988. Though finding clothes that fit must've been a chore at just shy of 7 feet, Seikaly demonstrated he knew big-man tailoring with his double-breasted suit, not to mention spicing up the look with brown tasseled loafers and tan socks.

What do you wear on the day you not only join the fraternity of the best basketball players on Earth, but become a rich young man in the process? Why, your very best threads, of course. Over the years, draft suits have gone from formal and traditional to bold sartorial extravagance. What follows are standouts—for better and worse—across the eras.

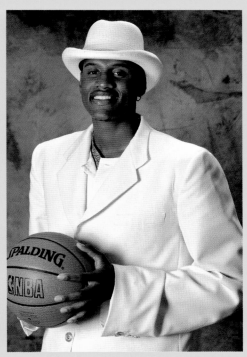

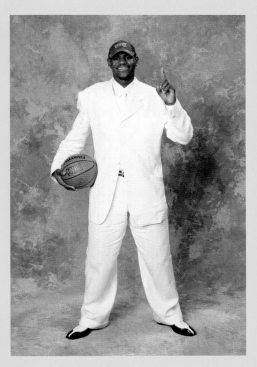

JALEN ROSE
1994

As a member of the University of Michigan's Fab Five, Jalen Rose helped usher in the era of ultra-baggy playing shorts. The number thirteen pick of the 1994 draft, Rose flexed his Detroit heritage in this pin-striped, double-breasted tomato-red suit, a look complemented by a baroque necktie and patterned pocket square.

SAMAKI WALKER
1996

Of course, there's the obvious of Samaki Walker's draft day fit: that cream derby. But let's not forget about the other aspects of the suit worn by the man drafted as the ninth pick in 1996 by the Dallas Mavericks. Like that hella capacious matching suit. Like the reptile skin under his collarless shirt.

LEBRON JAMES
2003

In the year of our Lord 2002, high school junior LeBron James covered *Sports Illustrated* with the headline "The Chosen One." The next year, his hometown Cavs made him the number one overall draft pick. LeBron dressed the part in a spacious heaven-white suit and spectators.

LOTTERY PICKS
2014–2015

Don't sleep on the draft class of 2014. It's one of the most stylish classes in the annals of the league. Look no further than a few standout lottery picks:

The number one overall pick of the Cleveland Cavaliers: Andrew Wiggins. On draft day, the oft-soft-spoken Wiggins leaned into his moment as the cynosure in a black-and-white rose-printed, shawl-collared smoking jacket; satin trousers; and velvet smoking slippers.

Marcus Smart—drafted number six by the Boston Celtics—who had the inside of his jacket embroidered with personalized meaning: the logo of his college team, Oklahoma State; the shape of his home state of Texas; the words "RIP Todd" in honor of an older brother who died of cancer. Not to mention the lining matched his powder-blue bow tie.

The style daring continued the following year when the Los Angeles Lakers chose D'Angelo Russell with the number two pick of the 2015 draft. Russell paid homage to his college—Ohio State University—by sporting a scarlet smoking jacket with a gray shawl collar, a white-and-scarlet gingham shirt, and cream cropped trousers. He finished his Buckeye-themed threads with a scarlet bow tie, belt, and velvet slippers.

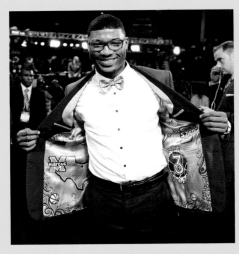

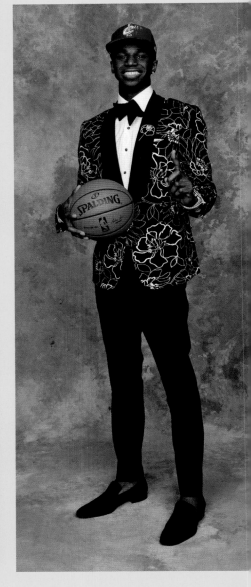

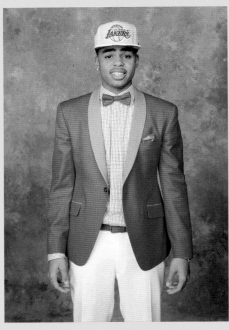

ZACH COLLINS
2017

As we've said, it's oh-so hard to get fly if you're anywhere close to 7 feet. Hence the reason Zach Collins appears on this list. The somewhat unheralded Gonzaga University forward was drafted by the Sacramento Kings (he was later traded to the Portland Trail Blazers) with the number ten pick of the 2017 draft and, like prior draftees, paid homage with his outfit. Collins sauntered onstage razzmatazzed in a tailored black suit (its custom lining featured the "Welcome to Fabulous Las Vegas" sign), a skinny black leather tie, and black velvet slippers embroidered with "Las Vegas" in script, all of which were a nod to his hometown of, you guessed it, Sin City.

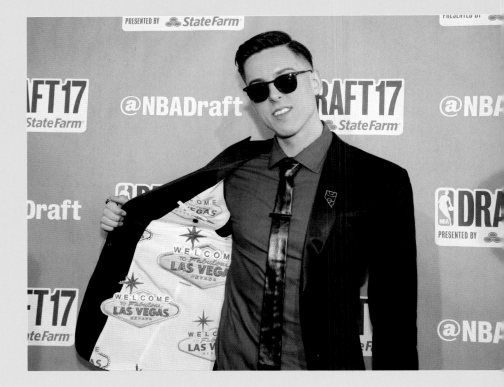

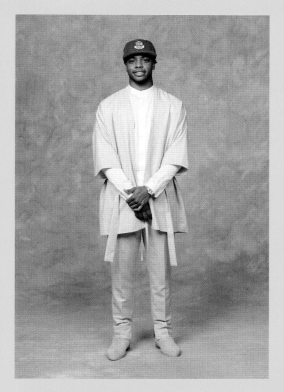

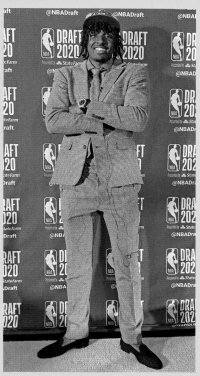

DARIUS GARLAND
2019

The Cleveland Cavaliers (yep, almost perennial NBA lottery pickers) drafted guard Darius Garland with the fifth pick of the 2019 draft. Garland went uber unconventional with his custom cream-colored Fear of God robe suit and tan suede Chelsea boots. He stayed on style theme with a white collarless shirt.

TYRESE MAXEY
2020

The 2020 NBA draft might've been socially distanced, but that didn't dampen the picks' big fit aspirations. And maybe none were more indelible than those of Tyrese Maxey—chosen number twenty-one by the Philadelphia 76ers—whose look can be summed up in a single phrase: all checkered everything. And a plaid tie.

LOTTERY PICKS
2021

Indeed the 2014 draft class featured stellar fashion. However, the style of the 2021 draft class was up, up in the stratosphere.

Case in point: Jalen Green—drafted number two by the Houston Rockets—extra styling and profiling in a shimmery flare-legged pinstripe gray suit. Plus: a white lace shirt. Plus: an iced-out number-four chain.

Case in point: Evan Mobley—drafted number three by the Cavaliers—bedecked in a seafoam-green shawl-collar suit with bold black-and-white penny loafers. Not to mention his lapel and pocket adornments were driptastic.

Case in point: Jalen Suggs—picked number five by the Orlando Magic—who went for overstated in an all-silver sparkly suit, black tie and loafers, and a wrist bejeweled with the iciest of watches.

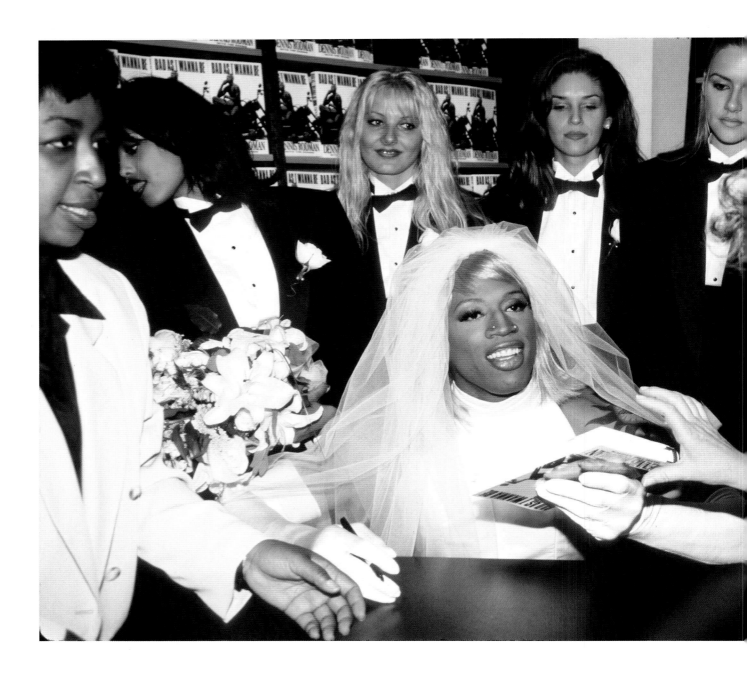

Few NBA players have understood the power of image the way Dennis Rodman does.

ABOVE For a 1996 book signing in New York, Rodman appeared in a custom wedding dress and makeup by the legendary Kevyn Aucoin. He said he was bisexual and marrying himself.

OPPOSITE Rodman took his look to a new level for his role in the movie *Double Team*, costarring Jean-Claude Van Damme and Mickey Rourke, a year later.

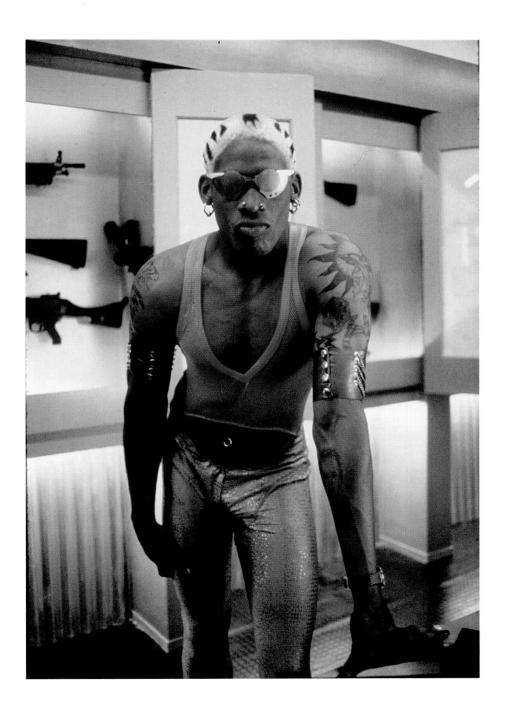

ABOVE, LEFT Isiah Thomas at the U.S. Open at Flushing Meadows Park, Queens, New York, 1992. His print shirt, pleated shorts, and loafers all on trend.

ABOVE, RIGHT Charles Barkley during the 1992 Summer Olympics in Barcelona, Spain. Sir Charles, super casual, yes, but big big flexin' in a gold choker chain and gold Rolex.

OPPOSITE Utah Jazz great Karl Malone in head-to-toe biker leather, 1997. It should surprise no one that he owns a powersports emporium in Salt Lake City.

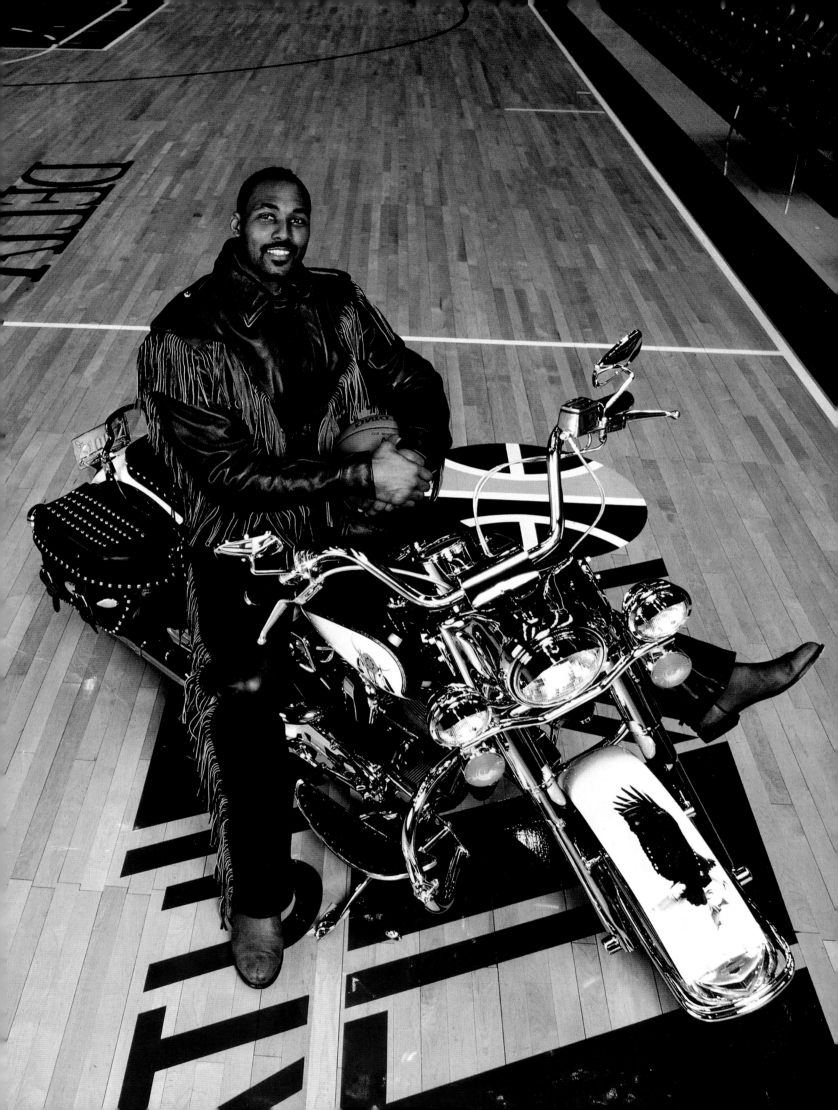

CHRIS AIRE

**JEWELER,
LOS ANGELES,
CALIFORNIA**

—

The self-made king of jewelry immigrated to the United States from Nigeria, put himself through college, slept in his car, and went on to build a golden empire— or rather, RED GOLD, his signature brand he designed to appeal to men. His watches and other creations adorn wrists, necks, and hands across the league.

MITCHELL JACKSON: Gary Payton, the NBA Hall of Famer, was instrumental in helping you break through. I also know that you had been in L.A. and had been in the business for a minute, and I wonder, what was it about G.P. and the NBA player's lifestyle that you saw as instrumental to you breaking through?

CHRIS AIRE: I messed around in the music industry making records. What I recognized, as an artist, is that most artists like to be exemplary, they like to distinguish themselves from the pack. I realized right away that it would probably be best to create pieces that weren't prevalent in the jewelry industry at the time and to find a way to present these items to people that I thought could afford them.

To my mind, the people that could afford them were some of the NBA players and some of the entertainers that I knew that were making that kind of money. I didn't know them directly, which created the other challenge—how do I meet these people? So, I took it upon myself to put a few pieces in my bag and start walking up to whoever would listen. Then I got wind that Gary was staying at the Ritz-Carlton Hotel, because his entire team was there.

I waited there for hours because I didn't know their schedule or anything. When he eventually came out, he was rushed by the press, but my instinct was to be chill, but not to back off; I wasn't going to miss the opportunity. He was extremely gracious. That's the kind of guy he was. He saw that I was trying to find my way. He did not disgrace me. He just quietly whispered in my ear and pointed to Monty, one of his guys that he was with, and said I should talk to him to come and show the pieces to him properly. That was exactly what happened.

MITCHELL: G.P. never struck me as a high-fashion guy, but he obviously liked his jewelry. That makes me wonder, how do you see the connection between jewelry and fashion? Some people I know, they'll build their whole outfit from shoes. I imagine, at least, that you think that there are people who would buy a piece of jewelry and build everything from that piece. Do you see it as supplementary or as a main element?

CHRIS: I've always thought that jewelry was more than accessories. I think many individuals express their identity through the type of jewelry they wear. It's a symbiotic relationship. You can build your jewelry around your clothing or clothing around your jewelry. They're not mutually exclusive.

They're probably not as disposable as shoes are. There might be a tendency to pay a little bit more attention to having jewelry that's universal and you can wear with anything. But I also think it depends on how you are feeling at a particular time or moment. Really, really nice pieces of jewelry tend to cost a little bit more.

MITCHELL: Can you give me a range of the kind of money that NBA players are spending on their jewelry?

CHRIS: It depends on the player and their love for it. There are people who just buy a watch and then there are players who get a little bit more liberal with their jewelry pieces. Have custom pieces made. It depends on financial ability and on how much they love jewelry.

MITCHELL: Do you see a kind of aesthetic in the different leagues? Like the NBA players like this kind of stuff versus other pros?

CHRIS: Yes. For most of the guys in Hollywood, there are certain nuances in the type of jewelry and watches that they wear to events or even in their everyday life. Then the rappers, they tend to wear things that are a bit more ostentatious. Most of the younger NBA and NFL players tend to emulate whatever the rappers do.

What I've noticed is that as players get older, their taste changes, not necessarily to ostentatious pieces, or about the quantity, it's more about the quality, the subtle elegance, and the value of those pieces. There can be two people standing side by side, one of them is a bit of an older player and the other is a younger one, and the younger one has ten chains, and the value of those chains, let's say is like $300,000. The older player could be wearing just one single piece that's half a million dollars.

MITCHELL: When you're working with a client, how much of that interaction is you directing them on what they should purchase versus them coming to you with an idea for a piece?

CHRIS: Well, one of the things that I think a lot of my clients appreciate about me is that if you ask me a question, I'm going to give you the honest answer. Whether I make money or not is inconsequential. I think it's important to develop trust. Once there is trust, making money becomes very easy. I never sell somebody something because I want to sell it. I talk to them about what their ultimate goal is, and based on that, I make recommendations. They look at it and if they like it, they trust me, and then we go from there.

MITCHELL: You've been in business for thirty years now, which also means you were doing business with players when the NBA instituted the dress code. How much, if at all, did it affect your business?

CHRIS: Oh, I remember that back in the day. Yes, they did restrict the fashion on the court, or at press conferences, but those players are individuals and they're from somewhere. They have cultural identities, and they interact with people in their communities. I equate that with having a job, maybe a corporate job.

In your corporate job, you're not allowed to wear jerseys to the office. You have some dress code, you wear a tie or a button-up shirt, but once you are out of the office, whatever you do with your time is your business. I really didn't notice any dip in myself because those guys were still buying the same thing.

They weren't wearing them to interviews but they wore them to the club and when they were hanging out at the malls. I don't think the intention of the NBA was to nip our business in the bud. I think they were just trying to do something that worked for them, but it didn't work against us. I'll put it this way: You can't stop an idea whose time has come.

CHRIS: I was a kid when I left Nigeria, but growing up there exposed me to so much, and so it's part of my identity. Coming to the United States and hanging out with a lot of my brothers and sisters here as well has molded me.

And hanging out with people from all walks of life, all nationalities, has really transcended who I am, and has really molded me into this person I am today. I take inspiration from many different things. Sometimes subconsciously, when I'm asleep, I see an idea, and then I wake up and sketch it down, because otherwise I forget it.

I can get inspired by watching a rapper perform or listening to his lyrics. Or listening to Andrea Bocelli singing an opera song. Or listening to Afrobeats or watching a movie. I can't really say it's one particular thing. Sometimes I'm inspired by art. I have designs that were inspired by trees, created from the beauty of the leaves.

MITCHELL: So a lot of your designs are coming from your actual pencil, then?

CHRIS: Yes, so far. I've been the only designer for this company for many years. Everything you see is actually designed by me.

MITCHELL: You spoke about what guys purchased being dictated to some degree by how much they can afford. There are higher NBA salaries these days, as well as avenues for the seventh, eighth, twelfth guy on a team to become a star in the fashion world no matter his play. What kind of impact have those two developments had on your business?

CHRIS: Absolutely. Like I said, everything is about your ability. If you're making more money and you have a love for jewelry, obviously, that's going to factor in to how much you can acquire. Generally, the more money people make, I find the more they reward themselves. I'm a strong advocate for rewards. If something brings you joy, do it, as long as it does not interfere with the well-being of another human being.

MITCHELL: You've set a lot of trends. What do you see on the horizon in terms of jewelry in the NBA space?

CHRIS: I was just talking to Wyclef the other day. He's working with Lil Wayne on something. He was telling me about some of the things that he would like to do when they launched this album. I was showing him some of the things that I've been working on. I can't completely give it away, but there are things coming that I think a lot of people are going to love, people who love jewelry.

Right now, people are still wearing a lot of the Cuban links. They've become a massive wave that's now a little bit more heavy on the diamonds. Also, a lot of men are starting to wear bangles. Back in the day, we were already doing these bangles. I've repurposed them for the moment now. We're expanding those, and I think that's going to be big.

ABOVE The many extracurricular
activities of Shaquille O'Neal
included (*left*) posing in leather
and fur in Times Square, 1992
and (*right*) rapping. His debut
album released in 1993. (This
was before his movie stardom.)

OPPOSITE Michael Jordan,
1985 Slam Dunk Contest.
Was it the shoes?

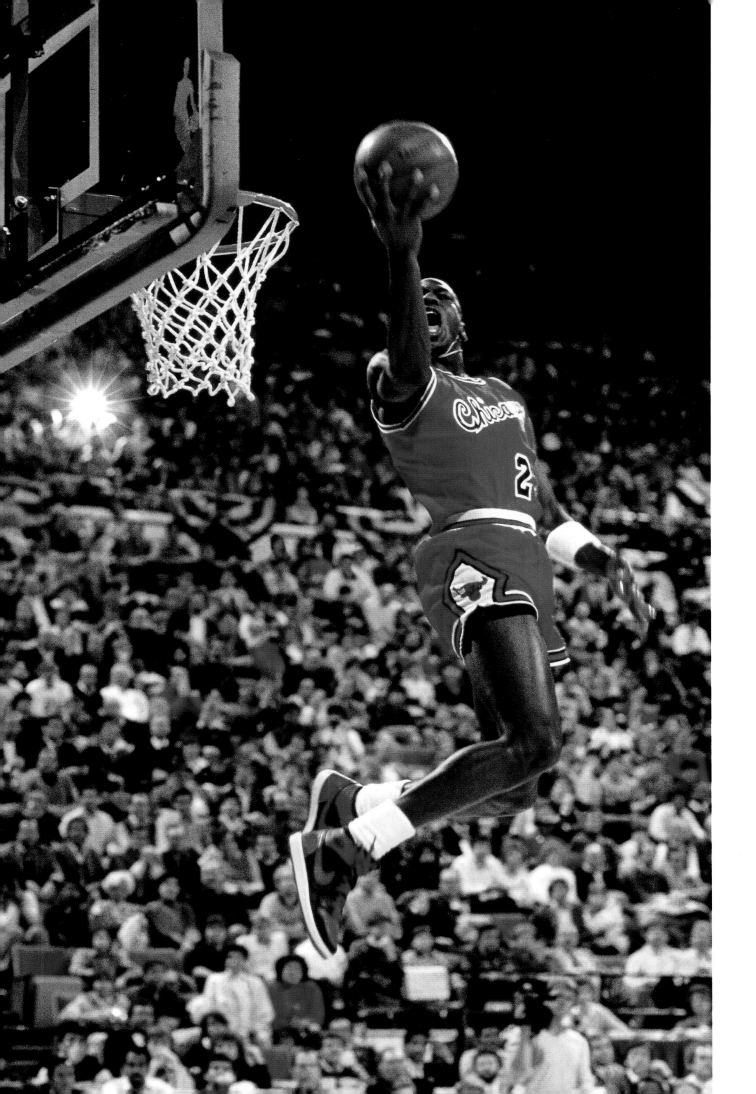

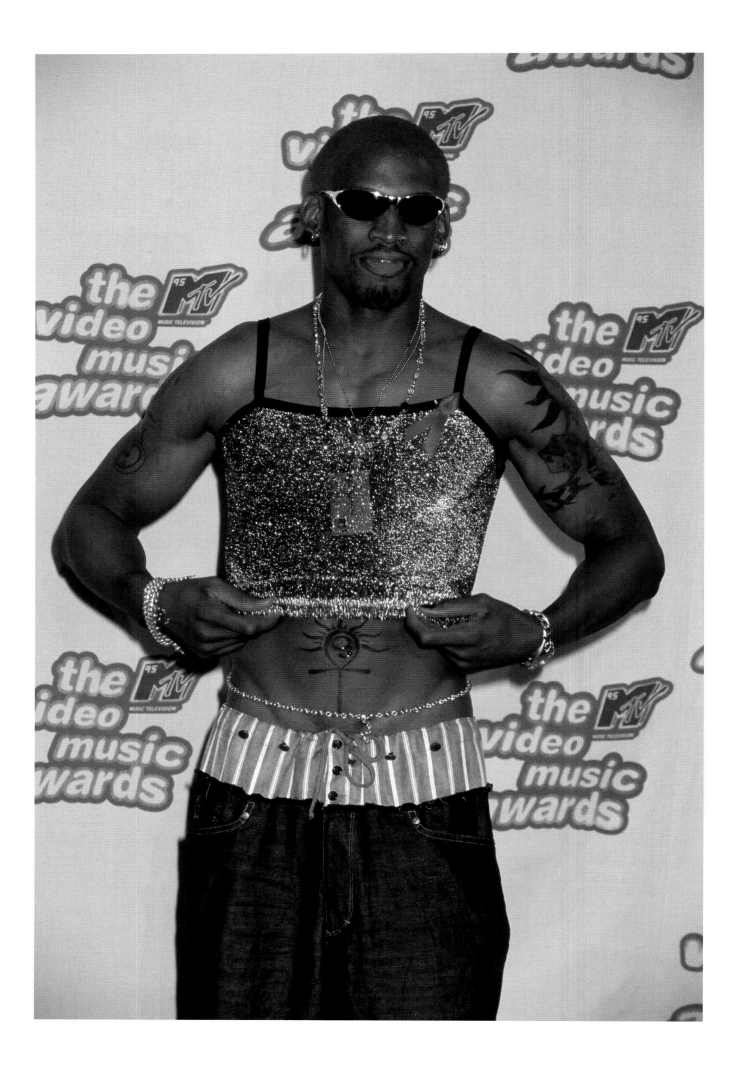

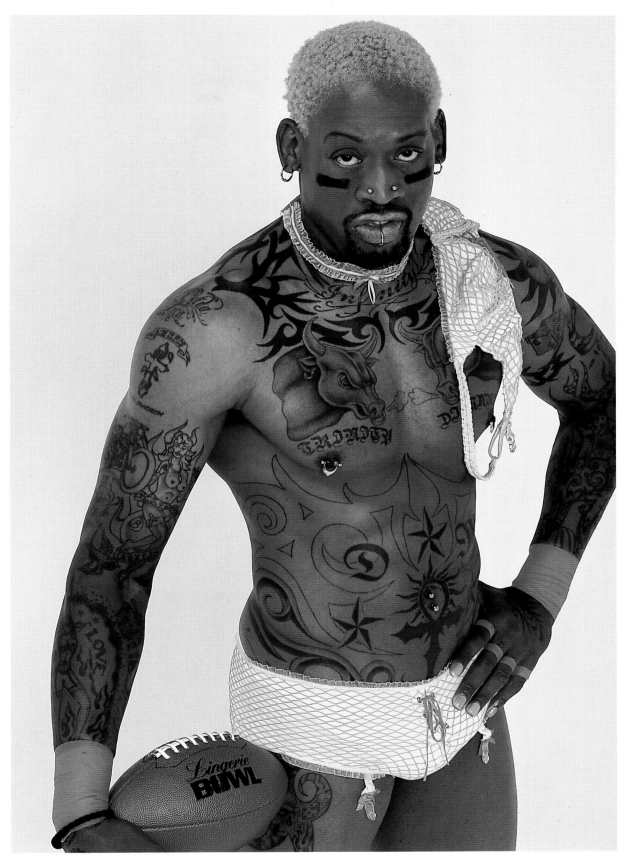

Dennis Rodman, at the MTV Video Music Awards in 1995 (*opposite*), and a decade later, at the 2006 Lingerie Bowl (*above*), has always pushed the boundaries of sexuality and fashion. He is also a Hall of Fame player.

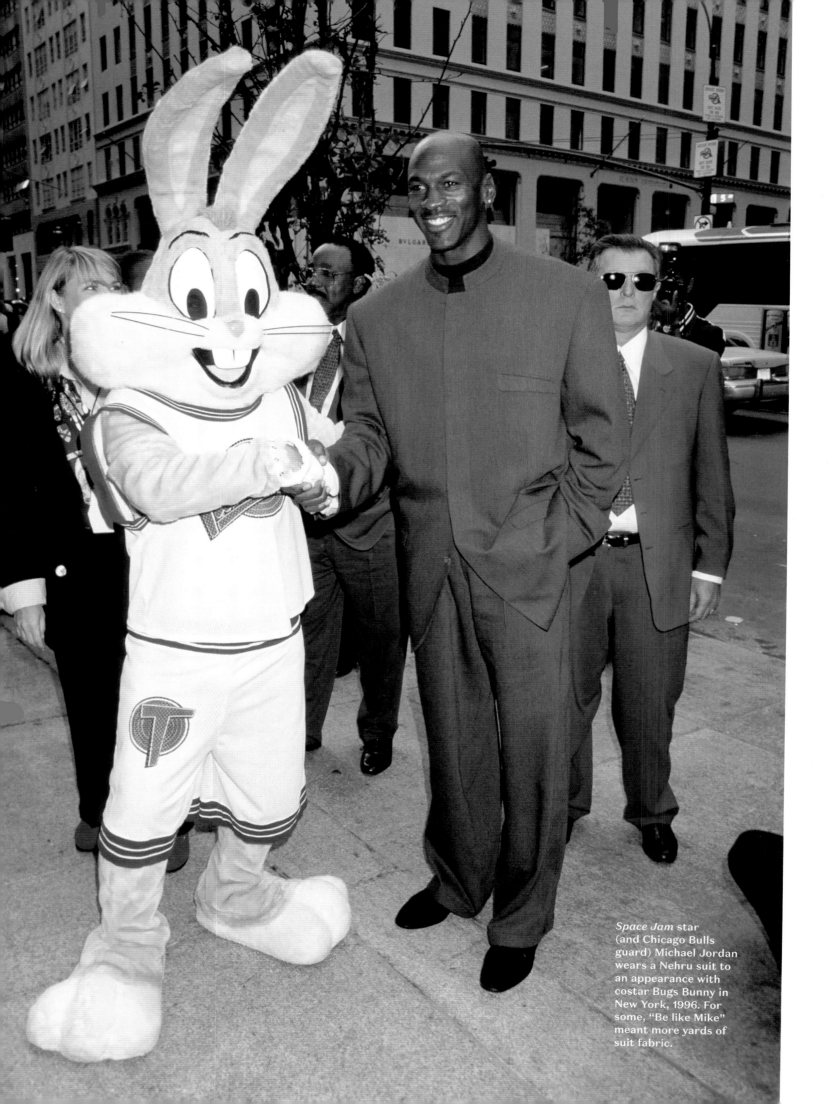

Space Jam star
(and Chicago Bulls
guard) Michael Jordan
wears a Nehru suit to
an appearance with
costar Bugs Bunny in
New York, 1996. For
some, "Be like Mike"
meant more yards of
suit fabric.

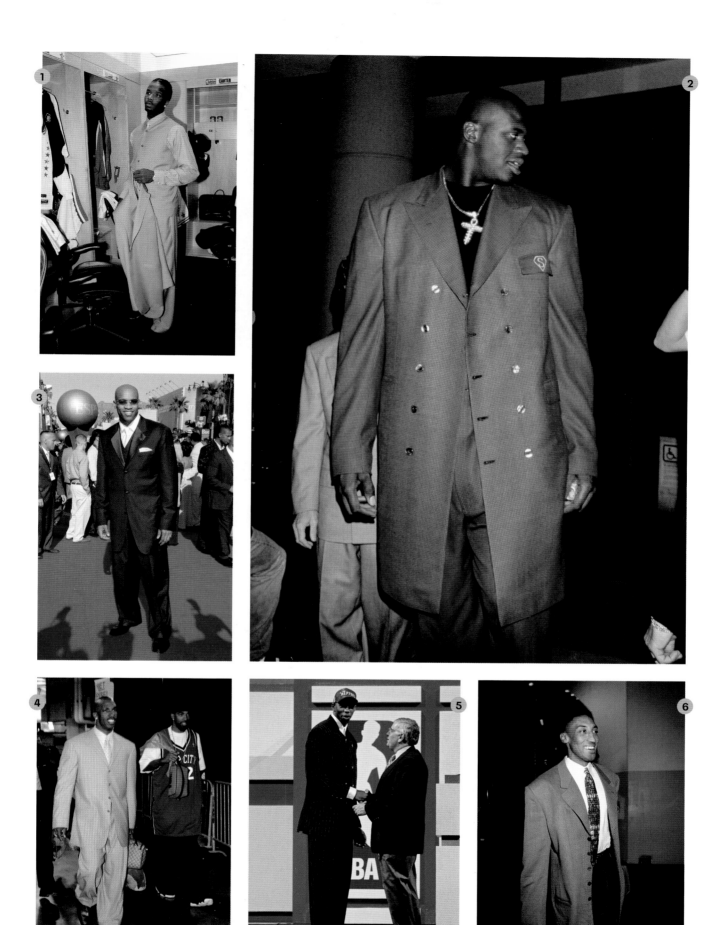

The age of baggy suits in full effect: 1. Jermaine O'Neal gets ready for the 2003 All-Star Game; 2. Shaquille O'Neal; 3. Vince Carter at the 2007 ESPY Awards in Hollywood; 4. Chauncey Billups, suited, and Richard "Rip" Hamilton, not; 5. Tracy McGrady (with NBA commissioner David Stern) at the 1997 draft; 6. Scottie Pippen.

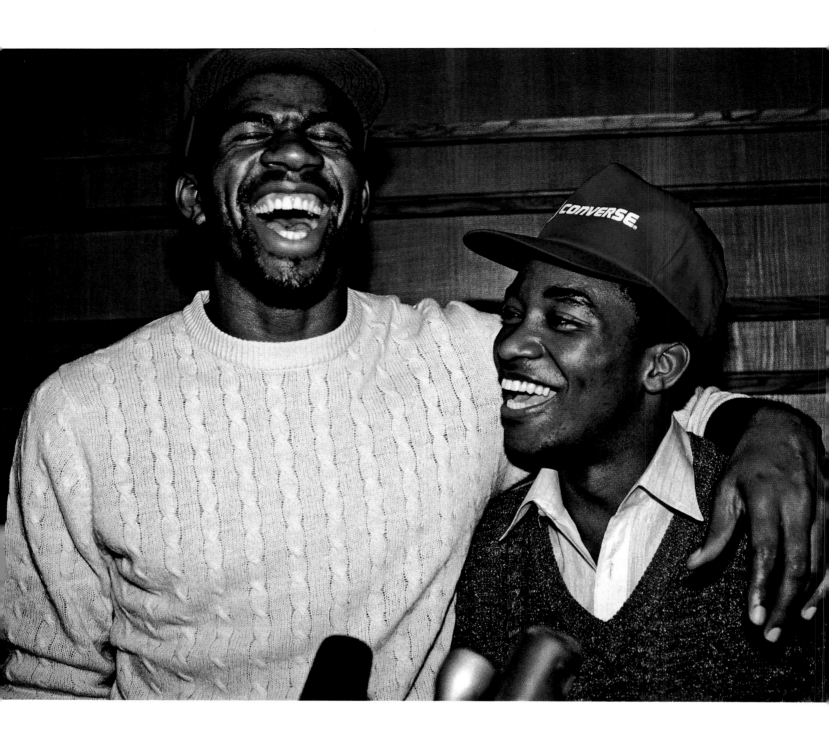

ABOVE Just before suits took over
the NBA, Magic Johnson (*left*) and
Isiah Thomas (*right*) demonstrated
the power of the sweater: Magic in
a cable-knit crewneck, Thomas in a
V-neck.

OPPOSITE Not to be left behind in the
knit trend, Larry "Legend" sported this
geometric pastel cardigan.

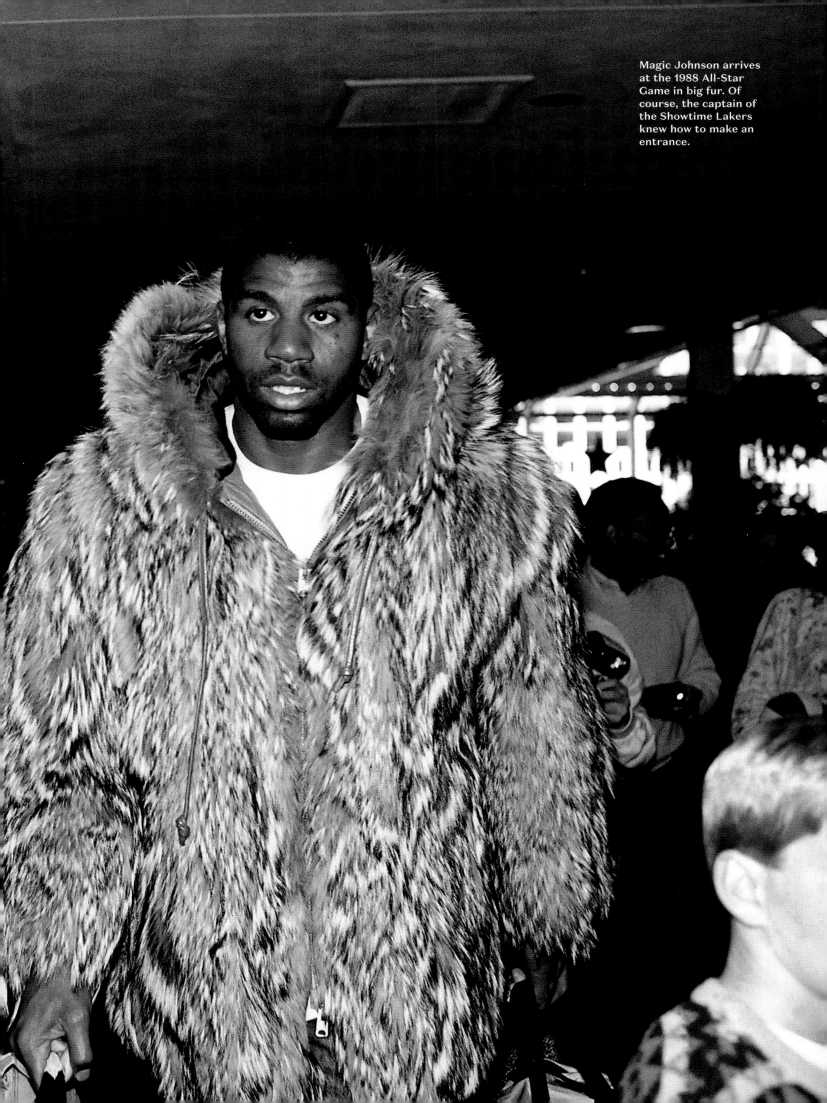

Magic Johnson arrives at the 1988 All-Star Game in big fur. Of course, the captain of the Showtime Lakers knew how to make an entrance.

The
lverso

Effec

This
intersection,
of money and
hip-hop, is what
catalyzed the
next era of
NBA fashion.

What comes after a golden era?

On the political side, Bill Clinton, who some jested was the first Black president, finished his second term in 2001, having presided over what was touted as unprecedented economic growth. On the cultural side, hip-hop, which had been burgeoning in the eighties and early nineties, was an indisputable cultural force by the early aughts.

And this intersection, of money and hip-hop, is what catalyzed the next era of NBA fashion.

The story of hip-hop, of course, began in New York's South Bronx, with impoverished youth inventing a new genre of music from a sparse set of materials: turntable, drum machine, synthesizer, mic. By the dawn of the new millennium, however, there wasn't nothing sub about hip-hop music nor its culture. In fact, by the time cool Bill left office, one could argue that hip-hop was the most influential cultural phenomenon in America.

The proof of hip-hop's wide appeal could be found in the hard numbers of record sales. Eminem, Nelly, Lauryn Hill, and Outkast all went diamond (ten million albums sold), and others including Jay-Z, 50 Cent, and Lil Wayne sold well into the millions. The arbiters of hip-hop started making money—in 1998 hip-hop outsold country music, which had been America's highest-grossing genre—real big scratch, becoming nouveau rich Americans almost overnight. And as those with new money often do, they put the world on notice, flaunting their riches with grand unabashed ostentation.

Maybe no other person in hip-hop heralded this new wealth like the man now known as Sean "Love" Combs. Love began hosting his now-famous White Parties (white as in clothing, not necessarily people) in the ultrarich Hamptons and making videos that were more like vibrant, over-the-top films (credit due to Hype Williams and Paul Hunter, who directed many of those videos) and wearing beaucoup gold, platinum, and diamonds.

For a vision of that era, look no further than Love's grand production of the Notorious B.I.G.'s song "Mo Money Mo Problems"; look no further than Jay-Z and Jermaine Dupri's "Money Ain't a Thang," which featured the pair tossing fistfuls of bills out of a speeding Ferrari and Porsche; look no further than the Cash Money Millionaires shouting, "Bling, bling," and flashing their diamond-encrusted teeth.

Blinging was a requisite of the era: diamond earrings the size of dimes, watches and thick bracelets flooded with diamonds, gold Jesus pieces the heft of small sculptures, multiple chains made of diamond solitaires. The goal, it seemed, was to become a glittering chandelier under the lights.

And while the eighties had *Lifestyles of the Rich and Famous*, the new millennium had MTV's *Cribs* (it debuted in September 2000). In an episode emblematic of the era, hip-hop mogul Master P showed off his many-roomed mansion replete with 14-karat-gold *ceilings*.

The fashion of the time matched the jewelry; the order of the day was *oversize*. Sagging oversize jeans. Throwback jerseys. Velour sweat suits. Tees long as knee-length skirts. Allover prints. Even the suits were over-size, a Jordan-era holdover. Rapper fashion brands were on trend: Love's Sean John, Jay-Z's Rocawear, Russell Simmons's Phat Farm, and Pharrell's Billionaire Boys Club, to name but a few.

Meanwhile, due in a major way to—again—Jordan, the NBA's young stars began signing gargantuan contracts. In 1996 Juwan Howard broke the NBA's $100 million mark with a seven-year, $105 million contract from the Washington Bullets. That same year, Shaquille O'Neal signed a seven-year $120 million deal. Kevin "The Franchise" Garnett scored a six-year $123 million contract from the Timberwolves in 1997. The NBA stars of the era—young men who'd been born around the advent of hip-hop and were, for all intents, its acolytes—were making as much as or more than their hip-hop counterparts.

It made sense that the players also dressed like members of the culture that shaped them.

Jermaine "J.O." O'Neal in long braids and a headband.

Richard "Rip" Hamilton in customized "Rip City" throwback jerseys.

Garnett in diamond studs the size of comets.

And arriving in 2003, about the middle of the era, LeBron "King" James swimming in an indelible four-button, all-white suit paired with square-toed spectators.

Dwyane "D-Wade" Wade as a Finals MVP on *Letterman* in 2006 wearing an oversize T-shirt and shorts, a White Sox fitted cap with a durag beneath.

Carmelo "Melo" Anthony during pregame for the Nuggets dressed in a tentish two-tone (yellow-and-white) Jumpman shirt, tall white T-shirt beneath, and jeans a size to fit a whole other human.

However, the unquestionable fashion (and cultural) leader of the NBA's hip-hop era was Allen Iverson.

A.K.A.: A.I.

A.K.A.: The Answer.

When the announcer called Iverson's name as the number one pick of the 1996 draft, he swaggered onto the stage wearing a tailored gray suit and patterned tie, his low Caesar lined sharp. But within just a few sea-sons, Iverson became a paragon of hip-hop splendiferousness—at press conferences, swanking the sidelines on game nights off from playing, and everywhere else the cameras captured him. Iverson debuted what became his signature hairstyle of cornrows during the 1997 Rookie Challenge

game, and quick as a Showtime Lakers' fast break, cornrows were damn near omnipresent in the league.

Iverson wearing his braids tied with a durag and topped with an over-size fitted cap, an extra-spacious white shirt and jeans, a diamond Chris Aire watch, and diamond pendants. Iverson in a Sixers throwback jersey on the cover of *SLAM* magazine, his hair blown into an orb, little diamond boulders in his ears, neck and wrist and finger adorned in more jewels. Iverson in his infamous "We talking about practice" postgame interview, donning an oversize white tee and side-cocked Boston Red Sox fitted cap over a black durag.

It didn't take long for Iverson and the players who followed his hip-hop cues to be maligned as bad for the respectability of the league, i.e., profits. And that stance was given much more purchase on November 19, 2004, the night the Detroit Pistons and the Indiana Pacers brawled—bellicosity that involved fans.

The "Malice at the Palace" became the unintended tipping point for NBA commissioner David Stern, who instituted, at the outset of the 2005–06 season, a "liberal and easygoing" dress code that mandated players wear "business casual attire" while participating in league or team activities. It also banned headgear "of any kind" (so long, fitted caps and sweatbands) as well as "chains and pendants, or medallions worn over the player's clothes."

In short, the dress code nixed hip-hop fashion from league business. A.I., who was viewed far and wide as the main target of the code, responded as one of its most ardent initial critics. "They're targeting my generation," he decried. "The hip-hop generation." Other notable players were also critical—Carmelo Anthony, Stephen Jackson, Marcus Camby, and Jason Richardson.

However, over time players began to embrace the dress code, accepting the rules as a reason to wear high fashion—to, as Jay-Z proclaimed in his 2003 hit song "Change Clothes," "throw on a suit, get it tapered up."

Perhaps the first star to embrace the code without reserve was Dwyane Wade. (His 2003 draft-class buddy LeBron James was also an early adopter.) "It was like, OK, now we got to really dress up and we can't just throw on a sweat suit," Wade told the Associated Press. "Then it became a competition amongst guys, and now you really got into it more and you started to really understand the clothes you put on your body, the materials you're starting to wear, so then you become even more of a fan of it."

D-Wade and King James teamed up in Miami, winning back-to-back championships for the Heat. They also became fashion all-stars off the court, and ushered in the next era of NBA fashion.

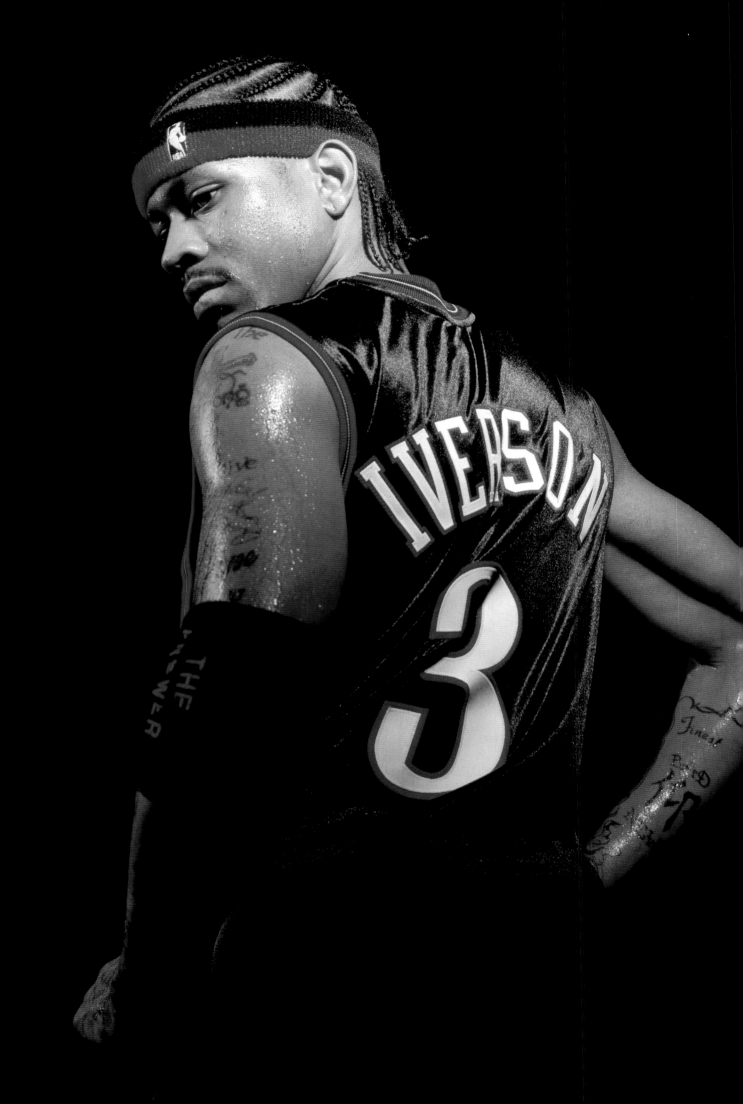

A.I.'s hip-hop fashion was viewed as the impetus for and later the rebellion against the NBA's dress code. The league couldn't legislate away his cornrows and ample tattoos, but it's a safe bet it wasn't a fan of those aesthetics either, 2004.

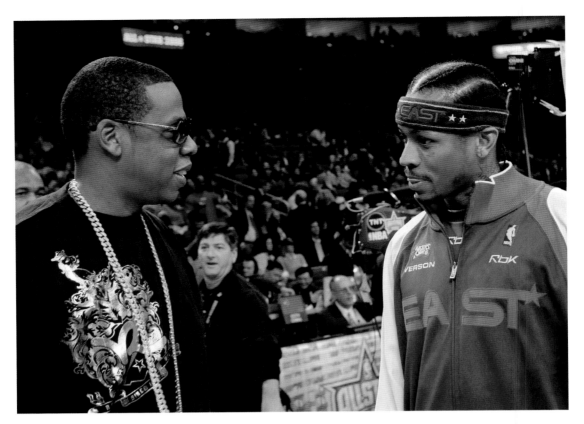

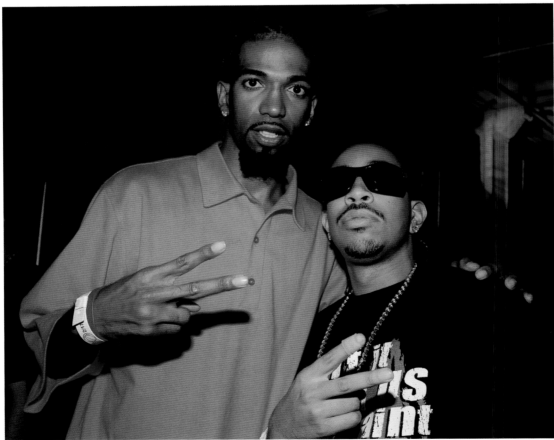

The intersection of the NBA and the entertainment world was on full display at the 2006 All-Star Weekend in Houston.

TOP Jay-Z and Iverson.

BOTTOM Richard Hamilton and Ludacris.

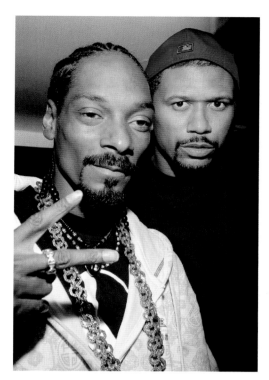

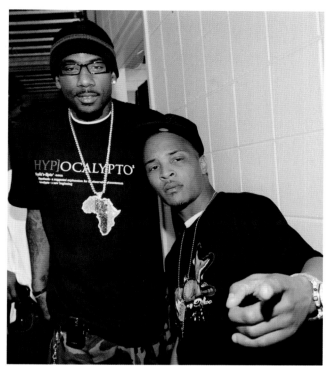

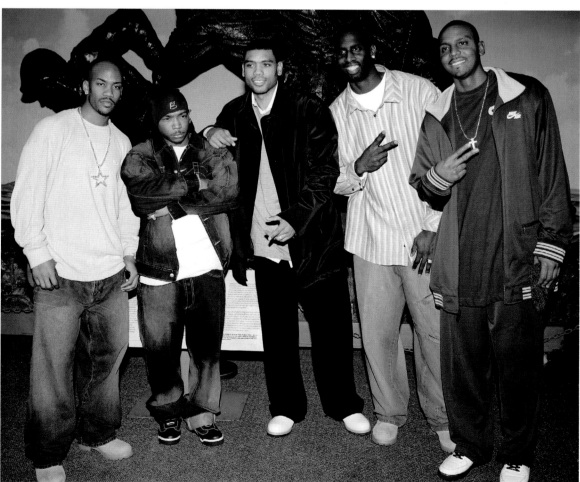

CLOCKWISE FROM TOP LEFT Snoop Dogg and Jalen Rose; Amar'e Stoudemire hangs with the rapper T.I.; the Knicks, in 2004, with rapper Ja Rule (*from left*): Stephon Marbury, Ja Rule, Allan Houston, Tim Thomas, and Penny Hardaway.

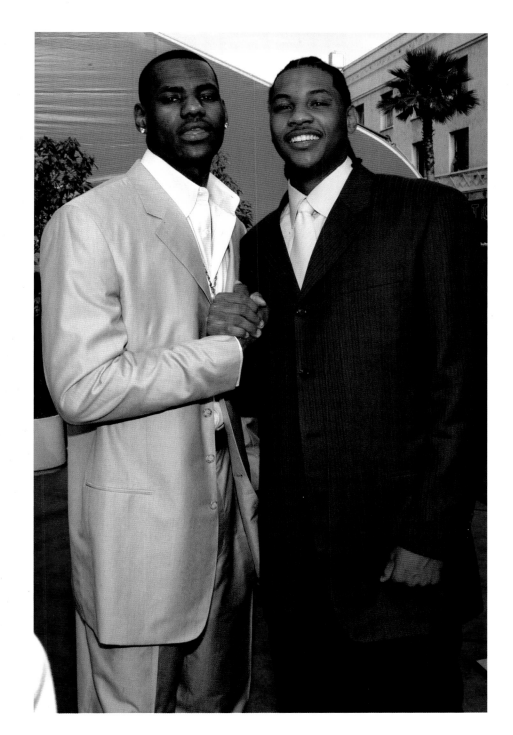

LEFT Eighteen-year-old LeBron James (*left*) and nineteen-year-old Carmelo Anthony (*right*) on the red carpet of the 2003 ESPY Awards. The future Olympic and NBA teammates (one season), draped in the many-buttoned-long-sport-coated suits of the day.

OPPOSITE Dwyane Wade in Miami, 2004. At the time, it didn't get more hip-hop than wearing a durag under a fitted cap. Not to mention, rap juggernaut 50 Cent made those tank tops popular in one of his music videos.

P.J. TUCKER

SUPERSTAR, PHILADELPHIA

—

Tucker entered the NBA in 2006 as a second-round draft pick and, traveling a road filled with pro hoop challenges, won his first championship in 2021 with the Milwaukee Bucks. Just as significant, *SLAM* magazine, the basketball bible, named him the league's number one sneakerhead. His style—replete with bright colors, all the right bling, plus a pair of kicks on his feet *and* in his hands—is smart, shocking, and undeniably his own.

MITCHELL JACKSON: How do you see the relationship between how you play, the grit, the toughness, and how you dress? Do you see it as a contrast or a complement or something else?

P.J. TUCKER: They don't even correlate to me. The way I play is the way I play and the way I dress is the way I dress. Like night and day. I guess it's kind of impossible for me to dress like I play 'cause, you know, I'd probably look like a homeless person.

MITCHELL: So it's a contrast, then?

P.J.: Yeah, it's definitely a contrast. 'Cause there's nothing pretty about the way I play. But I think it's funny because I get dressed to go to work to get dirty. And then you get dressed to get clean, you know what I mean?

MITCHELL: How would you describe your style evolution?

P.J.: I did a 360 and then another 180. Early on, I wore a lot of suits. Like really getting clean. Suits with turtlenecks—that was my style, early 2010s. And I kind of got crazy with oversized tees with the ripped jeans and the biker jeans—that kind of look, and then I kind of went preppy with the Chelsea boots, until my style evolved into where it is now, where it's all of that mashed together. Throwing on a suit today and then tomorrow some combat boots and a vintage tee. Or some '85 Jordans. And be able to mash it all up and figure out my own style is like a coming home. A coming to. Because you don't really know your style; you kind of figure it out over the years.

MITCHELL: I presume a style guy thinks about things like fit and texture and fabrication. Has your knowledge of those elements evolved too? Plenty of those old-school NBA guys had a tailor making them custom suits, but that seems like it's a different thing, or maybe a starting point, for where we are now.

P.J.: It's a completely different thing. And then when you start making stuff, and being aware of how stuff is made, and the materials and all that shit, it really changes everything. 'Cause it can be something so simple about why you love a thing so much. And people don't understand it's about the simple details, and how big a part they play in the big scheme of things.

MITCHELL: Definitely. I've seen a lot of your off-season looks. And it don't stop with you. It made me wonder if you're still working with your stylist, Kesha McLeod. It made me wonder in general what's your relationship with your stylist? And how has that changed, if at all? Like did it go from her saying, "Let's put this on," to you telling her what you're looking for? How does that work?

P.J.: It never was, "Put this on." It started off that she was working with James [Harden] and they were going to Fashion Week and she just added me on to the trip. And us working together came from that. And then it went from that to her being like, "I don't even want to style you. I just want to be there to help"—connecting me with the designers and the brands, getting the pieces, doing all the background work for me to be able to get some fly shit. Because we all know I like the one-offs from runways and all that shit. That's what she does. That's the beauty of our relationship. I don't need her to style me. I do all that shit myself. But she helps me get pieces. She's like my style director. It's more creative.

MITCHELL: Speaking of putting stuff on, everybody talks about your sneakers, but I want to talk about your jewelry. What part do jewelry and accessories play in your style? Do you have a collection of chains, watches, rings? Do you keep track of them?

P.J.: I keep it simple, honestly. You would think I'd have more because of the way people talk about it, but it's not like that. When you get pieces you like, like nice watches, rings, bracelets, that shit is so hard to find. Sometimes you got to make this stuff so you can wear it. Some watches I like to wear whether I've got a suit on or streetwear. Stuff that's just classy, and I'm gonna look good. It's hard to find unique stuff, especially nowadays where everybody's getting so hyped up by everything. I really play it cool in terms of jewelry. Like, I know sometimes I look crazy 'cause I'm wearing a bunch of chains and stuff, but it really is simple though, for real.

MITCHELL: Do you own some go-to pieces? A go-to watch, a go-to bracelet, chain?

P.J.: My rose gold Nautilus [Patek Philippe] is my everyday watch. It's my favorite shit. To me, it's the ultimate piece—there ain't nothing like that.

MITCHELL: I read an article in which Kesha McLeod was interviewed, and she was talking about y'all picking looks for the playoffs. She said, "We have hints of, 'You've never seen this yet,' or holding on to items he hasn't worn in years or somebody gifted him years ago. So we bring things out like that. That's usually how the playoff process goes with him in particular." She went on to talk about her philosophy on dressing for Game 1: "It's best in my opin-ion to always go with something from the past that you want to bring out. Game 1s do not call for a brand-new outfit." Reading Kesha's thoughts on playoff fashion made me wonder if you have a philosophy that guides what you wear during the season?

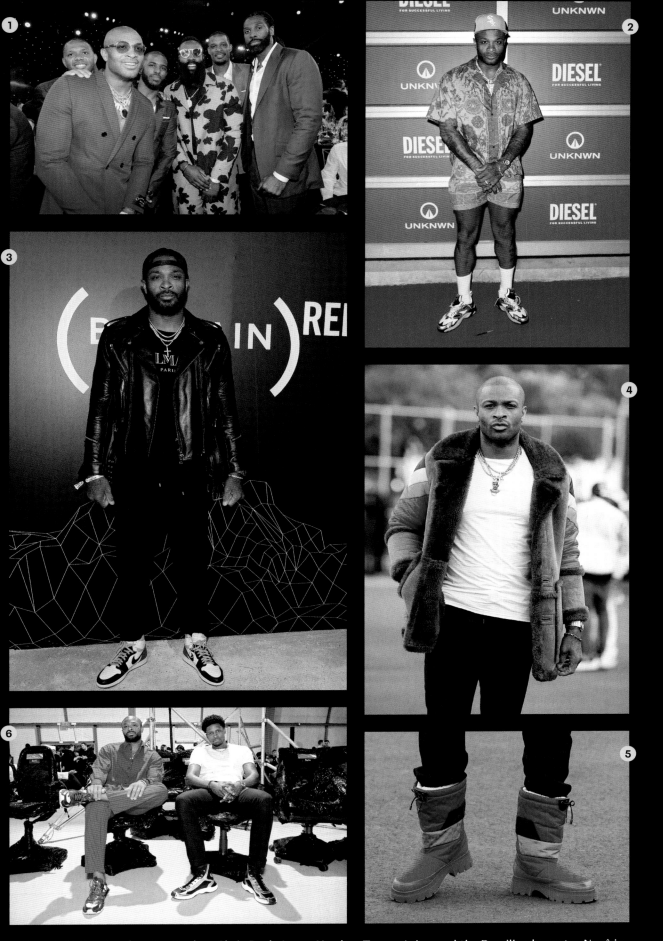

1. (*from left*) Eric Gordon, P.J. Tucker, Chris Paul, James Harden, Trevor Ariza, and the Brazilian hoopster Nenê in 2018; 2. Tucker at a Diesel sneaker launch; 3. Paris Fashion Week 2020; 4. Tucker arrives at a Coach show during New York Fashion Week 2021; 5. Close-up shot of boots that match the leather accents of Tucker's shearling coat; 6. Tucker and Rudy Gay attend the Raf Simons show in Paris, 2019.

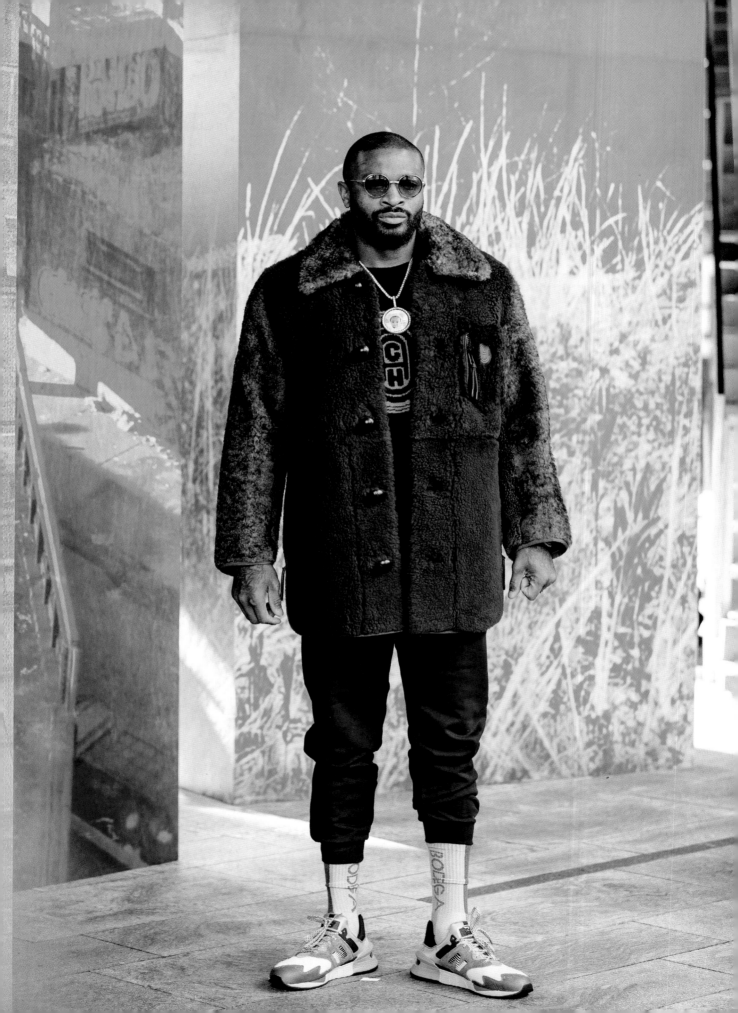

P.J.: It's not the Tunnel, it's more like the game. Where I'm at, who we're playing, and my mindset. I want to dress the part. It's mental. Riding the bus, what I got on, how I'm feeling, where I'm at, all that stuff. That's a big thing for me. Getting ready to play. The Brooklyn series was huge. Being in New York. I needed some real fly shit in New York—because I was having to do some wild stuff on the court, chasing around K.D. [Kevin Durant] and all that. I had to get in that mindset of going to work, and the fashion was part of it.

MITCHELL: Where do you get your fashion inspiration from? I've seen you sitting front row at fashion shows, but I've also seen you post pictures of riding around in a hood. Are you drawing inspiration from both settings? Do you think of your fashion as mostly high-end or a mix? More runway or the block?

P.J.: It's got to be a mix. 'Cause if it's not mixed, it means you're not getting the true vibe, real flavor, what all this shit is, right? Especially urban culture. You don't necessarily got to be from the hood to have hood friends, to know what that's about. Or you got to have friends with money to really know what that's about. So like the high-end, the low-end, it's the mix and the vibe of being able to put all that shit together. That to me is the ultimate style. Being able to have maybe a Virgil [Abloh] piece. That's cool. Being able to bring like streetwear and other shit with it, like bringing it all full circle. And that's what makes Virgil brilliant. To be able to do an Off-White [Abloh's own luxury company] and do a Louis [Vuitton]. It's insane for one designer to be able to jump back and forth from two totally different sides of the spectrum. But being able to put that shit together is everything.

MITCHELL: Do you think that we are now in the most fashionable era of the NBA? And if not, what was that era?

P.J.: Oh, without question. It is the most fashionable era of the NBA. I've been around for a while. I grew up watching the league in the mid-nineties; I started in early 2000. Now there's an awareness and attention toward it. No era has ever had this much attention toward fashion and what people are putting on. That alone has made it bigger. And now guys that don't really do it are going to do it, even a little bit, just because they know their picture will be taken.

P.J. Tucker outside the Coach show during New York Fashion Week 2019.

THE TOP 10 ACCOUTREMENTS OF ALL TIME

ALLEN IVERSON'S NECKLACES

The Answer's bevy of iced-out chains became a symbol of extravagance in the early 2000s—and later, a sign of the extent of the Hall of Famer's indulgence, when a thief made off from a Philadelphia hotel lobby with an unattended backpack holding a cool half milli of Iverson's jewelry.

There ain't no gainsaying the importance of choosing the right garments. But let it be known that accoutrements are often the flourishes that set the real apart from the pretend in the style quotient. That divide those riding a trend from those making one. And as stellar proof, we submit the list below.

DENNIS RODMAN'S BELLY RING
DENNIS RODMAN'S NOSE PIERCING

On the real, Rodman could probably hold all ten slots on this list, but honors go to his large nose ring, a staple of his look starting in the early 1990s, and the bejeweled belly chain he debuted at the 1995 MTV Video Music Awards.

KEVIN GARNETT'S DIAMOND STUDS

While playing for the Minnesota Timberwolves, the Big Ticket was often seen off the court sporting matching pepperoni-size diamond earrings in his lobes. In a league where styles and looks change all the time, KG's studs were a constant. They even won him a cameo in the jewelry-centric 2019 Adam Sandler drama *Uncut Gems*.

JULIUS ERVING'S TINTED GLASSES

Not much about Dr. J was subtle—not his explosive play on the court, not his slick stylings off it. His oft-sported shades, however, were tinted just enough to shield his eyes from the spotlight but not so much that you didn't know where he was looking. If they'd have let him wear them in games, he just might have.

THE CHAMPIONSHIP RING

It's become a bit of a competition, albeit among precious few competitors: On how many fingers can you wear an NBA championship ring? Though maybe the more interesting question is: Do you wear them forreal forreal? A few for whom the answer is a loud yes: Robert Horry (seven), Michael Jordan (six), and Steph Curry (four, as of 2022).

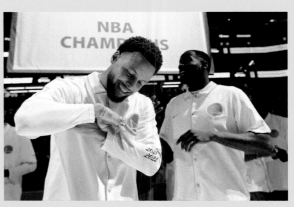

MICHAEL JORDAN'S HOOP EARRING

People don't use the word "understated" when they speak about His Airness's on-court performance. But there was often a deceptive quiet to it: the little juke, the flick of his eyes, the last-second dish to the open man no one else saw. Kind of like the tiny gold hoop earring he started wearing in the mid-1990s.

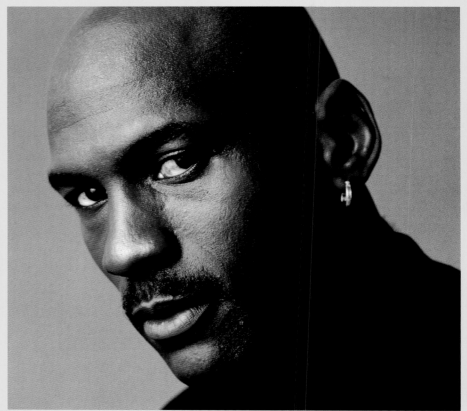

KYRIE IRVING'S PRAYER STICK

No bling here: In 2018, Irving and his sister were welcomed to the Standing Rock Sioux Reservation, which spans the central Dakotas, for a ceremony in which they were given Sioux names—Kyrie's is Little Mountain. Their mother, who died when Irving was four, was born into the Standing Rock Sioux, and the prayer stick he started using before games in 2021 is a symbol of that heritage.

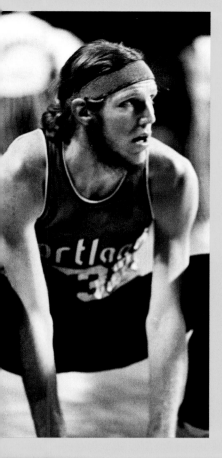

BILL WALTON'S HEADBANDS

A well-known Deadhead and self-proclaimed hippie, Walton wore his shaggy seventies hair in keeping with the peace-and-love crowd he felt a part of. Not so convenient on the court, though; so he held his red shag out of his eyes with the headbands that became his low-budget trademark.

DRAYMOND GREEN'S BROOCHES

On the court, Draymond's game testifies to a high hoop IQ. Yeah, he could score more, but to help his team win championships, he plays smothering defense, makes keen passes, sets hard picks, and serves as the emotional engine of his Golden State Warriors. His dress-up game is no less heady. Lots of players sport suits, but the ones who are 'bout it 'bout it for real know the efficacy of the right lapel pin. DrayMagic's choices range from classic YSL pins to the blingest brooches in the land.

JA MORANT'S DIAMOND GRILL

Though the ancient Etruscans were the first to do it—adorn their teeth with bits of metal—the grill has been a staple of hip-hop since at least the days of Slick Rick's 1988 debut album. And since they just might be the most ostentatious accoutrement a person can wear, it makes sense that Ja Morant—one of the flashiest (and best) players in the league—owns a custom grill designed by none other than celebrity jeweler Johnny Dang, the bedazzler who's appeared in the music videos of umpteen rappers.

OPPOSITE As a rookie in the 2003–04 season, Carmelo Anthony immediately made people pay attention to the once lowly Denver Nuggets—and achieved further Denver cred by sporting Broncos gear.

BELOW Allen Iverson, all-star, 2006. The untucked jersey is patented A.I. irreverence.

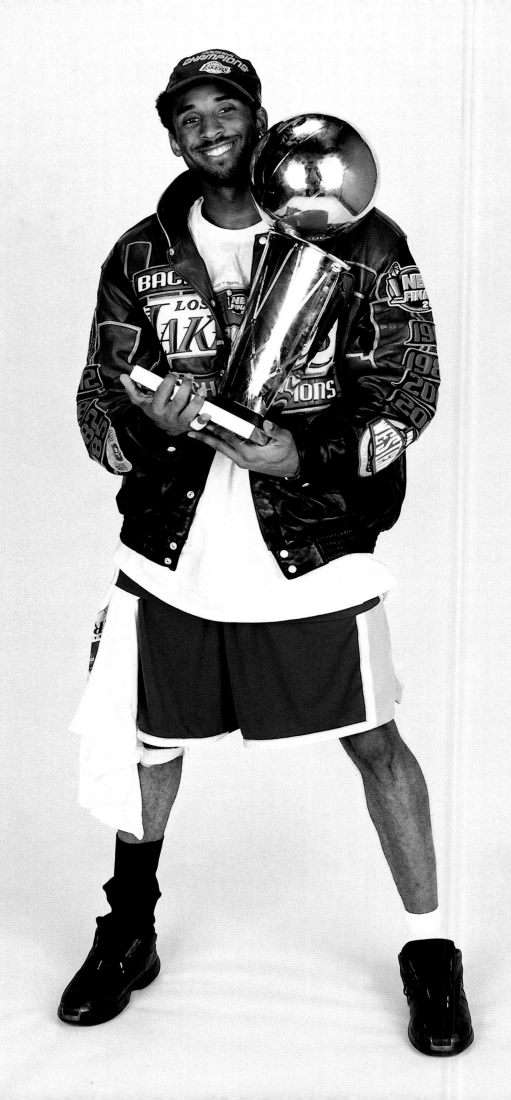

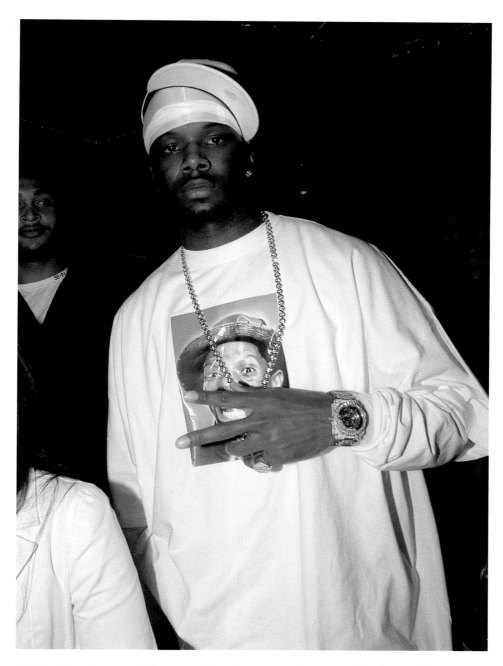

ABOVE When hoop and hip-hop collide: Pacers star Jermaine O'Neal at a Faith Evans album-release party in 2005.

OPPOSITE Kobe Bryant, decked in a custom leather jacket by famed designer Jeff Hamilton, was already a two-time NBA champion by the age of twenty-two in 2001.

ABOVE Jalen Rose in 2005 with the
diamond globes for earrings, the
extra-long white tee, the diamond-
encrusted Jesus piece—all hip-hop
official.

OPPOSITE Kobe Bryant modeling
the merits of impeccable tailoring
for *GQ* in 2009.

KHALILAH BEAVERS

**STYLIST,
BROOKLYN**

—

Beavers deserves much of the credit for helping turn the back halls and meandering tunnels of NBA arenas into fashion central. Back in 2008 she began styling Carmelo Anthony, a maverick who had been singled out as a huge part of the impetus for the NBA dress code. Since then she's lent her sartorial expertise to NBAers Jimmy Butler, JR Smith, and Rudy Gay—plus stars in music, fashion, and business. Her knowledge, and her influence, run deep.

MITCHELL JACKSON: What's your definition of style?

KHALILAH BEAVERS: You would think this is an easy question, but it's not such a typical answer, especially coming from a stylist who's been dressing people for so long. Anybody who can dress themselves and put a picture on Instagram feels like they have style, but being able to take pieces that don't typically go together that make people look at you and say, "Damn, I would've never thought of that" or "Those pieces don't work together, but they look great together," to me, that is what defines style more than just doing what you see people do, putting on monochromatic looks. That, to me, is fashion, but style is taking those pieces and creating something that is a bit more unique to you and feeling comfortable in it. If you don't feel comfortable in it, then it's going to show. It's all about owning your look and being really true to you. Of course you can be inspired by so many things, so many people, but then it's about how you turn that into something for you.

MITCHELL: It sounds like it also involves creativity. It's not just getting the right brands and putting them on.

KHALILAH: Yes. It's not just about going to Prada and Gucci and Balenciaga and putting the pieces together with some Louis Vuittons. Of course you can do that, and that's easy, but it's more about, how can you find vintage pieces, something from your local store, pieces that don't all go together, but work for that look you created. These days, a lot of things are cookie-cutter and it's easy to go to a store and pull a look. It could be a dope look, but it's a style created by someone else.

MITCHELL: On the subject, I know you've worked with a lot of NBA players, and specifically focusing on Melo [Carmelo Anthony], because of his involvement in changing the dress code, him and A.I. [Allen Iverson]. Could you tell me how you started working with him?

KHALILAH: In the beginning, I worked under Rachel Johnson, who at the time was styling LeBron. We were in Vegas, and I saw Melo and his manager, Bay Frazier. I'm from Baltimore, Melo is from Baltimore, Bay is from Baltimore, so I had known Bay for years. I was like, "What's up with Melo? He definitely needs a stylist." Bay introduced me to Melo. The very first look that I dressed him, I think it was 2008. It was the year he cut off his braids—that was one of the biggest things for me. It was like, "Bro, you need to cut your hair." He was like, "I'm never cutting my hair." The first time I went to his home, he was getting his hair cut. I was like, "Oh my God, you cut your hair." It was a change that started everything.

MITCHELL: If Rachel was styling LeBron, and Melo started working with you, did you get the sense that there was competition between the players?

KHALILAH: It kind of happened organically and at the same time. Their style was being recognized. Melo's definitely stood out. LeBron's was a bit more refined. Calyann [Barnett] was also working with us then, and she started dressing Dwyane [Wade]. And then the [2005 dress code] mandate happened and it was like, "OK, why can't everyone have their own individual style versus going to one person to get all of their suits made?"

MITCHELL: What's something invaluable you've learned over the years?

KHALILAH: As time goes on, your eye develops and matures, and you recognize that it's not just about the clothes, it's about the fit. And that comes with experience and trial and error.

MITCHELL: Other than finding the right fit, is there something in common that you see when working with NBA players?

KHALILAH: They have loyalty in common. They generally want to stick with the same stylist for the most part because you're in their personal space. You're around their family, their home—you're part of the team.

When it comes to dressing them, you have to pay attention to silhouette, body type, and the person. You can't use the same formula for everybody. When it comes to styles, I have not found the commonality. Oh, they do all have big feet—mostly size 13 and above.

MITCHELL: What kind of loot does it take to dress a top NBA player?

KHALILAH: You can go by the amount in their contract for some, but I have players who don't have the biggest contract, and they will spend money on clothes because they want to—it depends on the value you put on it. Also, a lot of players are gifted things and discounted them as well. They're very important and brands send different pieces so they can be seen in it.

But over the past couple of years, a lot of brands have taken back their discounts. I think, during the pandemic, the willingness of the people to just buy, it's less of a care to take the discount lately, and in those instances it's less of a care for me to purchase. It's like, why are we dropping twenty-five Gs on eight Dior pieces. For what? There's no point. They're going to come up with something else next season. My client got mad clothes in his closet, so let's start recycling. Let's start reselling, doing things that make more sense, that are sustainable.

MITCHELL: I resell to the RealReal, but I hadn't thought about NBA players recycling and reselling. How much is that a component of what you do?

KHALILAH: This summer Calyann and I started the NBA Closets, which is a resell situation at her store [The Shop Miami]. We have mad clients, and all of our clients have mad clothes. There's no point in just having these clothes sitting here.

MITCHELL: What do you think is the connection between hip-hop and fashion now? From the mid-nineties on, hip-hop was defining what NBA players wore, but has that shifted, whereas hip-hoppers are now paying attention to what NBA guys are doing? Or do you still think hip-hop sets the tone?

KHALILAH: I feel like it's one and the same. Think about it—back in the day, how many NBA guys wanted to be rappers? They wanted to be musicians, had their own studios. They hung out. They were very close to rappers, and then how many rappers wanted to play basketball?

I think it's the lifestyle that you never got to live that you look to pull from. It's NBA stars who wanted to be music stars and music stars who wanted to be NBA stars. Because they come from the same place. They just are on different paths, and what worked out, worked out. What didn't, didn't.

There are so many similarities. You want to look good, you want the latest thing. You've got to get your sneakers. You've got to get your jewelry. There's not a big difference when it comes to being a star. You're a music star, or you're an NBA star or an actor. The correlation is there because you came from the same place.

MITCHELL: We've got the Tunnel now, and everybody calls it the runway for NBA players, but I wonder how they're different. I know you've been to a lot of fashion shows, and also been in the Tunnel probably with a lot of players. What do you see as the notable differences between the Tunnel and an actual fashion runway?

KHALILAH: It's different because it's not one designer on all of the players. The comparison came because it became a thing to look for the guy before the game. I remember when it first started to pop off, we would be on TNT or ABC or wherever, the playoffs would come on, and they would show the guys walking in before the game. This is years ago, before Instagram.

MITCHELL: How would you describe this current era of NBA fashion?

KHALILAH: I feel like this is the most risk-taking era. While the younger generation is coming in, they are very concerned with being on LeagueFits, ProTrending, all of those things. If they're not on there, they think they're not popping. I think that people tend to go extreme so they can be seen. When you look back at style or fashion from the eighties and nineties and the NBA, it's nostalgic and inspirational. I feel like Melo is on everybody's mood board. At one time, he was ridiculed for the way that he looks, but everybody out here walking around looking like him with baggy pants and things on right now. History repeats itself. And there's pressure to keep going because they don't really have a choice.

Dress

Code

Before long, pregame arrivals rivaled postgame interviews for the interest of fans.

November 4, 2008—the night the long unfathomable became a sublime American reality. "Ladies and gentlemen, the next First Family of the United States of America," boomed an announcer, and out triumphed Barack Hussein Obama onto the T-shaped stage—bedecked in one of his custom blue Hartmarx suits, a red tie, and a tiny lapel pin of the American flag—with his beaming, pious family in tow. To the ecstatic applause of a crowd estimated at a quarter of a million, the country's forty-fourth elected president approached a podium and gazed out at the multitude. "If there is anyone out there who still doubts that America is a place where all things are possible, who still wonders if the dream of our founders is alive in our time, who still questions the power of our democracy," said Obama, "tonight is your answer."

Timewise, Obama's presidency may have begun during the fourth era of NBA fashion, but his reign very much demarks its fifth. During the Obama years, Black men—who in 2010 made up a hair shy of 77 percent of the NBA—felt buoyant with newfound possibilities, some even commanding Obama-esque deference in their own worlds.

Obama wasn't just a Black president, he was a cool (as far as the metric of past presidents went) Black man, not to mention a graduate of the Ivy League—twice. His ascension to the highest office in the land transformed him into a symbol, perhaps the greatest symbol in the history of America, of the potent intersection of Black empowerment, achievement, and uplift.

That prime triumvirate of attributes gave President Obama broad influence, significance that impacted the NBA too. As proof, I submit LeBron's televised free-agency announcement known as *The Decision*, the infamous special that aired on ESPN to an audience of ten million on July 8, 2010:

LeBron and sportscaster Jim Gray sat in director's chairs on a raised platform inside the Boys & Girls Club of Greenwich, Connecticut. Player and broadcaster surrounded by dozens of kids in Boys & Girls Club–branded T-shirts. (The special, in fact, raised more than $2 million for the organization.) LeBron dressed in clothes that must've been calculated to temper blowback: a purple-and-white gingham shirt opened at the neck with a peek of white T-shirt showing beneath it, along with liberal-fitting jeans and tan sneakers. (Notable that a guy who's no stranger to accessorizing wore not a lick of jewelry.) Anxious minutes into the special, Gray posed

the question everyone had tuned in to hear answered, the most pressing question of that NBA off-season.

"The answer to the question everybody wants to know, LeBron, what's your decision?"

"In this fall," said LeBron, with a nervous smile, "I'm gon' take my talents to South Beach and join the Miami Heat."

LeBron engineering his way to Miami to form a juggernaut with D-Wade and Chris Bosh was a watershed for the league. For one thing, it birthed the age of star players acting as de facto GMs who wheeled and dealed themselves onto a team of their choosing, a trend tantamount to the stars bolting from the ball clubs that drafted them to create superteams wherever they could.

The Decision was also a game changer because the squad that became known as the Heatles not only competed on the court, but soon also became tacit fashion rivals off it. As the most popular team in the league, they played beaucoup games on TV, which meant the style wars of LeBron, D-Wade, Bosh, and co. garnered their own ample airtime. Before long, pregame arrivals—the superstars, yes, but also the role players—rivaled postgame interviews for the interest of fans. Before long, a leagueful of competitive and rich young men found another means of vying against each other in what became known as the Tunnel.

In fact, the Tunnel walk comp got so intense that, akin to players hiring trainers to help improve their game, the upper echelons of stars went so far as to hire stylists. The emphasis on fashion spanned the league, but it was clear from the jump that a few style-minded stars would set themselves apart.

Beyond the Heat's big three, there was Russell Westbrook, then playing for the Oklahoma City Thunder, arriving at a game in a royal-blue knit polo, slim gray slacks hiked to mid-calf, and a pair of light-gray oxfords with royal-blue soles, his outfit adorned with dark aviators.

Self-proclaimed "Mr. Fashion" Amar'e Stoudemire at the 2013 Met Gala, on his Knicks' home turf, wearing a sheened purple Calvin Klein Collection suit, a black leather tie, and black leather Chucks.

Serge "Protector" Ibaka, also on OKC, arriving at a Balmain show during the 2015 Paris Fashion Week: up top, a white-and-black vest over a resplendent white shirt; down below, slim black jeans and suede gray Yeezy sneakers.

Chris "CP3" Paul, then an L.A. Clipper, on the cover of *GQ*'s 2012 Fall Style Playbook issue, styled in an Etro sport coat with a rugby shirt over a dress shirt and tie, washed and distressed blue jeans, and brown wing-tip oxfords.

Paul's styling in the issue was apt given that no NBA style exemplified the era more than the nerd-chic that peaked in 2012. Beyond Paul's cover, the 2012 NBA Finals were prime evidence. That year the Heat faced Westbrook, Kevin Durant, James "The Beard" Harden, and Ibaka's Thunder in a Finals that showcased the stars of both teams dressed for postgame interviews like the poindexter nephews of Obama.

Westbrook decked in a cartoon-print shirt and lensless Sally Jessy Raphael–style red specs. Durant after their fifth series loss answering questions in a blue V-neck sweater, white undershirt, and gray backpack. LeBron sitting for an interview with ESPN's Stuart Scott after the Heat's Game 2 win in a striped light-blue-and-royal-blue rugby over a powder-blue oxford, paired with slim white jeans and suede navy oxford kicks. D-Wade after Game 4 answering his postgame questions in a three-piece gray suit and light-gray oxford shirt open at the throat, his luxe look accessorized with a trio of lapel pins, a striped pocket square, and—drumroll please—flip-top glasses with the tinted lenses flipped.

Here were four of the NBA's biggest stars embracing the heretofore uncool style of nerds, an aesthetic that was almost the antithesis of what A.I. had made popular enough to prompt league-wide dress strictures.

And something else happened that season of 2012, something that sprung from the intersection of Obama's influence and the power of the players represented in the Decision. On March 23, 2012, LeBron tweeted a photo of the entire Heat team wearing hoodies in honor of slain teen Trayvon Martin. He captioned the photo with these hashtags: #WeAreTrayvonMartin #Hoodies #Stereotyped #WeWantJustice. Four years before Colin Kaepernick would kneel in the NFL, the gesture was a launching pad for NBA players to use fashion as a means of calling attention to issues of social justice, a phenomenon that one could argue was catalyzed by the very presence of a Black president in the White House.

In 2015, the NBA staked another claim as the most fashionable pro sports league by becoming the first to feature a fashion show. *NBA All-Star All-Style*, a fashion competition that took place during All-Star Weekend, was coproduced and cohosted by LeBron. The show included seven NBA players, each modeling three different looks for a panel of judges: TNT hosts Charles Barkley and Kenny Smith, WNBA star Elena Delle Donne, and designer John Elliott, along with a *GQ* magazine style editor. JR Smith—who flaunted a fur-lined green peacoat for his first round—won the competition that night, receiving a crystal-encrusted bow tie for his triumph.

As much as anything, the show was proof that the league had embraced the fashion ambitions of its players, a truth that left players free to flout what was left of the rules governing what they could wear—and how.

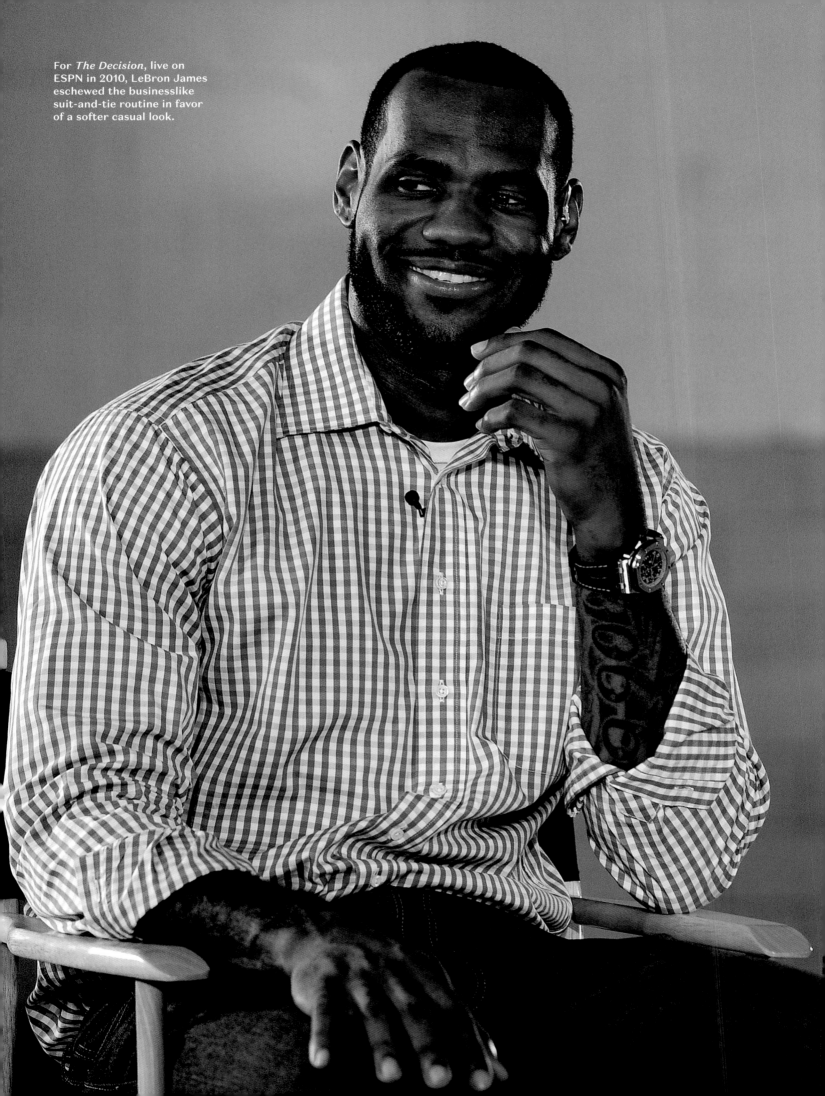

For *The Decision*, live on
ESPN in 2010, LeBron James
eschewed the businesslike
suit-and-tie routine in favor
of a softer casual look.

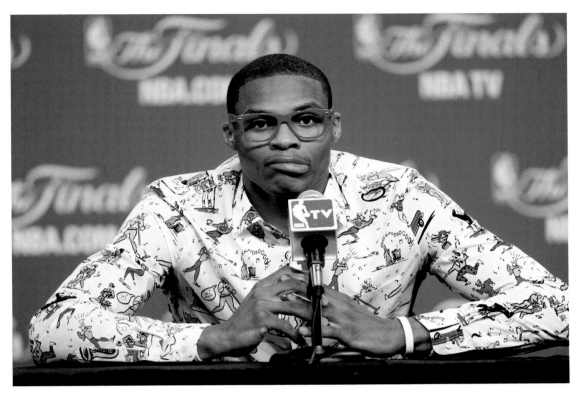

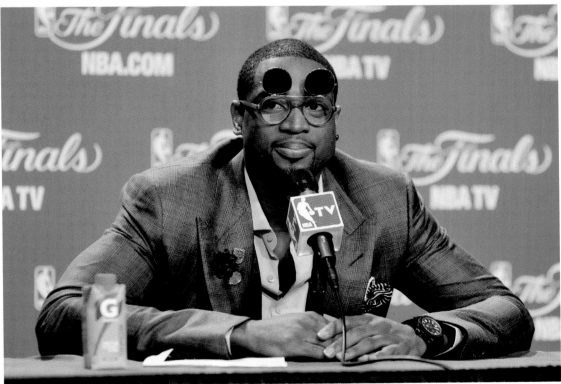

Eyewear is one accessory that allows for individual expression within a dress code, as Russell Westbrook (*top*) and Dwyane Wade (*bottom*) demonstrate during the 2012 NBA Finals.

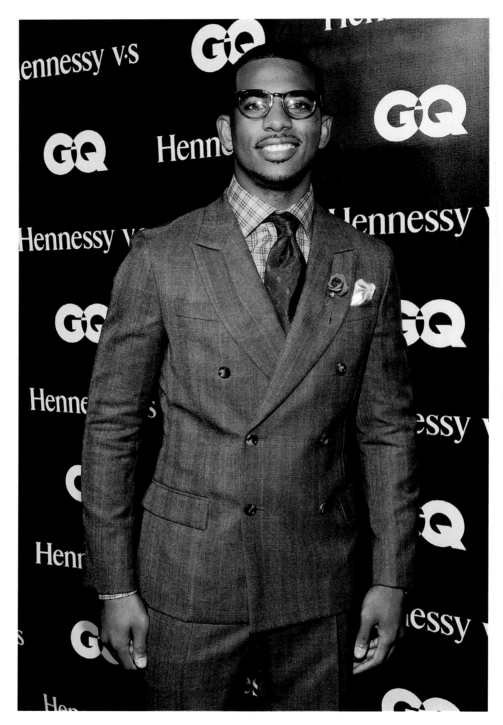

ABOVE Chris Paul at a *GQ* cover party in 2012. The outfit is darn near a tutorial in semiformal pattern-mixing, not to mention one in how to finish a look with just the right touches: a pocket square, a rose lapel pin.

OPPOSITE Amar'e Stoudemire at Paris Fashion Week 2016. His brooch and brim game on one million, plus the peep of an iced-out watch under his sleeve.

ABOVE Russell Westbrook gets an audience with the queen of fashion, *Vogue*'s Anna Wintour, front row at a Rag & Bone show in 2013. (Or maybe it was Wintour who lucked into an audience with Westbrook?)

OPPOSITE There may be nothing more eternally cool than all black, nothing more emphatically cool than a biker jacket and turtleneck sweater. Judging by Westbrook's smirk, the former MVP is well aware.

CHAD AVERY

The world of NBA fashion would look a whole lot different without Instagram, without the accounts dedicated to showcasing the players' off-the-court outfits and, to varying degrees, their lavish lifestyles. And Chad Avery's @NBAFashionFits reigns as not only one of the most popular handles, but a pioneering one.

MITCHELL JACKSON: How did you see the landscape of NBA fashion back in 2016, when you started the @NBAFashionFits account?

CHAD AVERY: At the time, I worked at the NBA, for their streaming service, where we would watch all the games that came through the feed. Then we would route the feeds whenever they had to go to commercials. We'd have to get there two hours before the game started and adjust all the camera feeds to go out to all the various partners. I noticed that they had the cameras set up so we could always see the players coming into the arenas, and I'd see what they were wearing. Especially with a lot of the younger players' outfits, there was nowhere else to find these images other than these feeds. It wasn't being posted by the NBA at all. They weren't really focused on that aspect of the players. They were mostly focused on highlights on the court. Anything off the court, they wanted the players to be in the best light possible, at charity events for example. But I liked the fashion stuff, so I created the Instagram page and tried to find pictures online, through Twitter, anywhere I could think to look. It wasn't as easy as it is today. I'd curate them and then just put them up.

MITCHELL: How has NBA style evolved since then? What kind of online presence did it have?

CHAD: The style of the players has definitely evolved since I started. But they do go with the trends. In 2016, everyone was rocking skinny jeans, the Amiri jeans, Chelsea boots. They started to switch to sneakers, and it's just streetwear now. The only person that is consistent with being inconsistent is Russell Westbrook because his outfits have always been all over the place. I don't think he's ever been put in a box.

MITCHELL: One player that I think has never gone with the trend, or maybe he is on a trend, but trends from decades ago, is Devin Booker.

CHAD: Yes. As you look back over Devin Booker, it has changed from back in the day. Now he's been doing it so long since he made that transition that his style is a staple. Devin Booker is a West Coast kind of vibe. But it has transitioned to that. When he first came into the league, it was a little bit different. But his style now is part of his identity. It's the Booker style and I love it 100 percent. It's great.

CHAD: Just starting the page up at first was one of the biggest growth pains. My idea initially was to build something, then pitch it to the NBA. First it was trying to find the footage. That was a job in itself. It was constantly going through pictures and then seeing what the players are tagged in. Growing a page from nothing was tough.

Once you get the stuff, you post it, but it takes time to build followers. You just have to keep going and pushing. I knew this was a good idea, so I stuck with it, even though it was tough. It has changed over the years because now I can find the photos within seconds of a player arriving.

MITCHELL: Are you still running the account? Do you have people working with you?

CHAD: I do not have anyone working with me. This is something I built from nothing. The stuff you see is the stuff I like. I find the photos every night and then put them up. I definitely need to scale it in some way, but it's trying to figure out the right ways to do that.

MITCHELL: Was there a moment where you felt like you caught hold?

CHAD: There was, in 2019. When I first started doing this, I would message players all the time asking them what they're wearing. None of them responded because they're probably getting a million DMs. One time DeMarcus Cousins hit me back and reshared the picture that I posted. He was the first person to respond to my DM and then share the post. That was pretty cool. At that point, I only had about four thousand followers. Slowly but surely, other players would do the same, and it started to grow.

MITCHELL: Who has been the most supportive of the players?

CHAD: Torrey Craig is great and always down to share my stuff. One of the first interviews that I ever did on the site was Jared Dudley. The last team he played for was the Lakers. Now he's one of the assistant coaches at the Mavericks.

MITCHELL: You used to post what players were wearing and how much the outfit cost, and then a budget version. How did your posting evolve from that?

CHAD: I used to do it, but that takes a lot of time to do right. Not only is it finding the photos, but I had to figure out exactly what they're wearing. It took too much time; that's why I veered away from doing it. I was like, "I don't even know if people are getting that much benefit out of it, or are they more interested in just seeing the outfits and then going out there and picking it up themselves, or are they trying to just duplicate it themselves." I just didn't have enough time. Again, one-man band, so it's tough.

MITCHELL: I'll see a T-shirt and try to find it myself and it can take a very long time to find one item. I can just imagine you doing several players and a lot of outfits. How do you see your relationship in this ecosystem now of stylists and jewelers? Is the relationship collaborative and symbiotic or is it competitive?

CHAD: I like to tag the stylist, but not necessarily the brands. I've always wanted to start my own fashion brand [Avery started his own brand Forever Fitted in 2016]. I thought I'd build a platform and be the news outlet for what everyone's wearing. Then I'd launch my own brand and post only if players wear my stuff. That's the ultimate goal. It depends on the brands, and if they reach out, but I don't necessarily want to.

MITCHELL: Do you feel competition with the other sites in your space, like @ProTrending or @LeagueFits?

CHAD: I don't think there's competition. We can just say we're different. I do things a certain way, as do they. It takes creativity to put things together the right way. Then you do it and they copy you. I know I should take it as a compliment, but they're also backed by billion-dollar corporations. It used to make me upset, but if that's what they have to do, then I'm not going to stop it.

MITCHELL: Yes, that's one thing I noticed—the way that you caption and even the theme stuff like date night, or you'll pick certain players who are all wearing vests. I do recognize the thoughtfulness that you are putting into it and also how hard it must be to go up against a corporation when, at this point, you're a one-man band. But also, when I look at your account, I now know that I'm getting the eye, the tastes of one person. Which brings me to another question. Do you think there's a difference between a person of style and a person that's fresh or fly?

CHAD: I think there's a difference. I think everyone has a style. What determines if it's fresh or fly is how the person puts it all together. I could wear the same stuff as Devin Booker, but no one would think, *That's so fly.* Style is unique to each person. You could be wearing the most expensive outfit in the world and still not look fresh or fly.

MITCHELL: Seems like you're interested in people getting fresh or fly in your designs. Why did you name your brand Forever Fitted?

CHAD: I've always cared about the way that I look and dress. I'm not going to put anything out there that I wouldn't wear myself. Ultimately, I created the brand with the goal of players wearing it and for people to think it's cool. I want the clothes to be comfortable, and for them to just fit right.

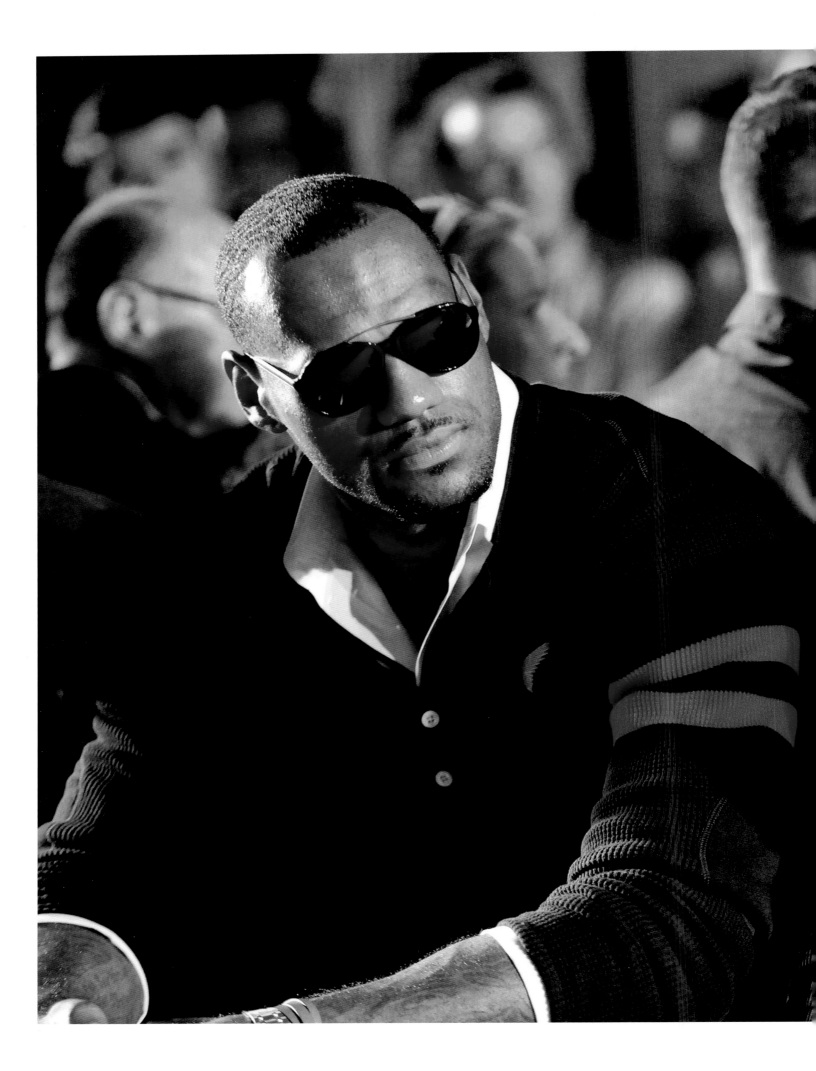

GQ

*Special Issue

WE SHOW YOU HOW TO LOOK SHARP AT THE OFFICE, AFTER HOURS & THROUGH THE WEEKEND

＋

MITT VS. BARACK: THE BLOOD MATCH

THE 18 MOST BONEHEADED DECISIONS IN SPORTS HISTORY

THE BEST BEER GARDENS, BREWERIES & BROUHAHAS IN AMERICA

OCTOBER 2012 $4.99US $5.99FOR 10

Our Big Fall

Style Play-Book

A Step-By-Step Guide To The Best Clothes, Tips & Gear Of The Season

STARRING
Javier Bardem
Denzel Washington
AND THIS GUY,
Chris Paul

ABOVE Chris Paul bedecked in ultra-preppiness for the cover of *GQ*'s Style Playbook in 2012.

OPPOSITE LeBron "King" James at Mercedes-Benz Fashion Week in 2011. Few things confirm a belief in one's star power more than dark shades worn inside.

ABOVE Rudy Gay, of the Memphis Grizzlies in 2012, an underrated fashionisto.

OPPOSITE Nick Young (who, for good reason, called himself "Swaggy P") of the Los Angeles Lakers, during a *Sports Illustrated* shoot at his home in Tarzana, Los Angeles, 2014.

ABOVE James Harden, an NBA and tunnel all-star who's no stranger to color or bold prints, 2015.

OPPOSITE Tyson Chandler attends an Alexander Wang fashion show in New York, 2012. Chandler's fashion sense was in the top tier of NBA big men.

ABOVE Chris Bosh of the Miami Heat during the 2013 NBA Finals, the all-star sporting tone-on-tone excellence in plaid slacks and low-profile sneakers.

OPPOSITE Miami Heat star Dwyane Wade attends an opening event for New York Fashion Week 2016 in a tried-and-true fashion look: a sport coat and denim. He made the outfit his, though, with the paisley print of his sport coat, the granddad-collar shirt, and the fedora.

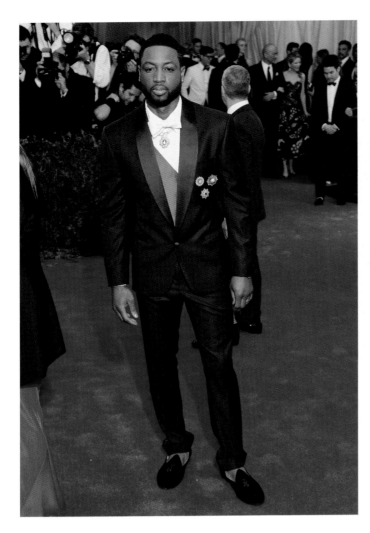

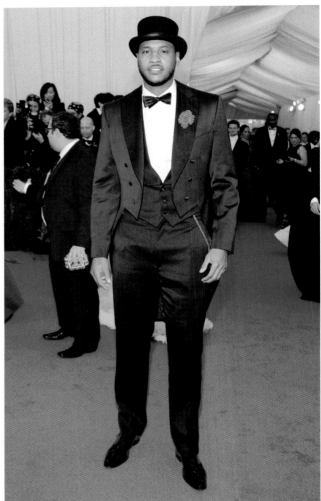

ABOVE, LEFT D-Wade arrives looking regal at the 2015 Met Gala. An annual fundraiser for the Metropolitan Museum of Art's Costume Institute, it's the fashion event of the year, every year, and NBA stars have increasingly been a presence.

ABOVE, RIGHT Carmelo Anthony at the 2014 Met Gala.

OPPOSITE Amar'e Stoudemire with Alexis Welch at the 2013 Met Gala.

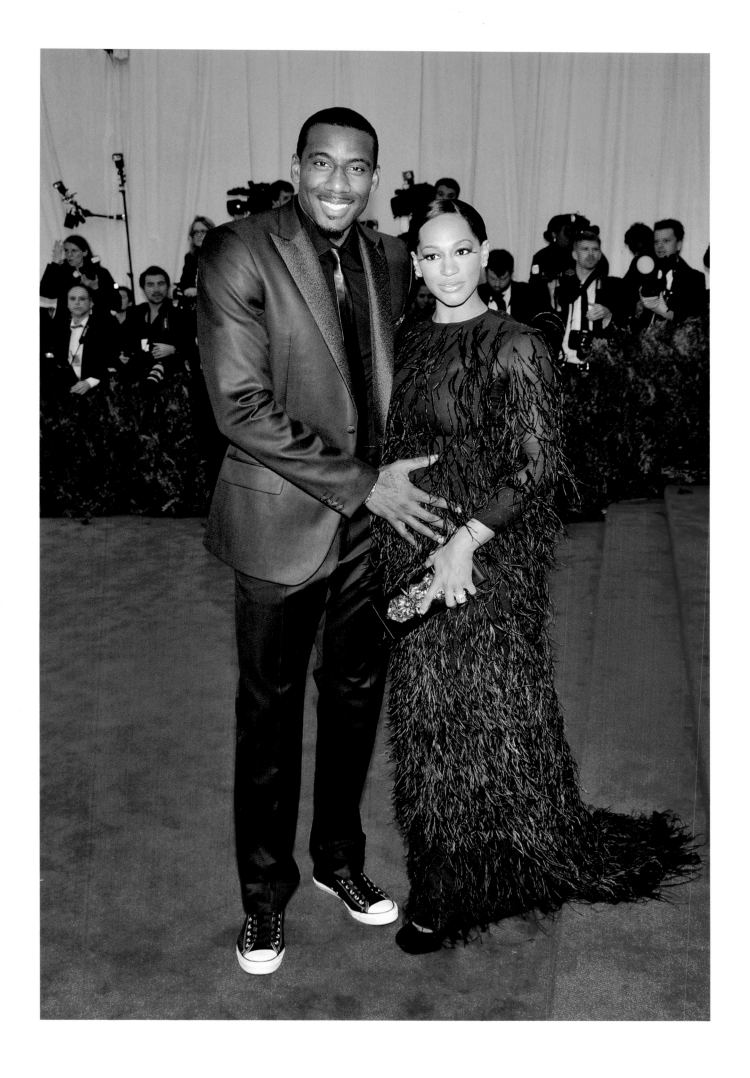

Fashion as protest: On December 8, 2014, LeBron James wears a T-shirt emblazoned with the last words of Eric Garner, who died at the hands of police officers.

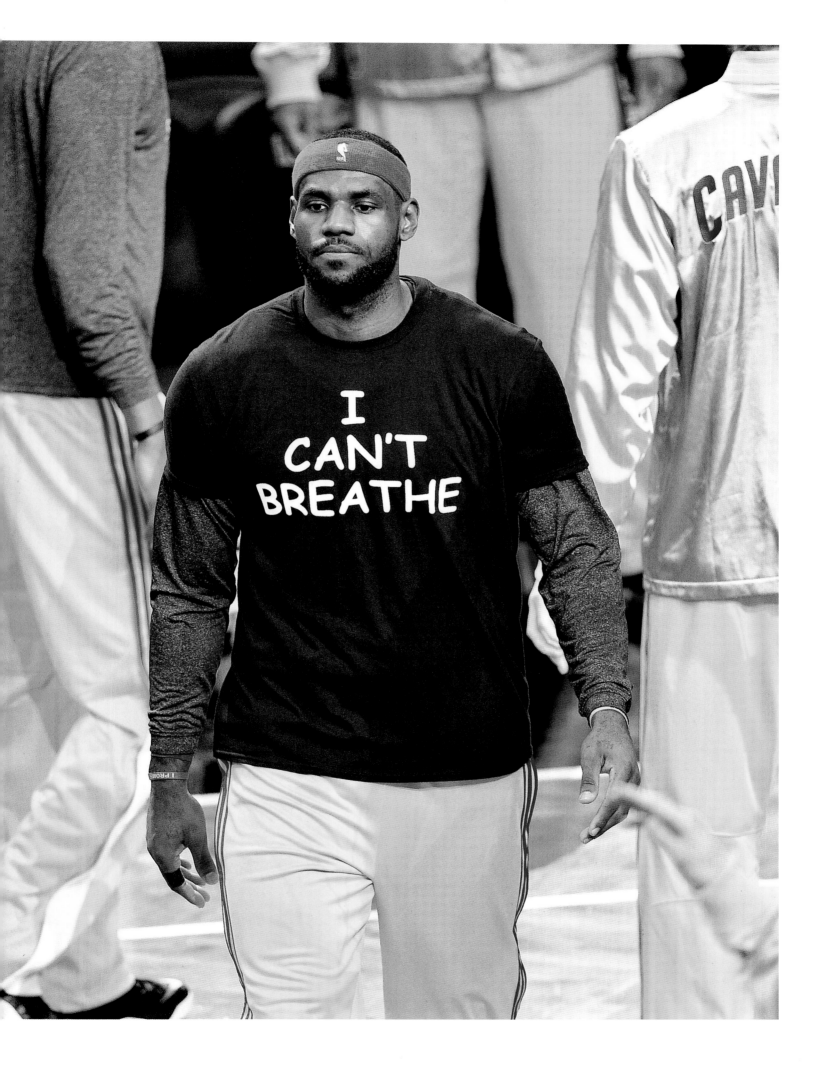

ABOVE Chris Paul, in 2014: all knit, no problem.

OPPOSITE Milwaukee Buck and defensive wizard Serge Ibaka letting the people know he's no slouch in the lifestyle sneaker department with his gray Yeezy Boost 750 in 2015.

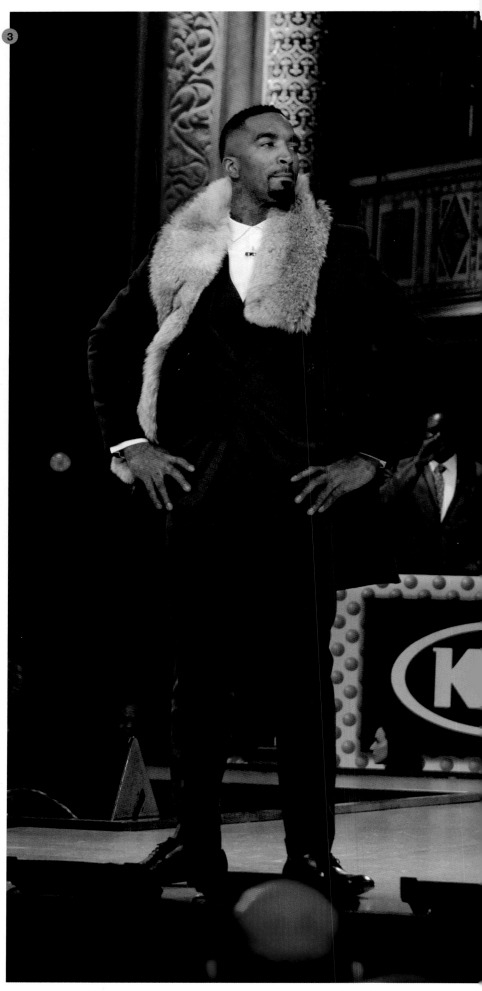

In 2015, the NBA held its first fashion show, the *NBA All-Star All-Style*, during All-Star Weekend in New York: 1. Jeff Teague walks the runway; 2. JR Smith, the winner, holds his trophy (because of course this fashion show has a winner); 3. Smith struts; 4. (*from left*) Charles Barkley, LeBron James, TV personality Carrie Keagan, and Shaquille O'Neal prepare to announce the winner; 5. James Harden.

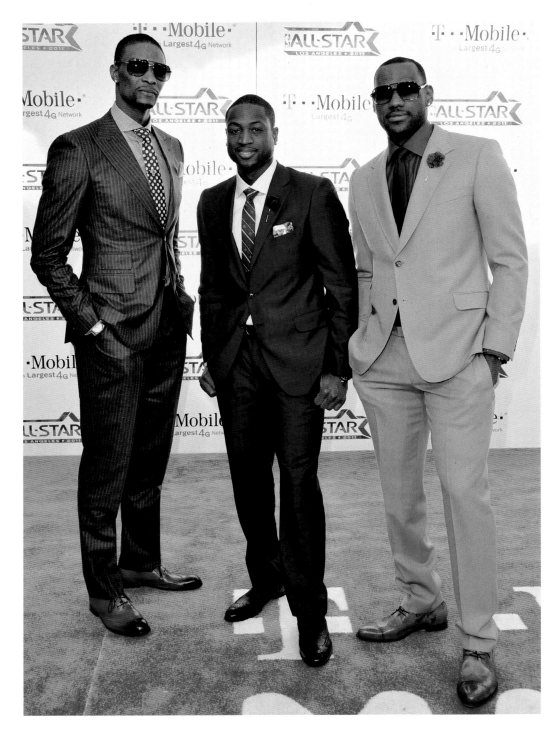

ABOVE (*from left*) Chris Bosh, Dwyane Wade, and LeBron James arrive at the 2011 NBA All-Star Game in Los Angeles. The Miami Heat's Big Three posed as the epitome of suited-and-booted.

OPPOSITE Kevin Durant, 2015, for *GQ*. Check the details: the mélange of the shirt, the ribbing around the knee of the jeans, the shine of his oxfords.

The Insta-
Tunne

l Walk

The founding and rise of Instagram defines the current era of NBA fashion.

A technological lifetime ago, a Stanford University graduate named Kevin Systrom worked at a travel-recommendation firm by day and designed a mobile app by night. It was 2009. Systrom's efforts manifested into an app called Burbn, its name inspired by his love for whiskeys and bourbons. In the spring of the following year, Systrom met a few venture capitalists and raised a cool half million in seed funding for his app. Grubstaked, he hired another Stanford grad named Mike Krieger. In short order, the duo decided it was wise to focus on a single aspect of the app: photo sharing. They spent a scant eight weeks fine-tuning and, on October 6, 2010, launched Instagram (the name an amalgam of instant cameras and the telegram). Twenty-five thousand people downloaded Instagram on its first day in the App Store. By the end of the first week, the platform boasted one hundred thousand users. In 2012, Facebook bought the company for a billion dollars, and the app kept right on enjoying exponential growth, reaching the milestone of one billion users in 2018. As insiders tell it—its parent company, Facebook-turned-Meta, no longer releases its numbers to the public—the number of people who use Instagram now exceeds two billion.

And as much as any cultural or political or social event, as much as any movement or phenomenon, the founding and rise of Instagram defines the current era of NBA fashion.

The app's early tagline was, "Capture and share the world's moments."

Pictures. Pictures. Pictures. No matter how many words you figure them worth, the incontrovertible truth is that a moment captured as photograph transcends the barriers of written and spoken language. In the pre-Tunnel days of yore, if a fan saw an NBA player out of their uniform, it was most often a big star, and, more often than not, a picture captured by a professional photog. But the tunnel became the Tunnel because media outlets began focusing on what the players wore.

And while the media's focus was still (for the most part) the stars, Instagram succeeded in democratizing the ability to reach a wide audience. With Instagram, role players—the journeyman forward, the seventh man, etc.—and even guys who have little to no impact on a game can shine, can transform themselves into bona fide stars of a different kind: those select few who command the interest of high-end labels, who garner invites to fashion and awards shows, to exclusive parties in the Hamptons, L.A., Paris.

179

With Instagram, the power has shifted from media outlets to individuals. The platform has given players the chance to create and modulate their images on their terms to an audience that, for a rare few, now rivals or even exceeds the crowds that view their basketball games. In this era, the most fulgent stars of NBA fashion eclipse (or at least challenge) musicians, rappers, and actors for the attention of the legions enamored by fashion. With Instagram, the outfit of any NBA player has a chance to go viral—inspiring copycats the world over, an effect once had only by movie stars, models, and the occasional cultural figure.

Men once took off their hats because JFK took off his. Wore khakis because Paul Newman did. Wore leather like Eddie Murphy. Nowadays? They rock Thom Browne because LeBron does.

That last example calls back to maybe the most viral fashion moment of this era, which occurred during the 2018 NBA Finals between LeBron's Cleveland Cavaliers and Steph "Chef" Curry's Golden State Warriors. For Game 2, LeBron outfitted his whole team in Thom Browne suits, and James himself strutted the Tunnel in one of the brand's gray suits (he customized his slacks into shorts) with a gray pair of its signature striped socks, a skinny gray tie, and combat boots. He also carried a custom alligator version of the brand's Mr. Thom bag. The rest of his Cavs teammates wore versions of the same outfit. And while they'd been wearing Thom Browne for away playoff games, the glare of the Finals, with almost eighteen million viewers per game, ramped up the attention on their coordination to viral.

A more recent viral bolt struck during the 2020 NBA pandemic bubble. Chris Paul, then a member of the Oklahoma City Thunder, wearing HBCU-themed outfits: A denim jacket and matching shorts with a blue-and-white Savannah State University T-shirt and a mask printed with the fist emblem of Black Lives Matter. Strolling to another game with a Howard University letterman jacket and shorts and a mask printed with "HBCU." Peacocking the halls of the bubble in a white graphic T-shirt repping Livingstone College, slim black sweats, and white-and-Carolina-blue Air Jordan 4s.

And how did many of us see all of this themed bubble fashion? On CP3's Instagram feed!

These days, not only does every fashionable hooper worth his designer toiletry bag (a common Tunnel accessory) have an Instagram account, but also a whole damn cottage industry of gawker accounts exists. That includes several popular ones focused on the players' fashion choices: @LeagueFits, which was founded by *SLAM* magazine employees three months before the Cavs' Browne fits; @NBAFashionFits, started by Chad Avery, back when he worked for the NBA; and @MoreThanStats and @ProTrending.

The market also includes, no surprise, podcasts. @LeagueFits has one called *Survival of the Fitted*; plus, there's *Running the Break with C.J. and Alex* and *The Complex Sports Podcast*, both of which feature voluminous cloth talk.

Even the venerable *Sports Illustrated* has gotten in on the style action, launching its Fashionable 50 in 2016. The list features athletes from all pro sports in the U.S. and abroad, but there's little doubt that without the NBA leading the way, the list wouldn't exist at all. The top ten of the 2020 list featured four NBA players and one WNBA player.

While the previous era of NBA fashion realized the wonder of players posing in the front rows of major fashion shows, the sixth era is marked by players collaborating with labels for capsule collections, designing accessories including hats and sunglasses—and, in the case of Russell Westbrook's Honor the Gift, launching their very own clothing brands. In fact, the NBA is so conscious of its happy intersection with fashion that it partnered with the late designer Virgil Abloh and Louis Vuitton to release athletic-inspired apparel and leather accessories. And that included a bespoke LV trophy case for the Larry O'Brien Trophy (presented to the 2020 NBA Champion Los Angeles Lakers). That Lakers championship team was led by LeBron, a player who remains not only one of the league's brightest stars on the court—and, kudos, kudos, its all-time leading scorer—but one of its fashion supernovas off it.

And yet there's a new era of NBA fashion stars, all of them Tunnel favorites, all of them flaunting their fashion triumphs on Instagram.

Shai Gilgeous-Alexander of the Oklahoma City Thunder (who was voted *GQ*'s most stylish man of the year 2022): wearing a cream-and-black Christian Dior Cactus Jack sleeveless sweater, black Rick Owens drawstring pants studded down the side, and a pair of cream sneakers, his look accented with several pearl necklaces.

Jalen Green of the Houston Rockets: posed near artwork in an oversize black-and-white GCDS sweater, baggy multipocketed cargo jeans, and high-soled silver boots.

Jordan Clarkson of the Utah Jazz: in a vintage brown sport coat and baggy washed blue denim jeans, a yellow gold Jesus piece lying over the white T-shirt beneath his sport coat, dark flat-top glasses completing the look.

Kyle Kuzma of the Washington Wizards: at Paris Fashion Week dressed in an orange-and-green Casablanca Tennis Club silk shirt and green wide-legged pants, the outfit finished with a white tank top, white big-soled boots, and a white bucket hat.

Kelly Oubre Jr. of the Charlotte Hornets: outside a mansion in pink-printed jeans, a graffitied white leather coat, pink sneakers, and mirror-tinted shades, a bevy of chains around his neck.

D'Angelo Russell of the Minnesota Timberwolves: the winner of *GQ*'s 2019 Style Showdown outside the Giorgio Armani spring 2023 men's fashion show in Milan, decked out in a black Armani suit with a black T-shirt, polished black oxfords, and gold aviators.

The NBA is eras and eras away from the incipient days of fashion as nonfactor beyond the ordinary, war-rationed dress codes of the day. It is eras and eras away from the tacit charge of respectability that governed what players wore all the way through the Civil Rights Movement.

The league is eras and eras away from the decade during which a minor few flaunted their fashion sense, from the era predominated by Jordan, years in which the fashion spotlight shone, if at all, on the superstars alone. The NBA is a great philosophical distance away from the era of opposing the Iverson-esque influence of hip-hop. The current NBA is even evolved from the era in which it relaxed its rules in favor of embracing the fashion sense of its players.

Look hard enough at what exists now and see its seeds. The 1960s counterculture and social concern, the freedom of the 1970s, the excess born in the 1980s and heightened in the 1990s. The immense impact of hip-hop, a culture now interwoven with high fashion. The player empowerment imbued by LeBron's Decision. An embrace of the look-at-me-like-me era of the 2010s.

The future of NBA fashion? No one knows for sure. But bet this: It's ever evolving and ever evolving and bright as an arena with all its lights cranked up.

2018 NBA Finals, Game 2: LeBron James sports a Thom Browne suit—as did just about the whole Cavaliers team.

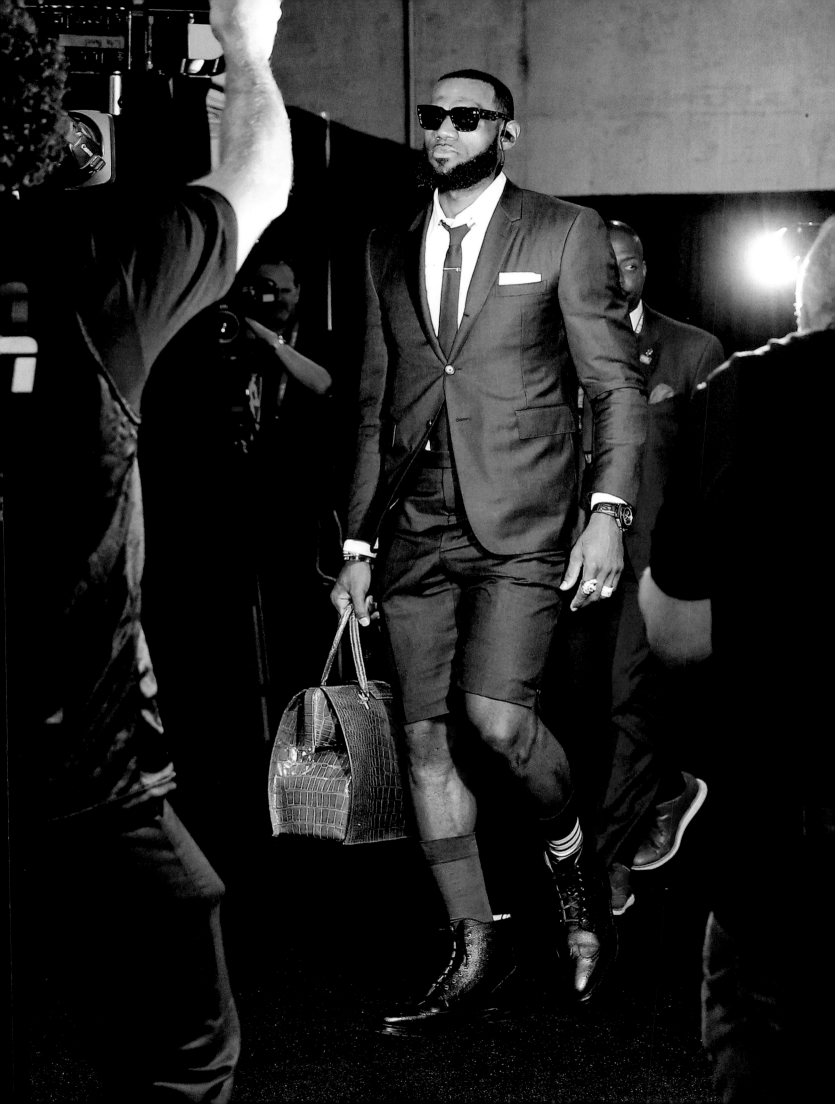

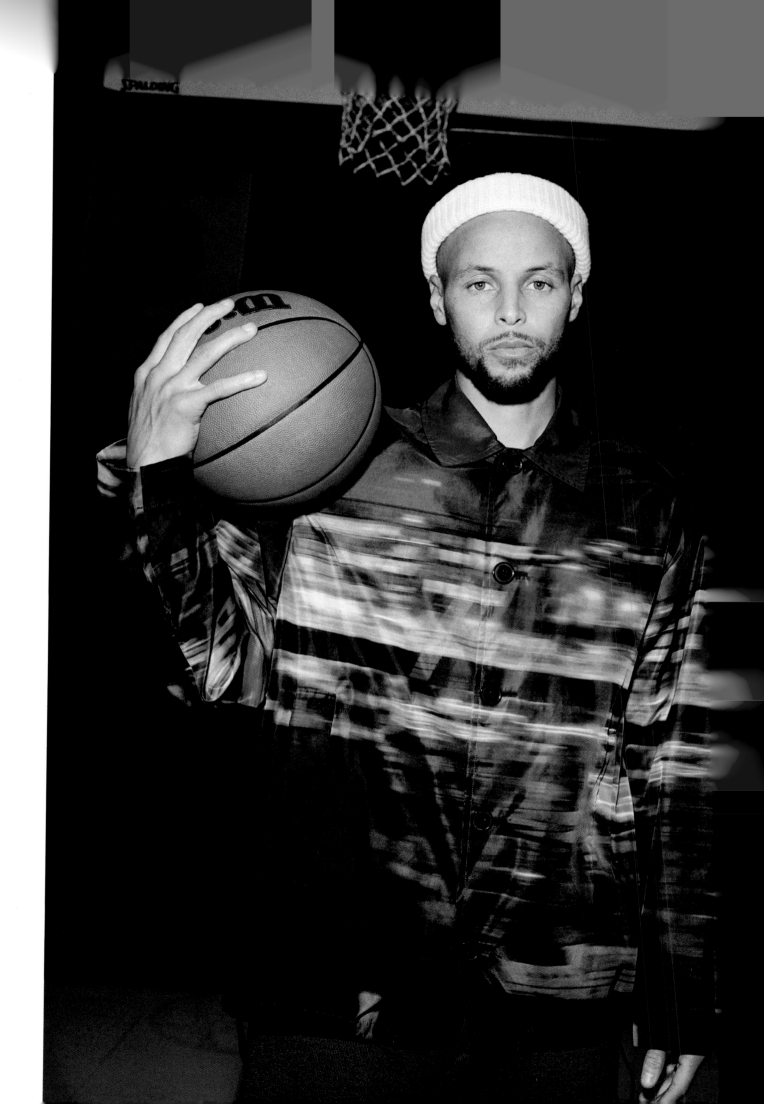

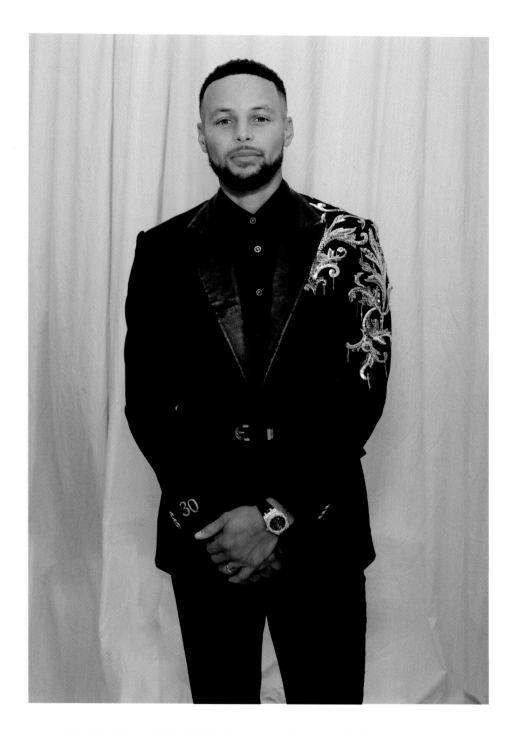

ABOVE Stephen Curry of the Golden State Warriors attends the 2021 Met Gala in New York wearing a bespoke Versace suit replete with his jersey number (30) embroidered on a sleeve.

OPPOSITE Stephen Curry poses for a 2022 photo shoot with *GQ*. The all-time great dipped in a Dries Van Noten jacket that echoes the Warriors' team colors.

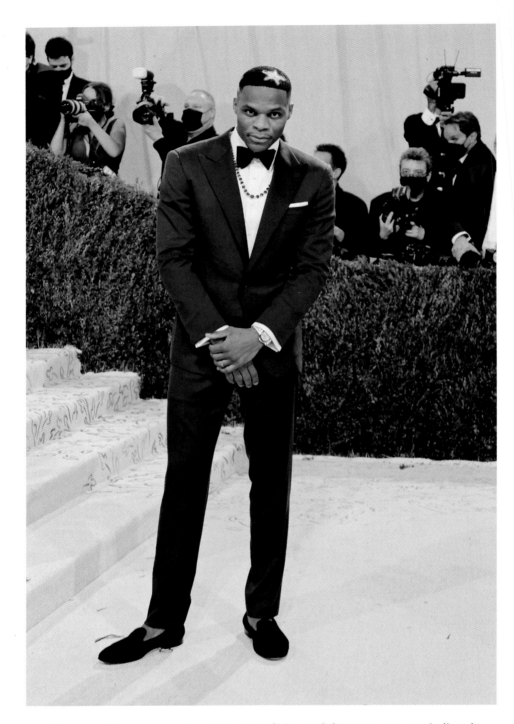

ABOVE Russell Westbrook at the 2021 Met Gala in a Ralph Lauren tux, reminding the world, in a gesture that matches his on-the-court ferocity, that he's a huge star.

OPPOSITE Dwyane Wade at the 2022 Met Gala, memorably shirtless in a Versace suit.

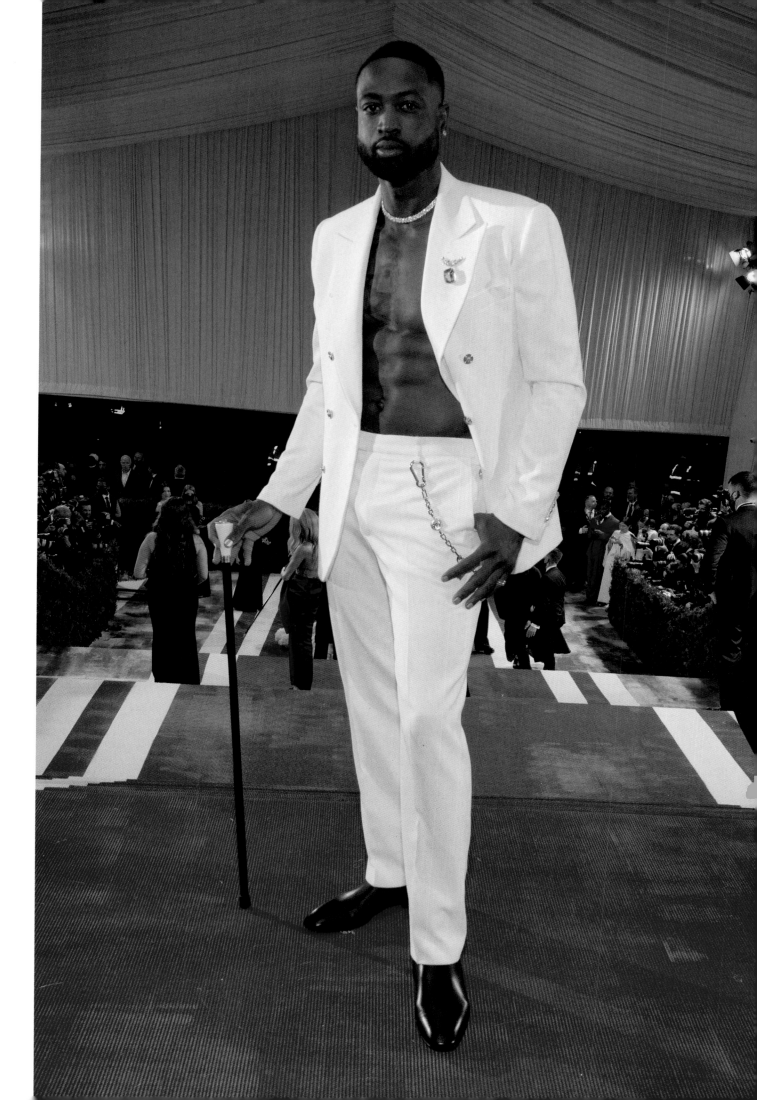

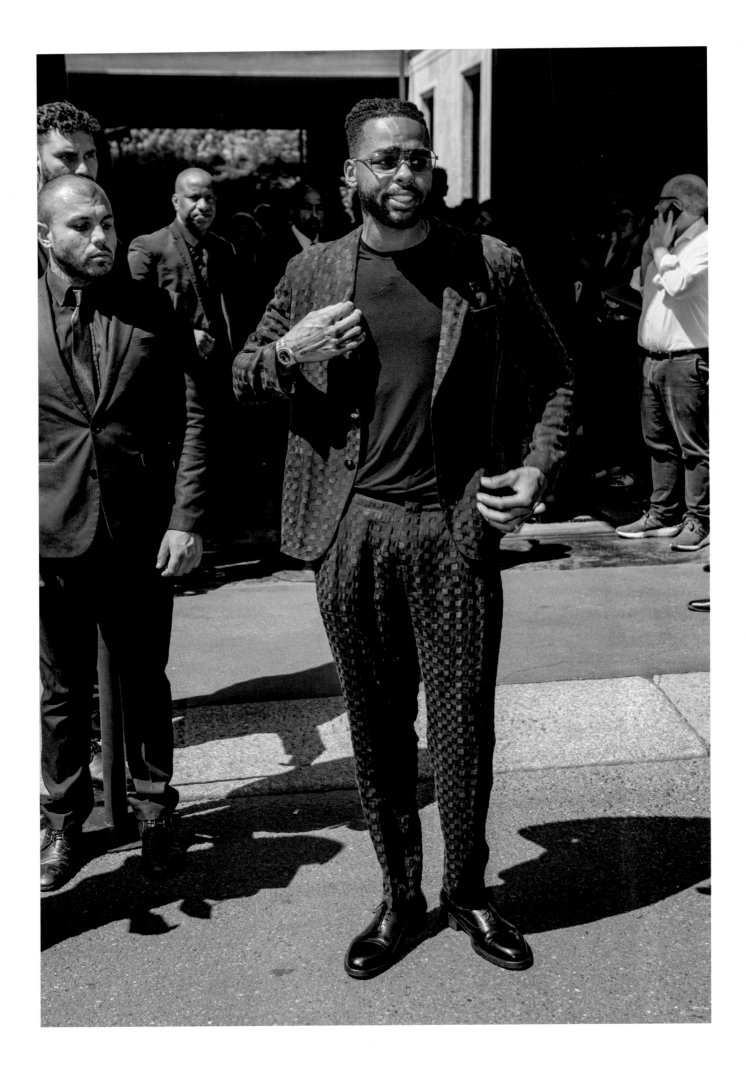

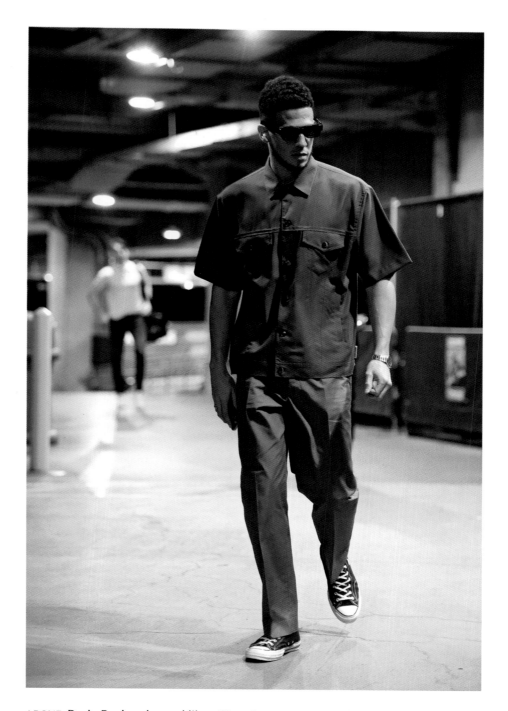

ABOVE Devin Booker dressed like a West Coast representative in creased slacks, Chuck Taylors, and an updated version of Locs shades in 2021.

OPPOSITE Minnesota star D'Angelo Russell at an Armani show in Milan, 2022. The texture on that suit is straight sophisticated.

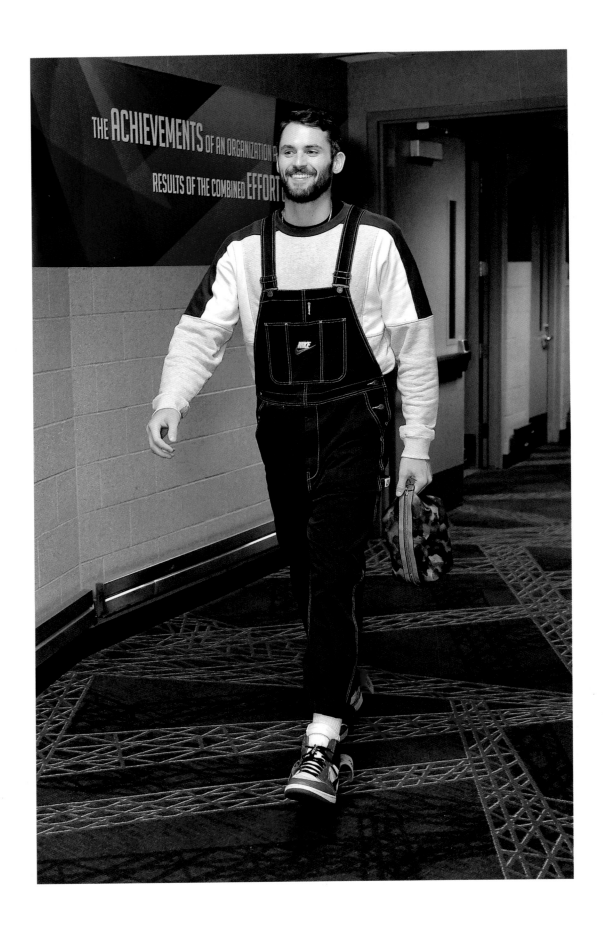

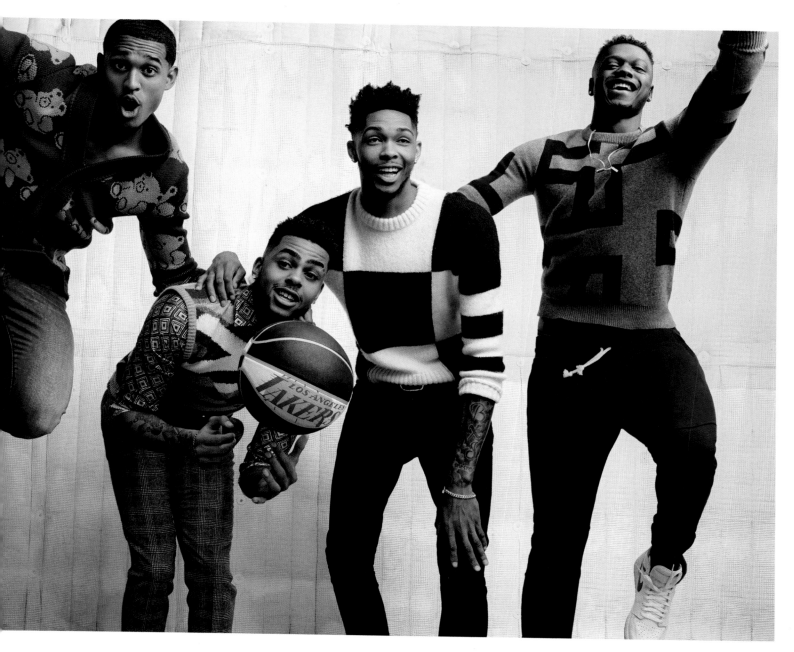

ABOVE (*from left*) Jordan Clarkson, D'Angelo Russell, Brandon Ingram, and Julius Randle, photographed for *GQ* in 2016. Three future NBA all-stars, one Sixth Man of the Year winner, and all on the way to refining their style.

OPPOSITE Kevin Love (see also: *overalls, Phil Jackson wearing*, pages 47, 60) turning a workwear staple into a sporty tunnel look in 2019.

LEFT Jordan Clarkson at a party hosted by Bloomingdale's and *Harper's Bazaar* in 2022. The Utah Jazz star in Thom Browne from head to toe: the bold tweed skirt-suit combo, the signature three-stripe socks, the brogues.

OPPOSITE Shai Gilgeous-Alexander of the Oklahoma City Thunder at a Tom Ford fashion show during New York Fashion Week 2022. The winner of *GQ*'s Most Stylish Man of the Year (2022), styled in Ford's subtle luxuriousness. However, there's nothing understated about those shades or his double-layered pearl necklace.

ABOVE Ja Morant on a night off from playing in 2022. Ain't nothing subtle about Ja's game nor his fashion sense, as evidenced by his Louis Vuitton logo jacket, collection of iced-out chains, and multicolored braids.

OPPOSITE Kelly Oubre Jr. executing a high-level streetwear look during Paris Fashion Week 2020.

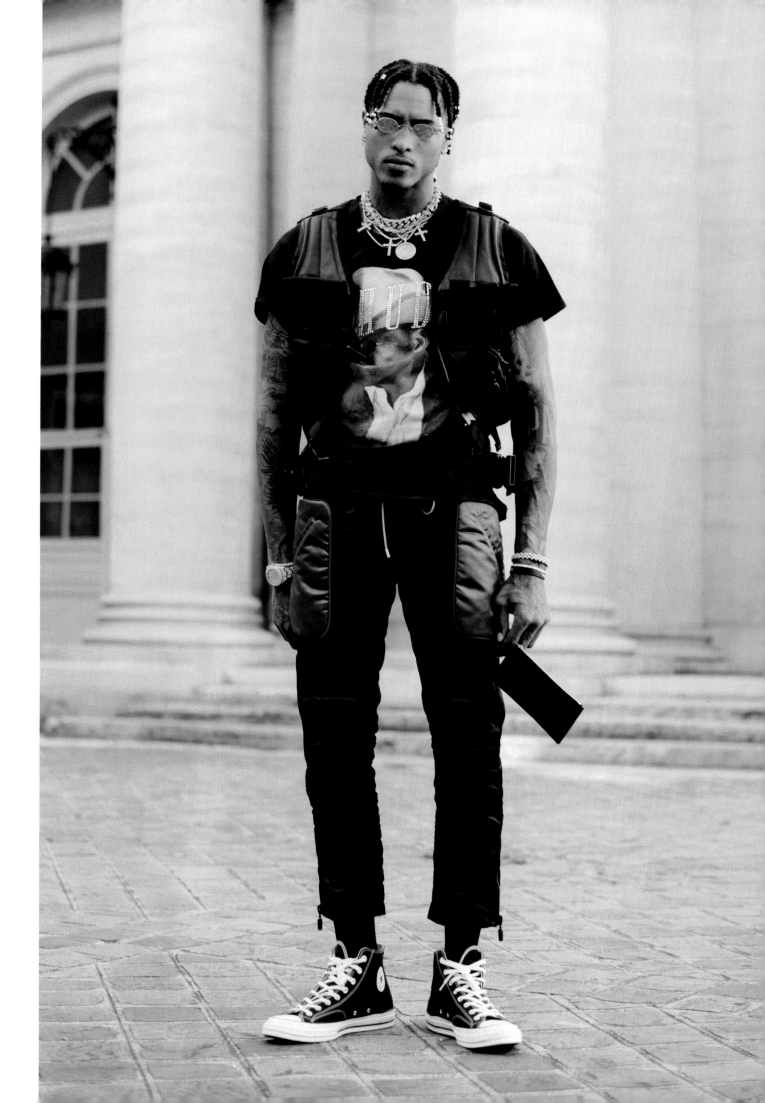

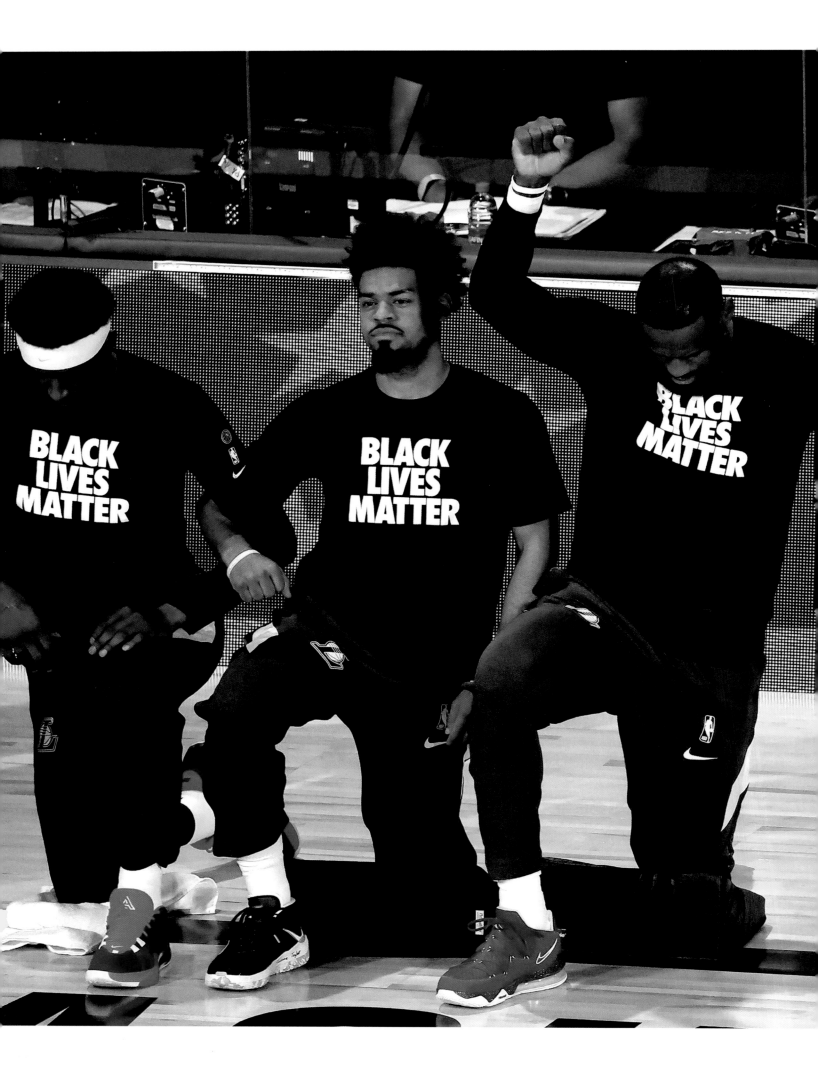

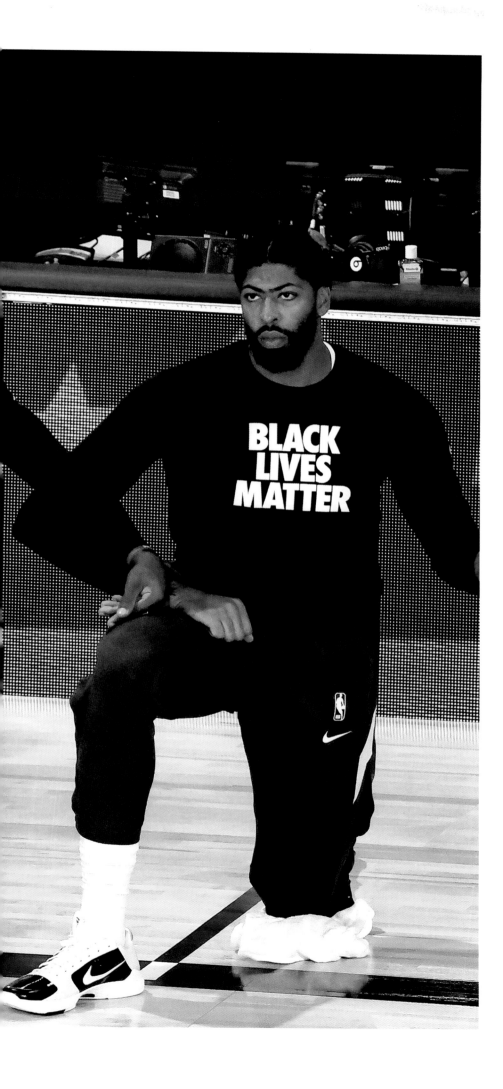

In August 2020, (*from left*) Quinn Cook, LeBron James, Anthony Davis, and Lakers teammates kneel during the national anthem of a game in the NBA bubble—a cultural, political, and historic moment all in one.

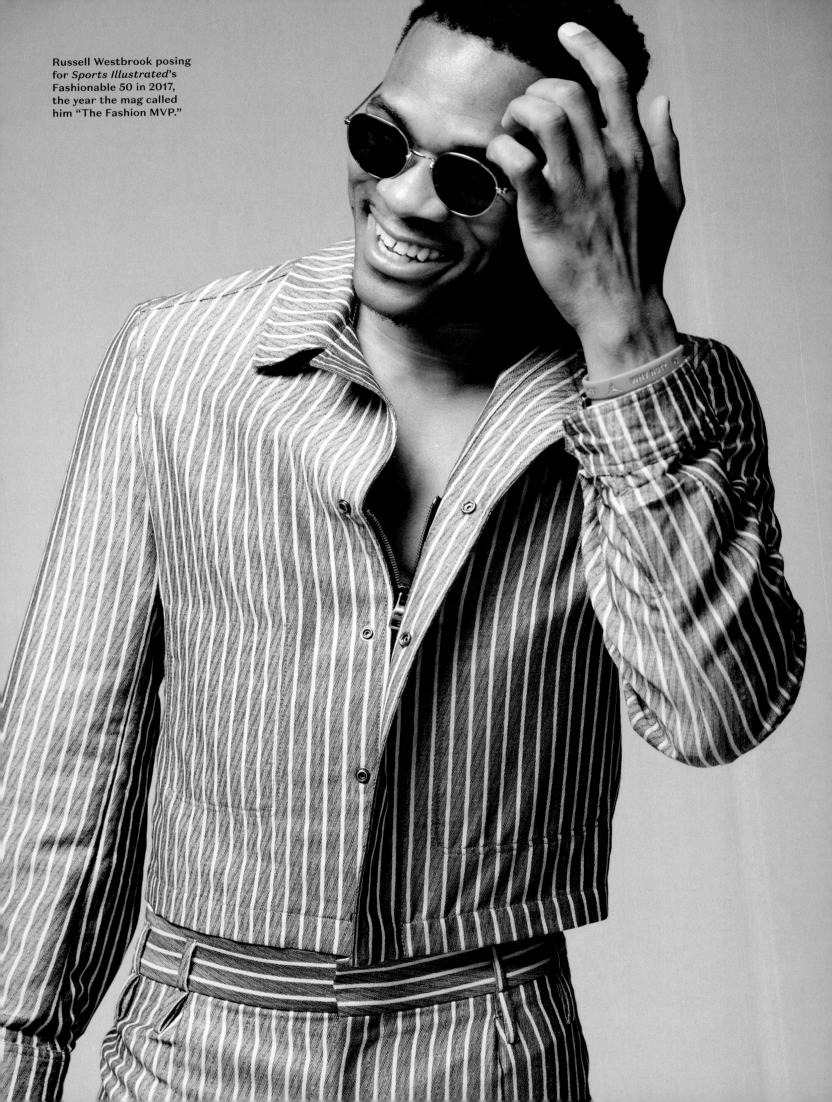

Russell Westbrook posing for *Sports Illustrated*'s Fashionable 50 in 2017, the year the mag called him "The Fashion MVP."

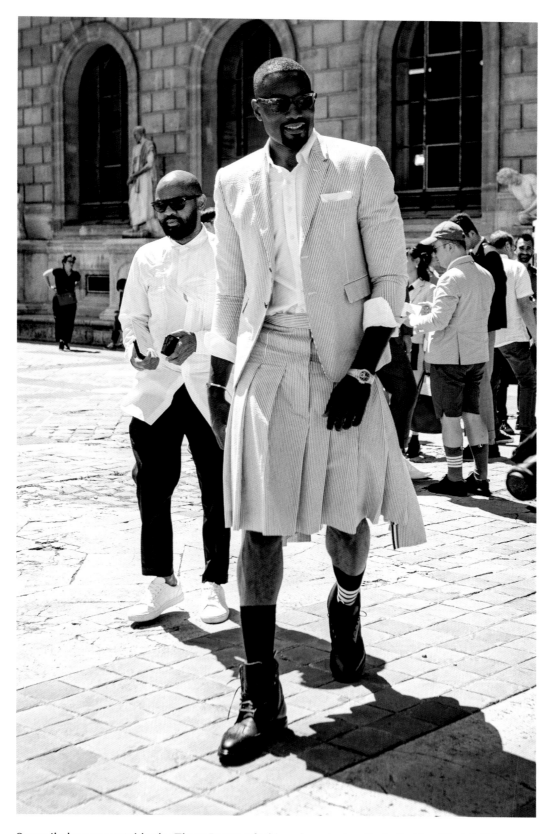

Serge Ibaka seen outside the Thom Browne fashion show during Paris Fashion Week 2020. The French speaker hashtags many of his Instagram photos with #avecclasse (with class).

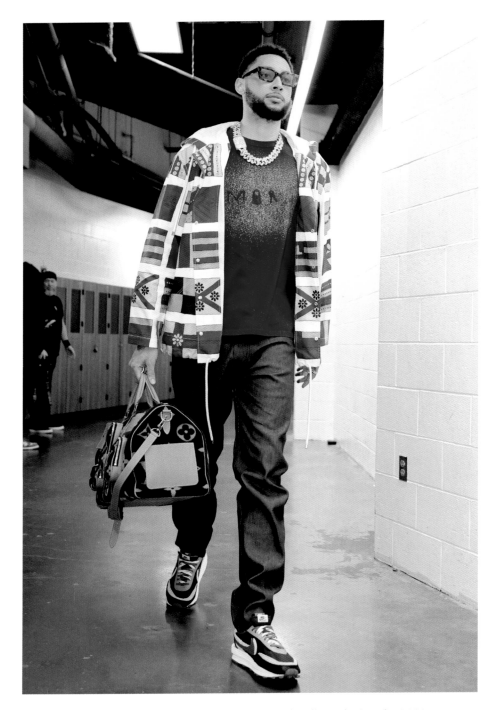

ABOVE Brooklyn Net Ben Simmons gets his tunnel walk on during the 2022
Playoffs in one of the hottest sneakers in recent years: the Nike x Sacai LDWaffle.

OPPOSITE Portland Trail Blazer Jerami Grant tunnels into the Mavericks'
American Airlines Center for a game in 2022 wearing one of the most fashion-
forward shoe styles of the day: the Tabi by Maison Margiela.

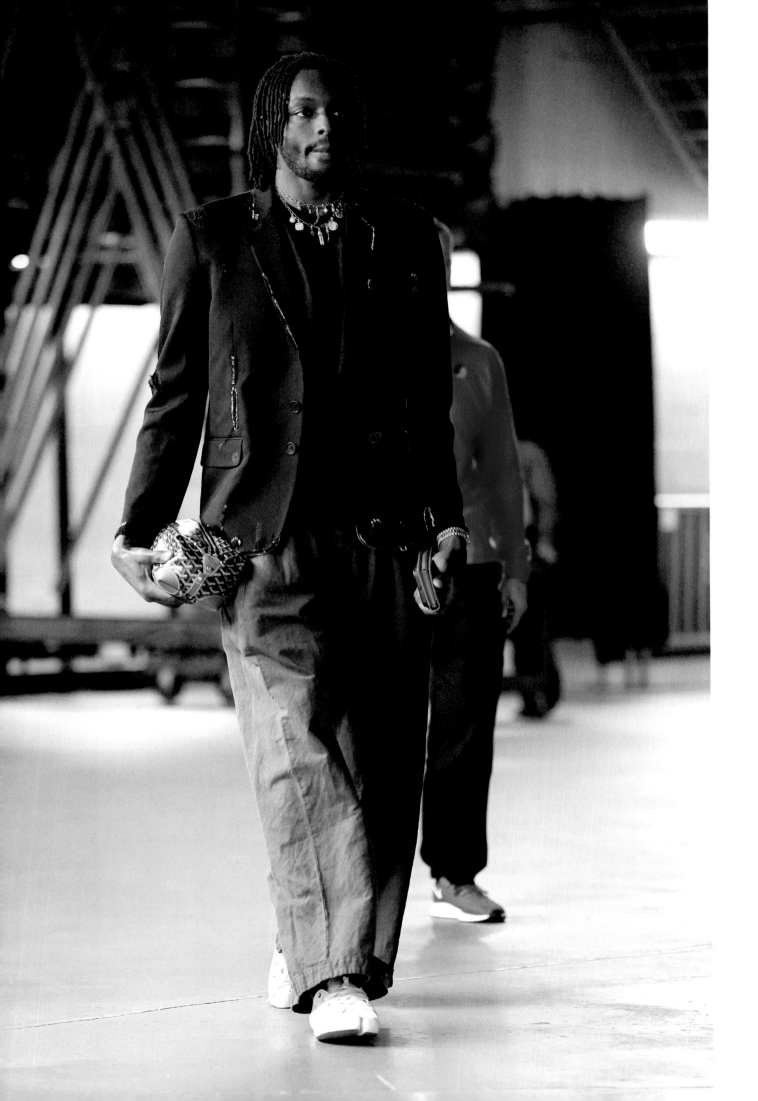

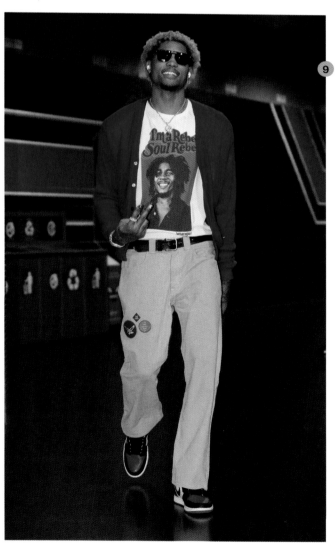

Players strutting the Tunnel:
1. Terry Rozier; 2. Devin Booker;
3. Shai Gilgeous-Alexander;
4. Tyler Herro; 5. Scottie Barnes;
6. Myles Turner; 7. Jaren Jackson Jr.;
8. Frank Jackson; 9. Kelly Oubre Jr.

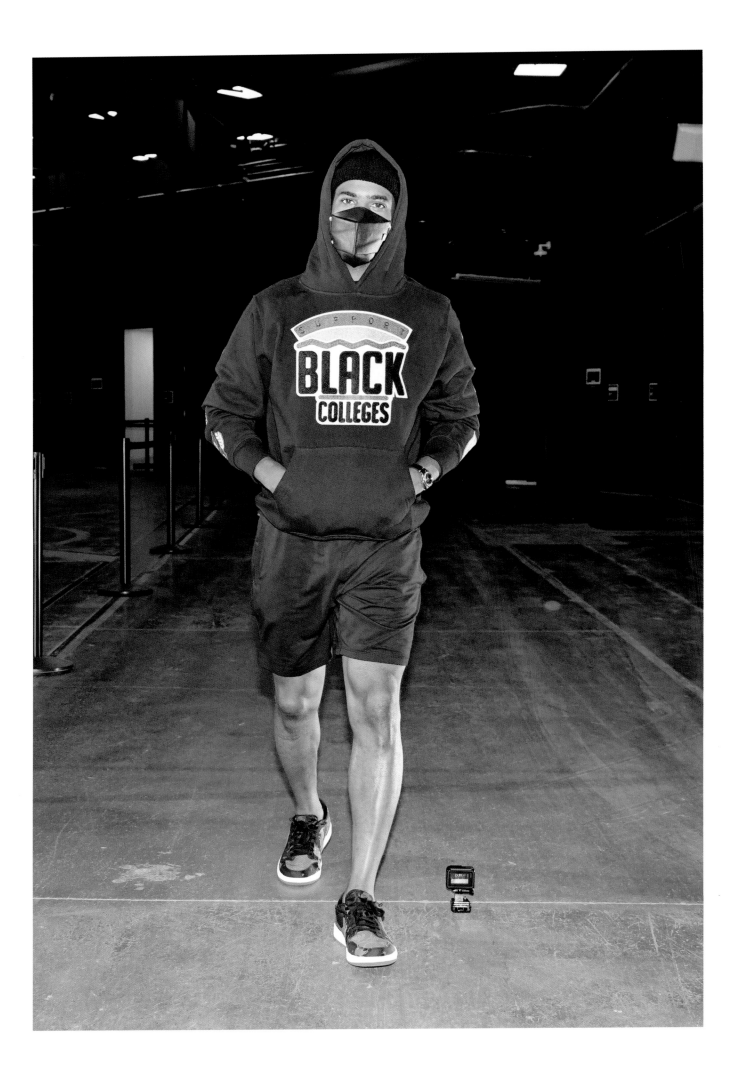

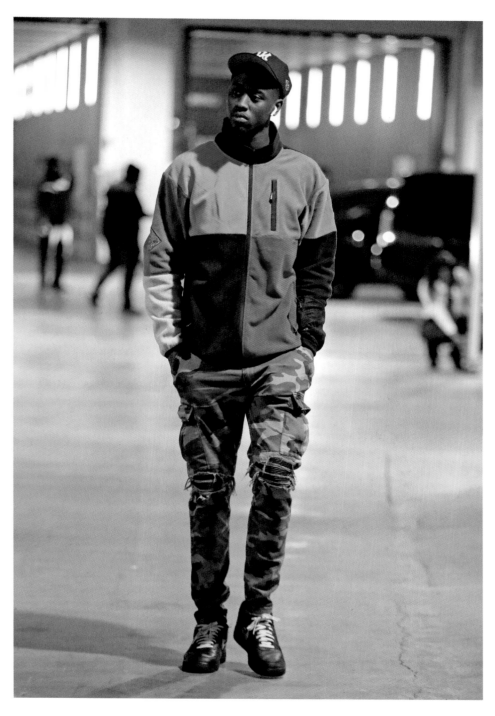

ABOVE Caris LeVert of the Brooklyn Nets arriving at Barclays Center in Brooklyn, 2019. Yet more proof that army fatigues are a style staple.

OPPOSITE Chris Paul of the Phoenix Suns, turning his support of HBCUs into a streetwear tunnel look in 2021.

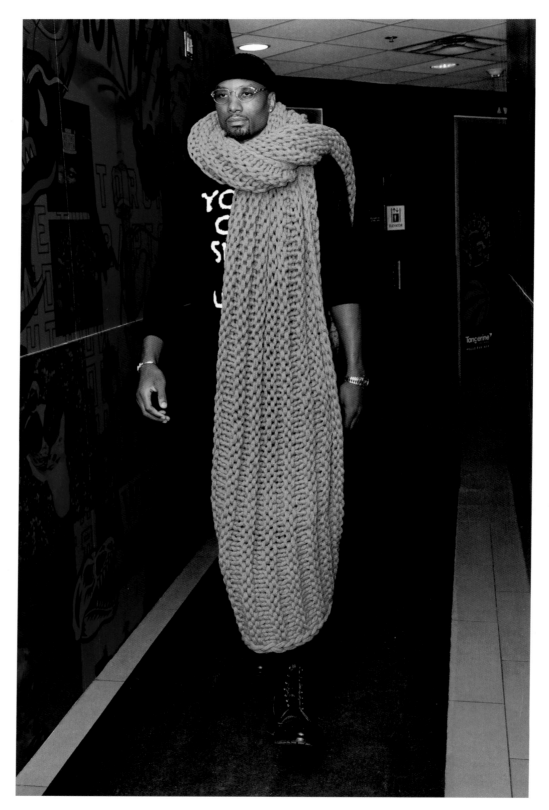

ABOVE Serge Ibaka of the Toronto Raptors in 2020, sporting a scarf that's nearly the length of his 6-foot-11 frame, a most memorable tunnel look.

OPPOSITE Kyle Kuzma during Paris Fashion Week 2022, wearing a printed camp-collar shirt by Casablanca and thick-soled Alexander McQueen sneakers.

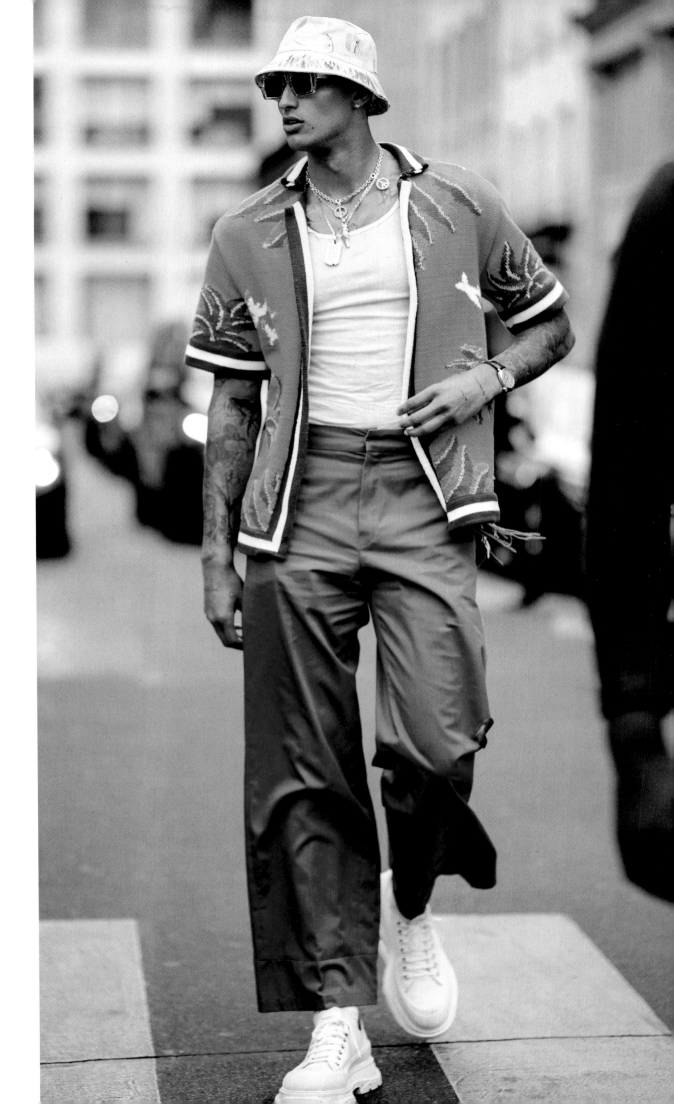

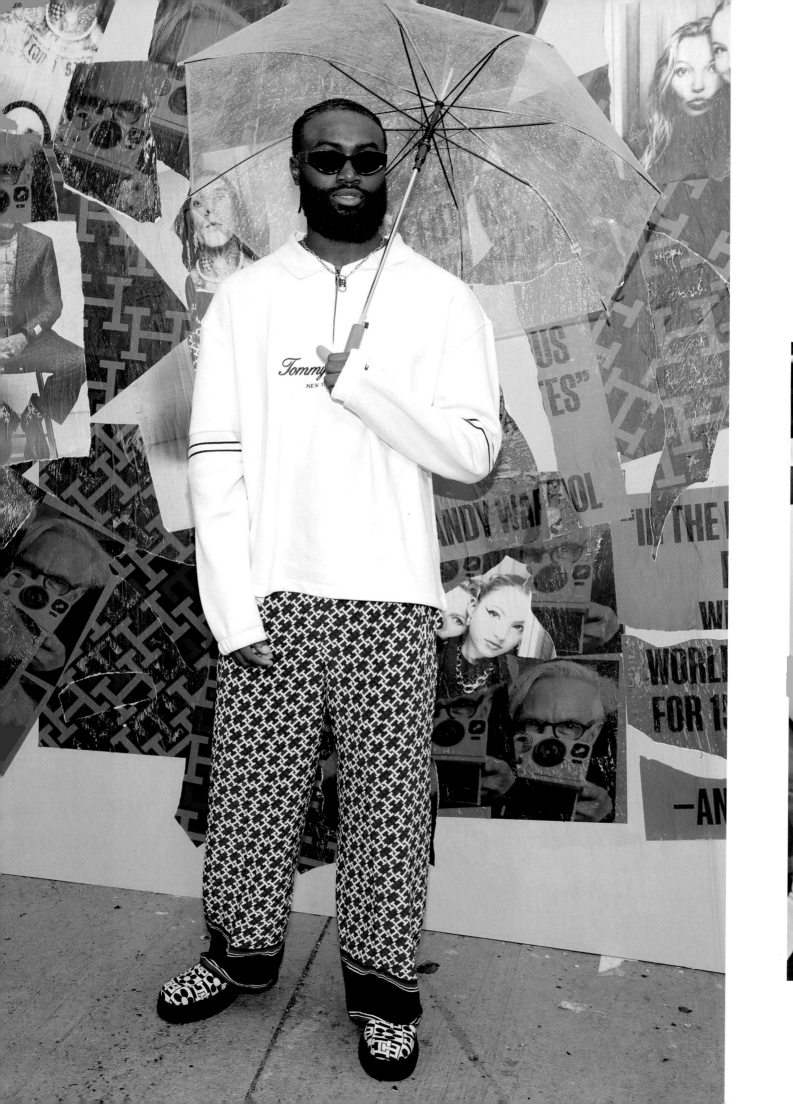

OPPOSITE Boston Celtics star Jaylen Brown attends a Tommy Factory fashion show in New York City and displays great print-mixing aplomb, 2022.

BELOW Jalen Green at the Louis Vuitton Men's Spring/Summer 2023 Show during Paris Fashion Week. Pairing an LV monogram shirt with Damier print pants was a stroke of style brilliance.

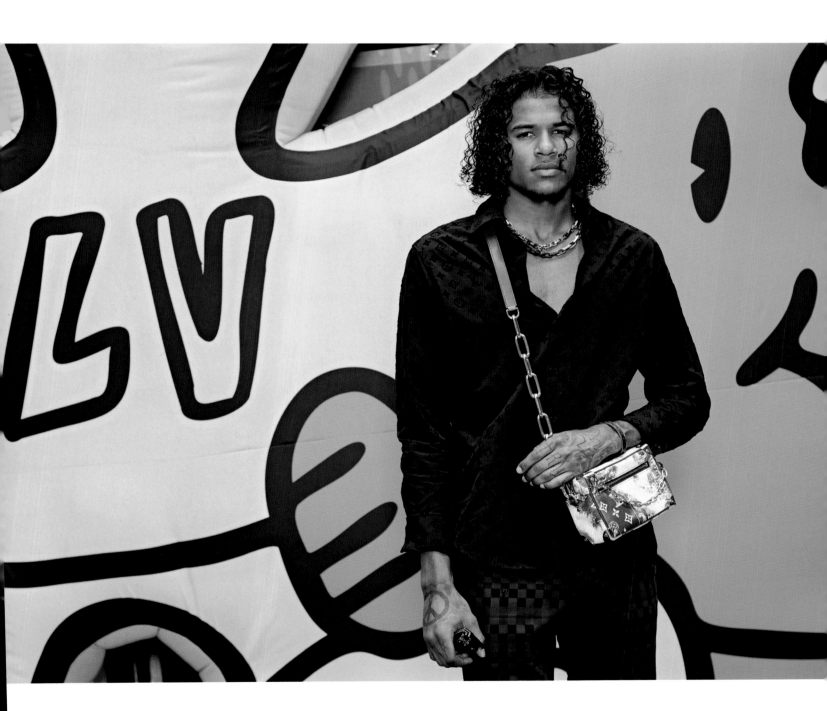

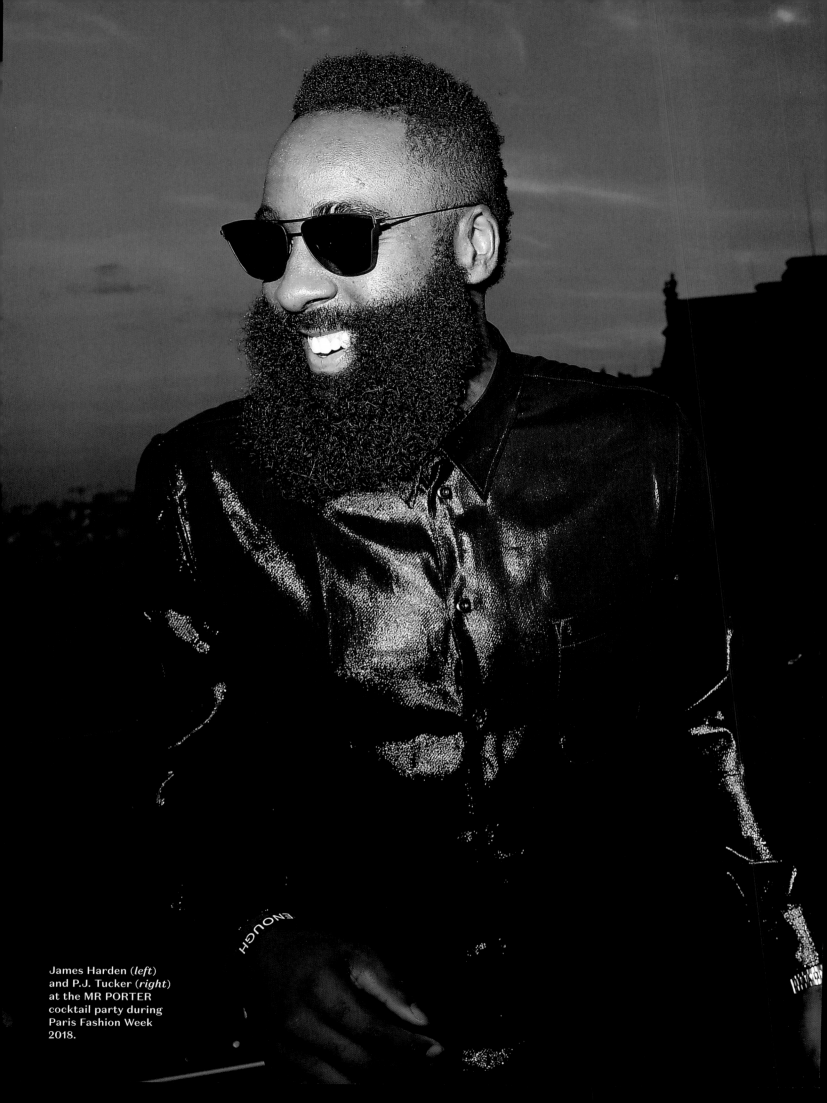

James Harden (*left*)
and P.J. Tucker (*right*)
at the MR PORTER
cocktail party during
Paris Fashion Week
2018.

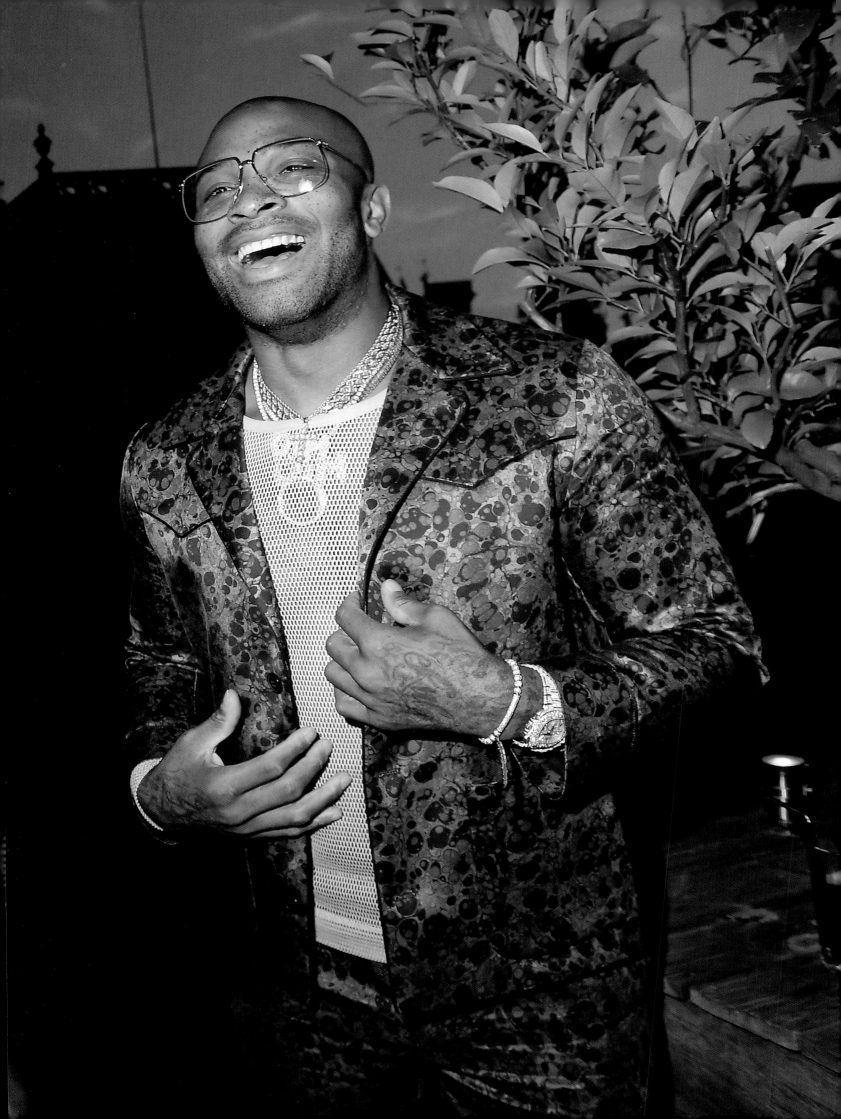

ABOVE (*from left*) Ja Morant, Jaren Jackson Jr., and Tyus Jones of the Memphis Grizzlies, courtside in Memphis, 2022. A young brash team with a color palette to match.

OPPOSITE Kyle Kuzma of the Los Angeles Lakers, incognito to the max in Oklahoma City, 2021.

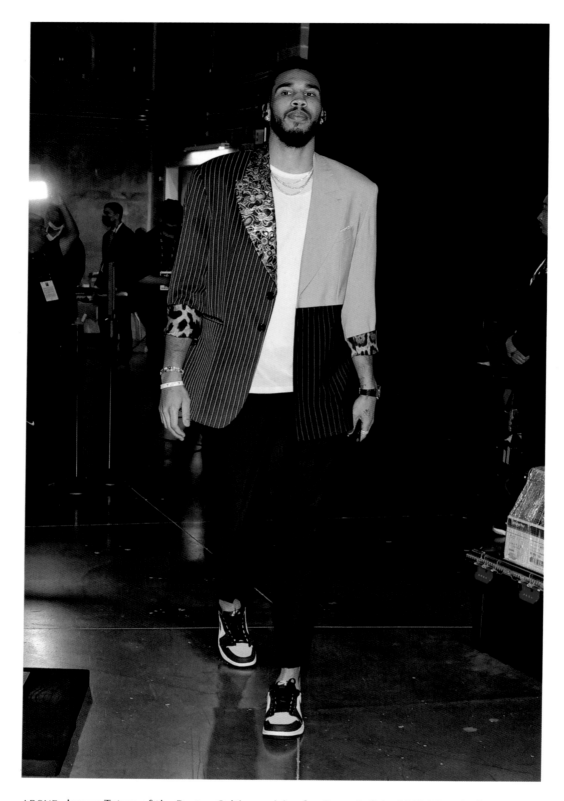

ABOVE Jayson Tatum of the Boston Celtics arriving for Game 1 of the 2022 NBA Finals in San Francisco. Tatum had one of his worst playoff performances that game, but his Dolce & Gabbana sport coat was still a star.

OPPOSITE Rudy Gay, wearing Puma sneakers, seen outside the Y/Project fashion show during Paris Fashion Week 2019. An example of color coordinating gone right.

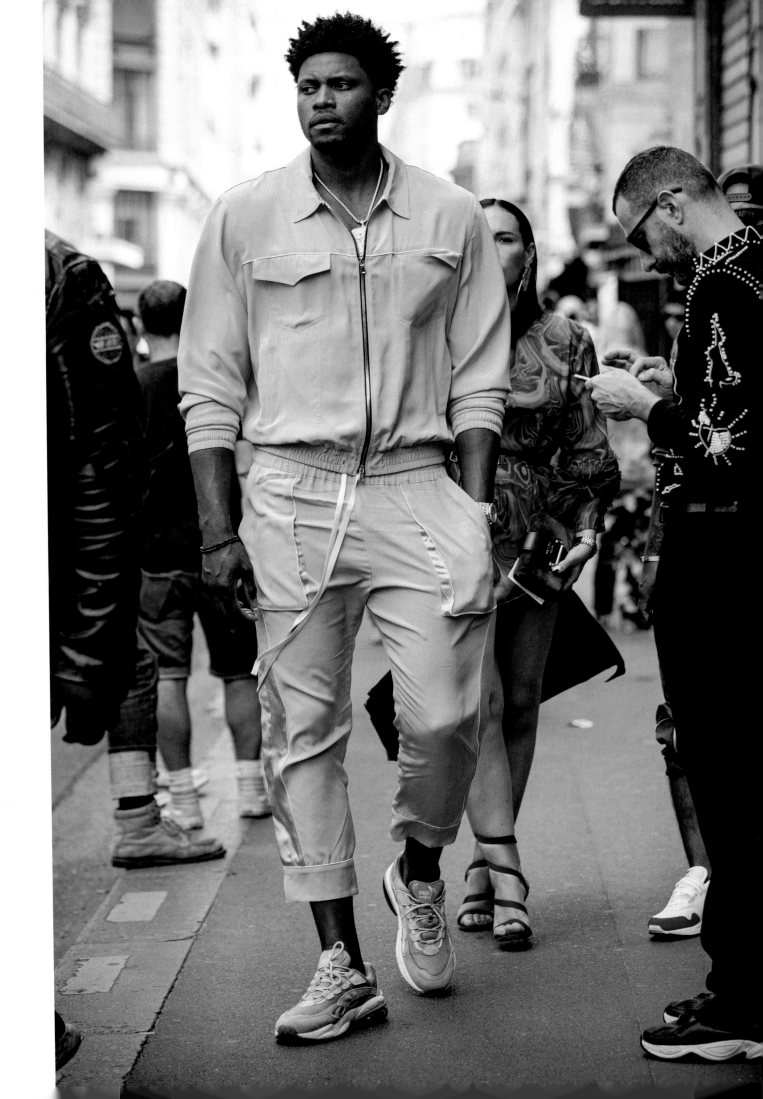

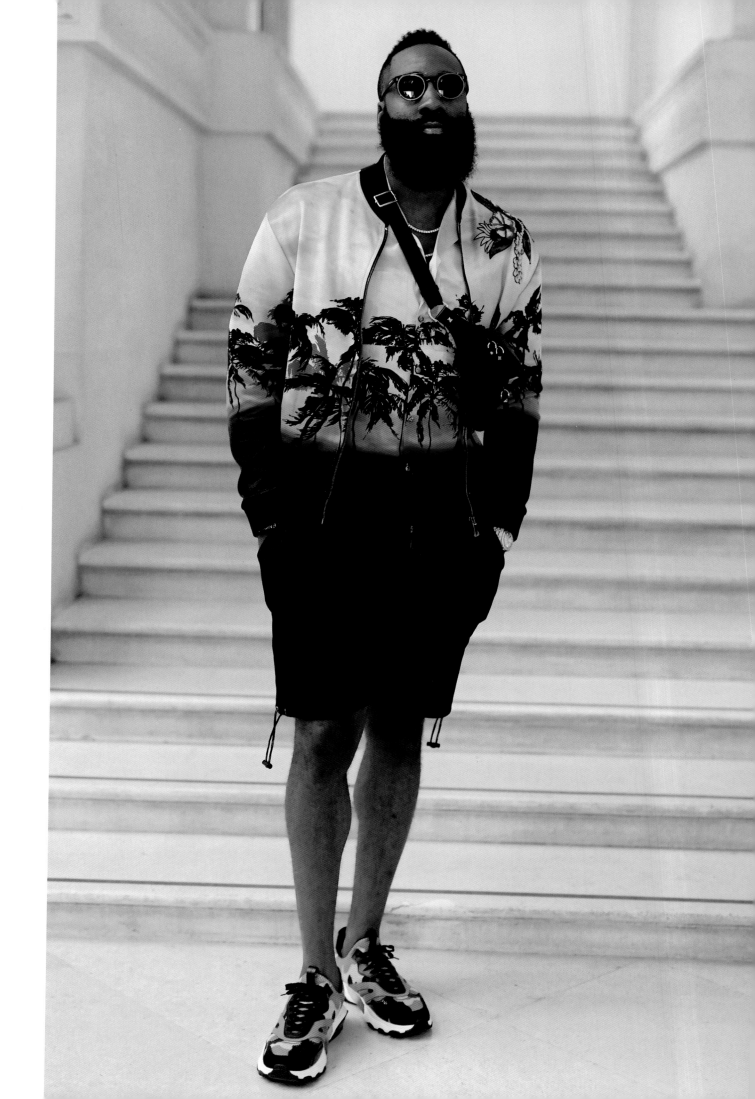

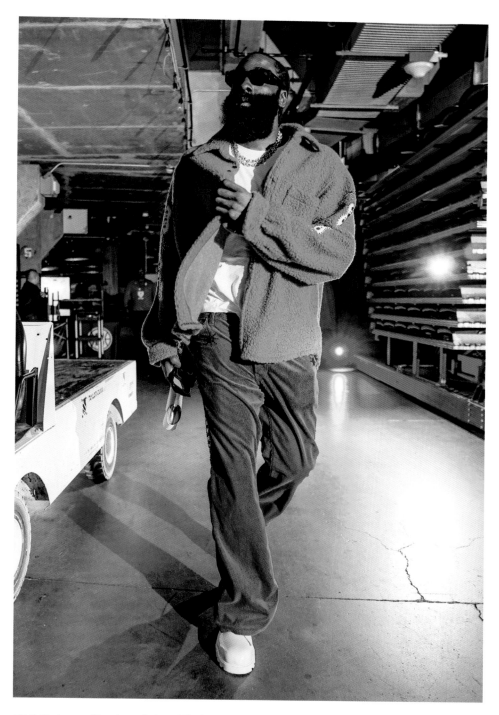

ABOVE James Harden of the Philadelphia 76ers in the Crypto.com Arena in Los Angeles, 2022. Baby, I'm a star.

OPPOSITE Harden at the Valentino Menswear Spring/Summer 2019 Show during Paris Fashion Week. Tally another win for color and pattern coordination.

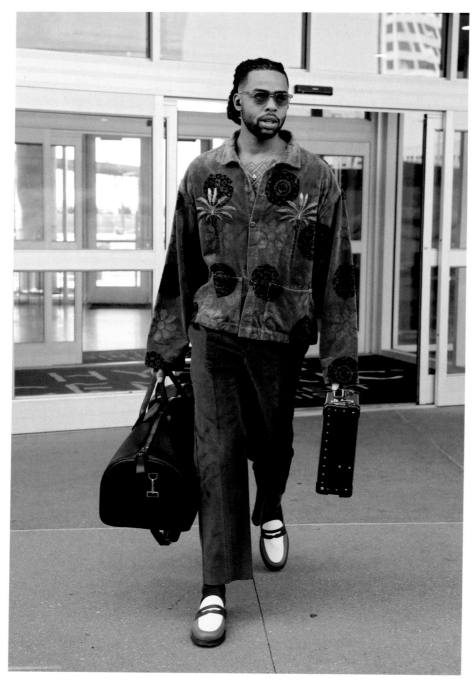

ABOVE D'Angelo Russell of the Minnesota Timberwolves arriving for an away playoff game against the Memphis Grizzlies in 2022. The jacket alone should've ensured a victory.

OPPOSITE DeAndre Jordan of the Brooklyn Nets at Barclays Center, Brooklyn, 2019. Tone-on-tone magnificence, which is tough to achieve at an inch shy of 7 feet.

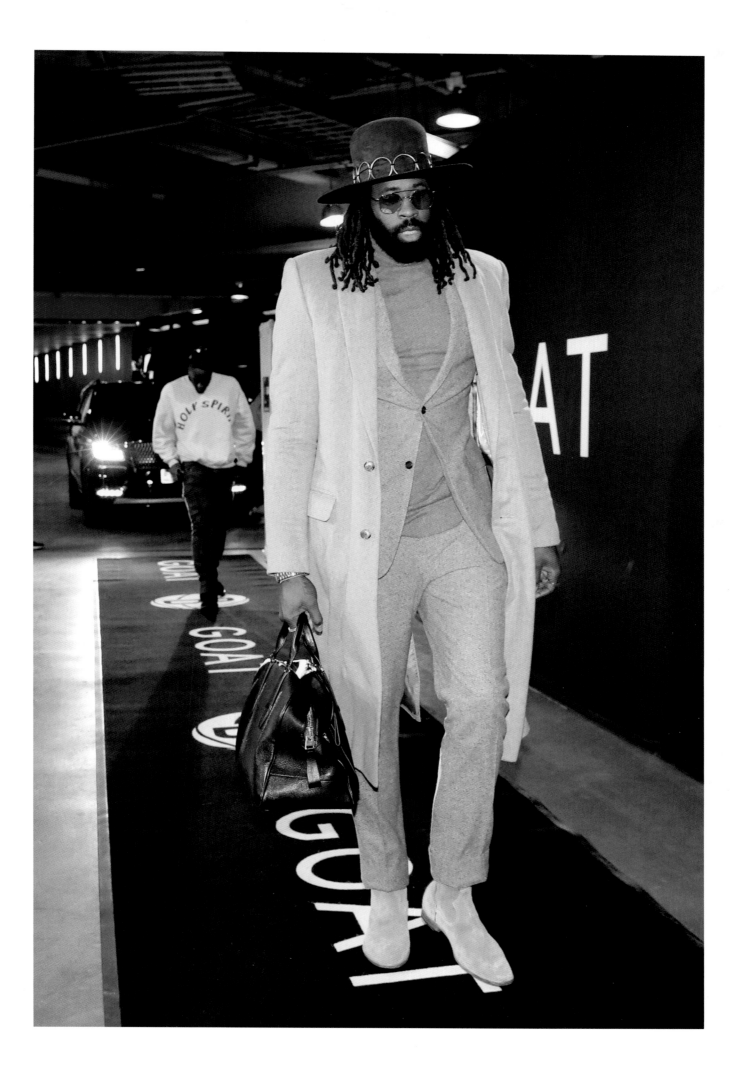

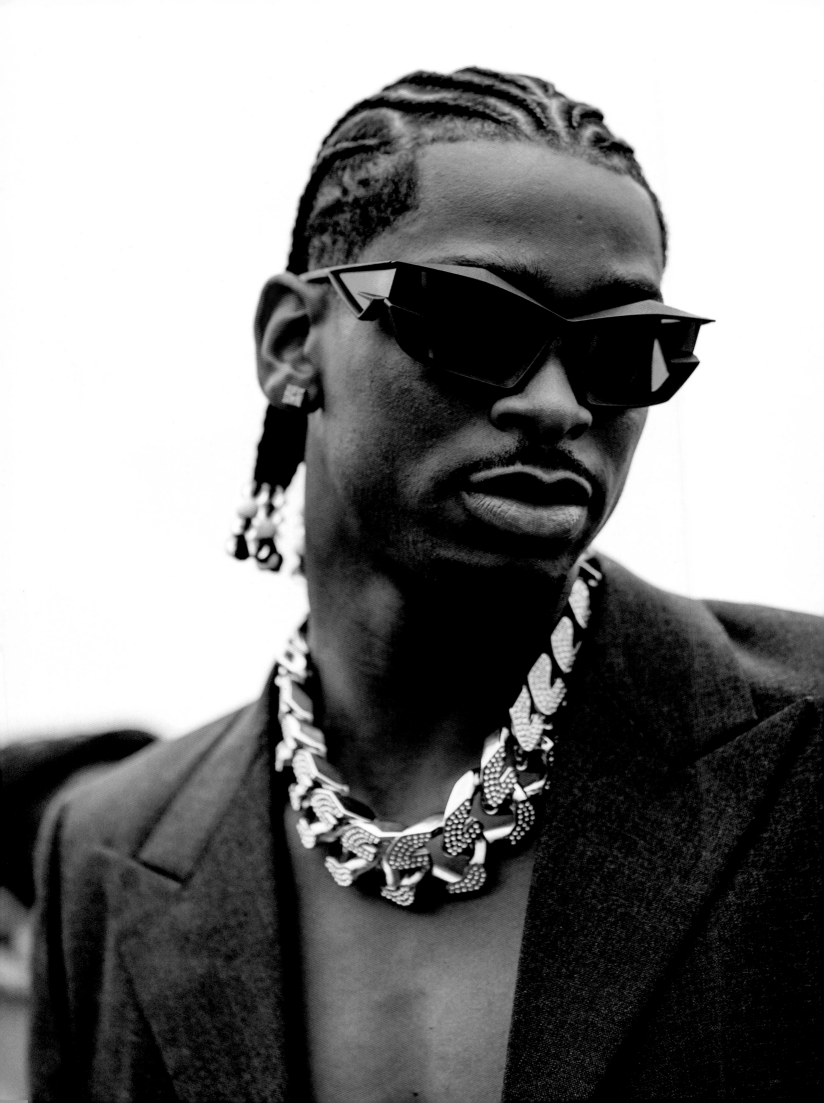

Shai Gilgeous-Alexander outside the Givenchy show during Paris Fashion Week 2022. As stated, Shai was voted *GQ*'s Most Stylish Man of the Year for 2022. More proof that NBA style and high fashion are now synonymous.

PHOTO CREDITS

LISTED BY PAGE NUMBER